1

2

3

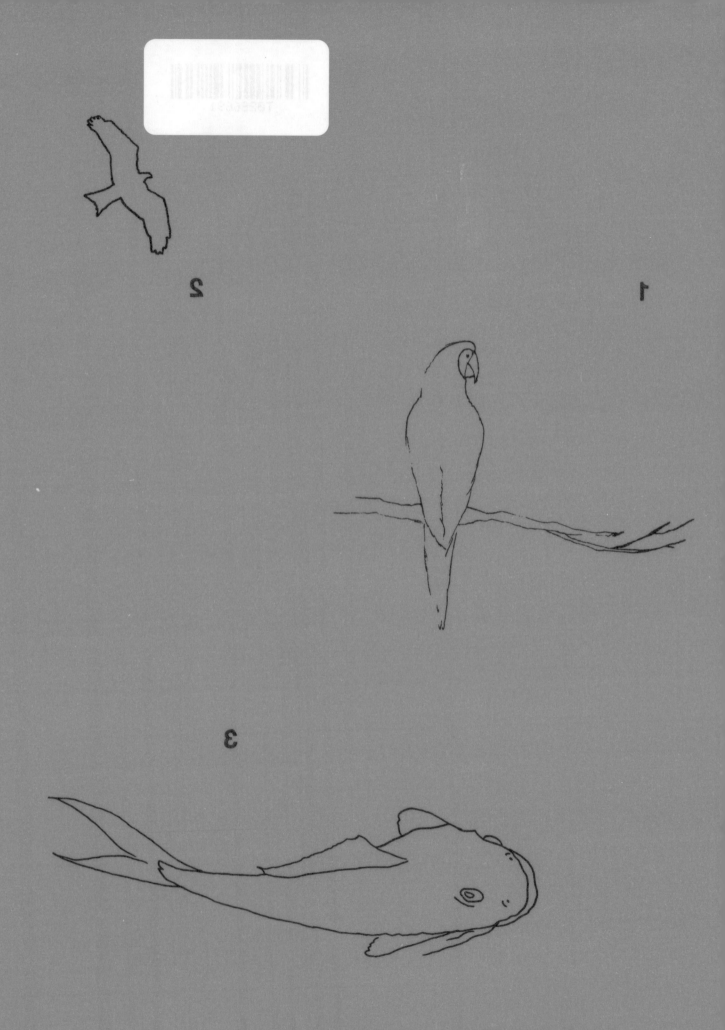

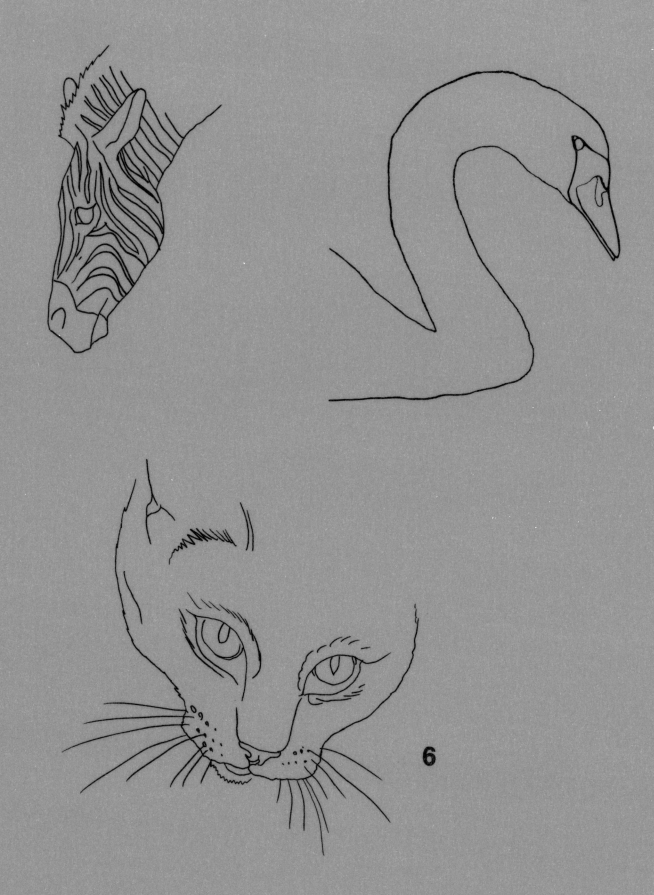

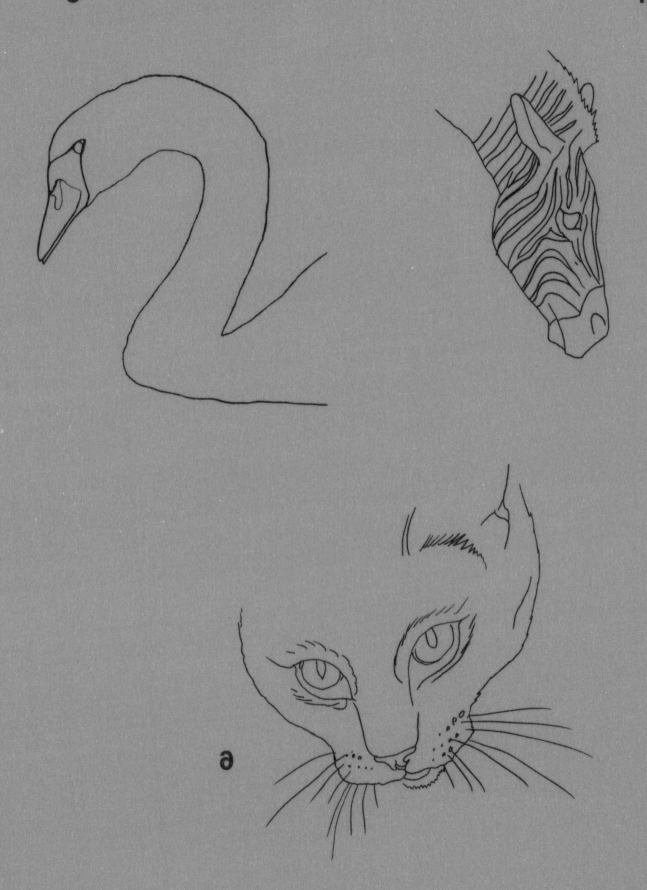

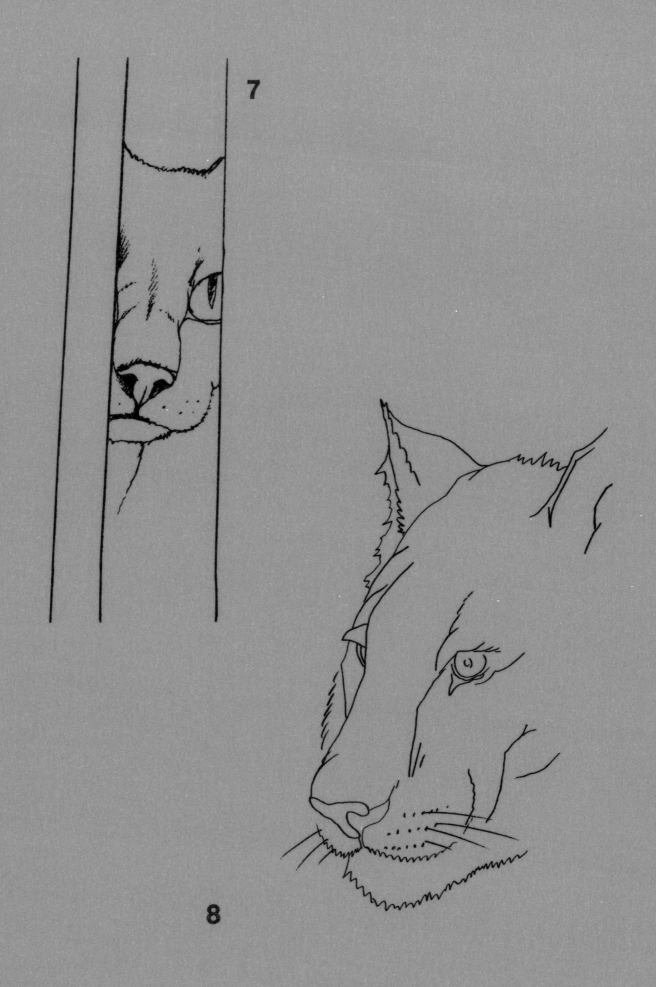

7

8

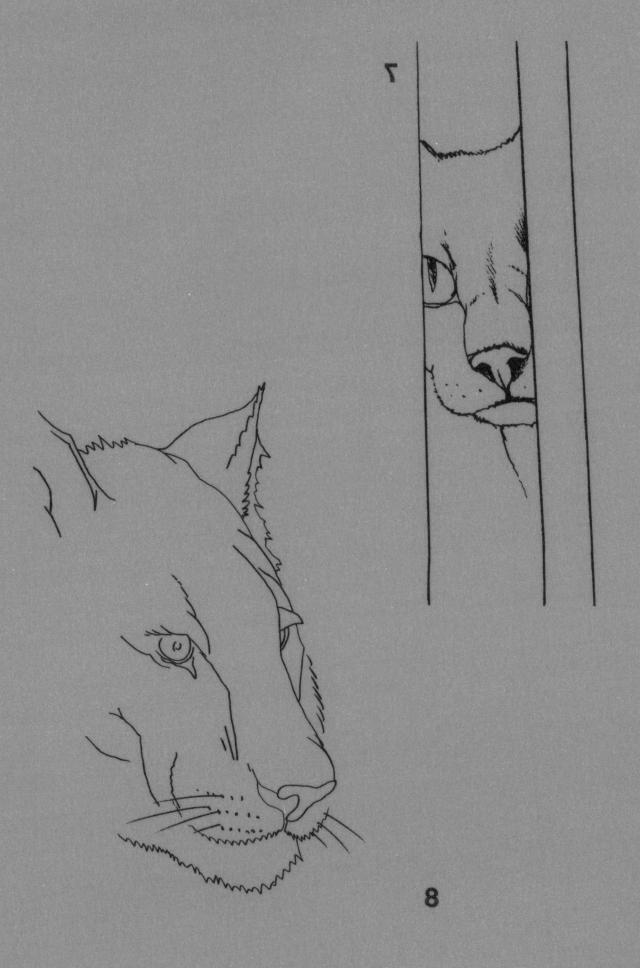

7

8

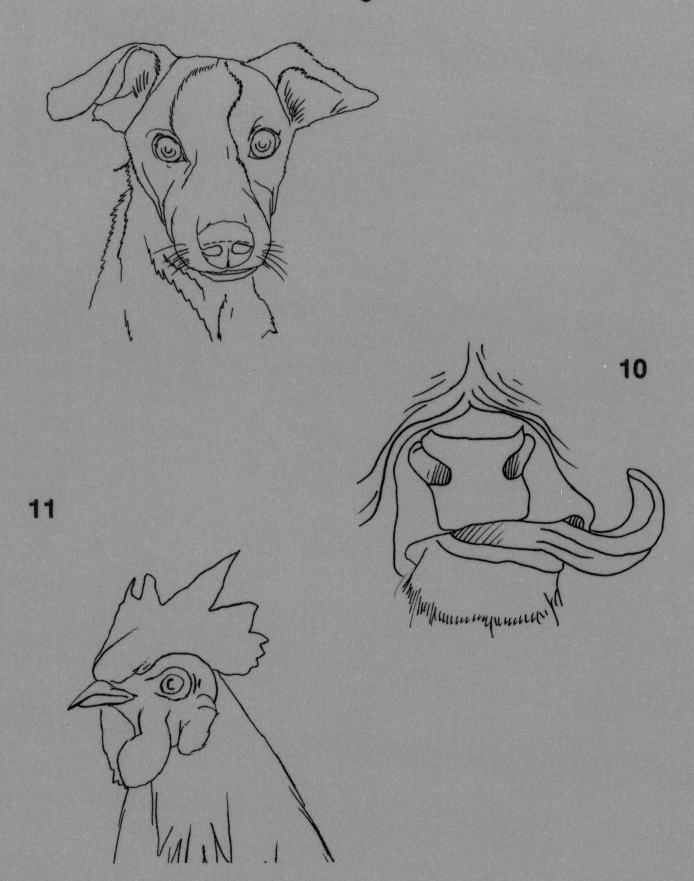

9

10

11

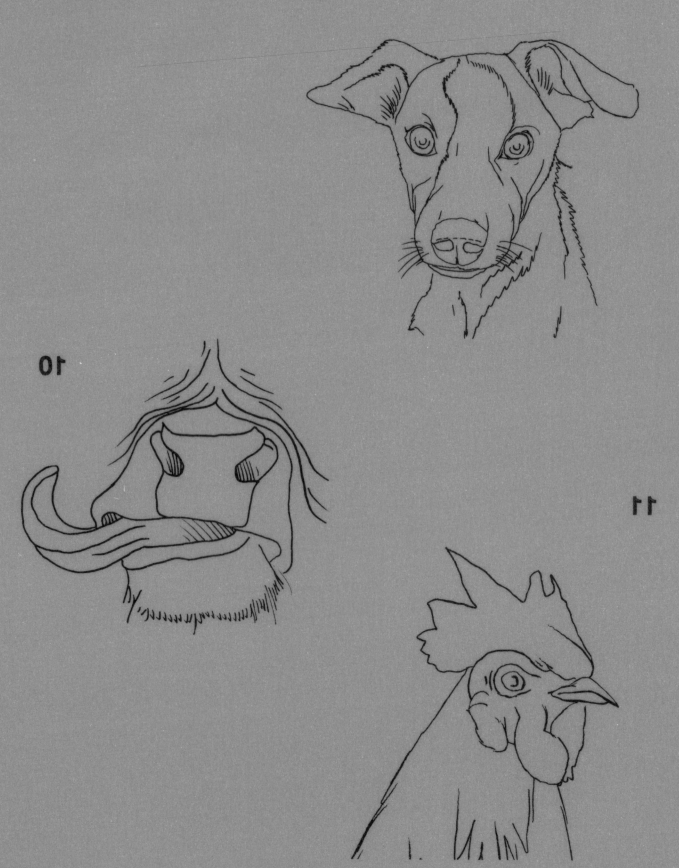

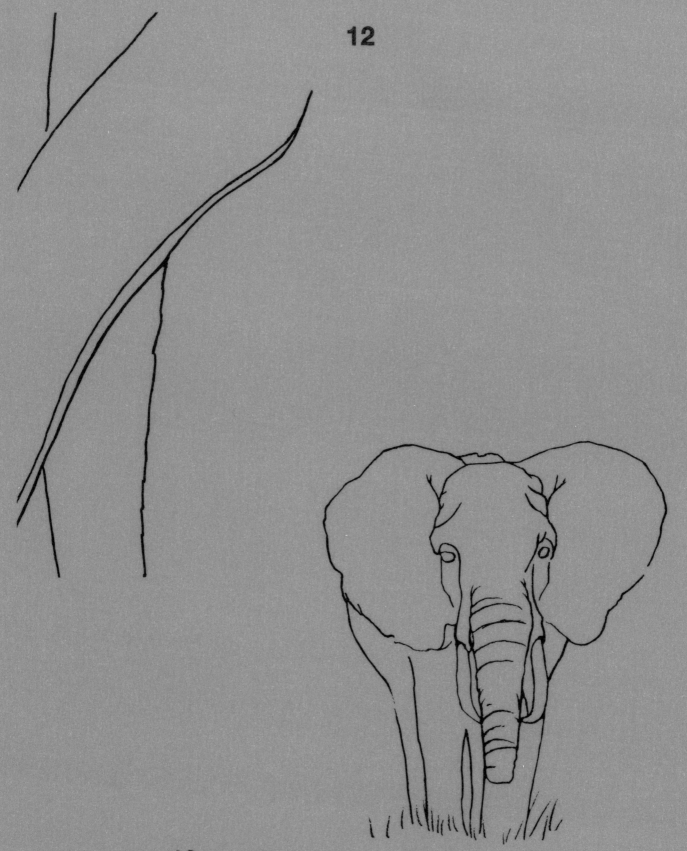

12

13

12

13

14

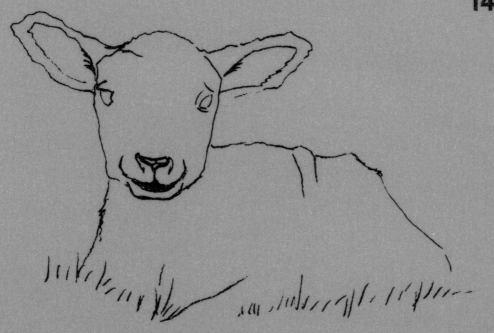

15

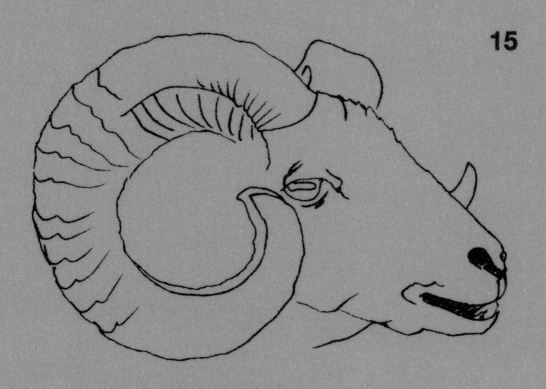

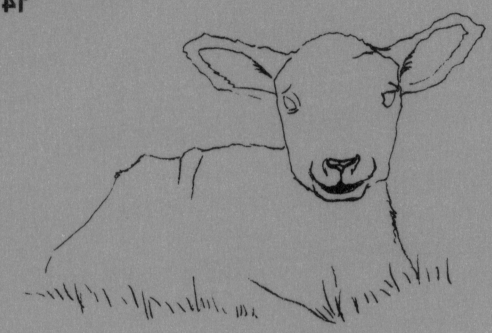

14

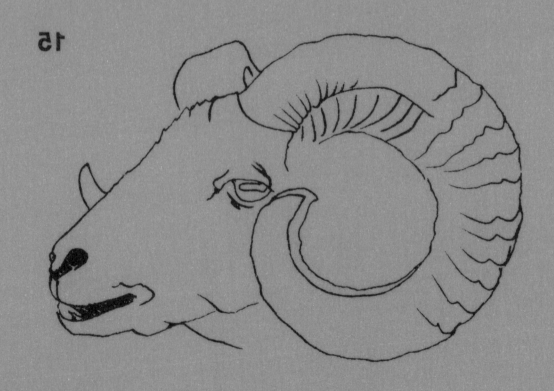

15

16

17

16

17

18

19

18

19

20

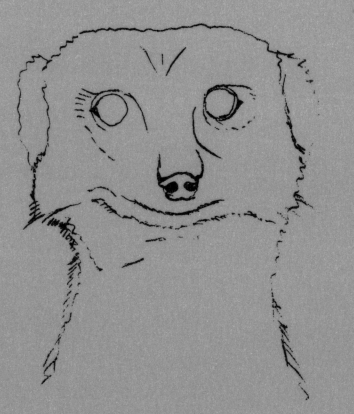

21

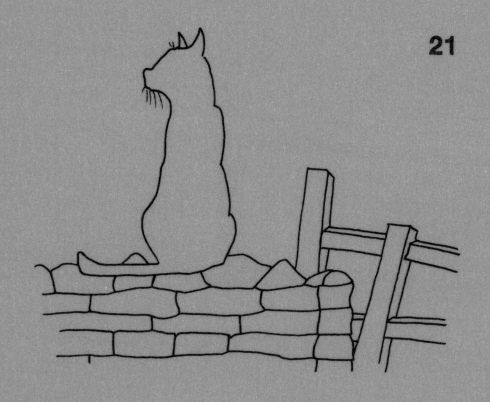

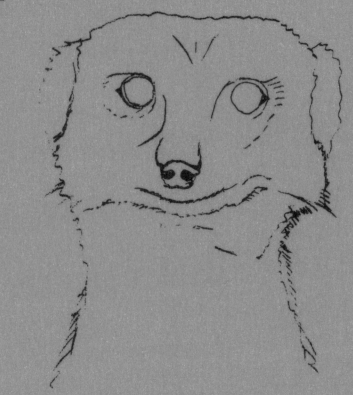

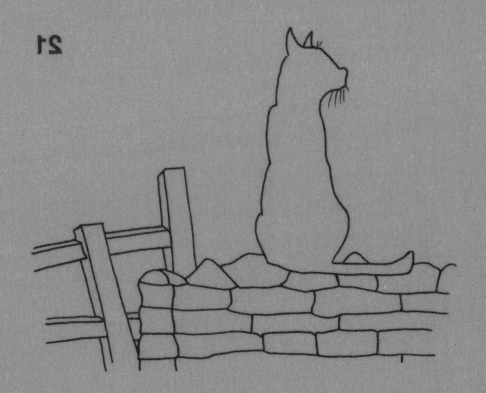

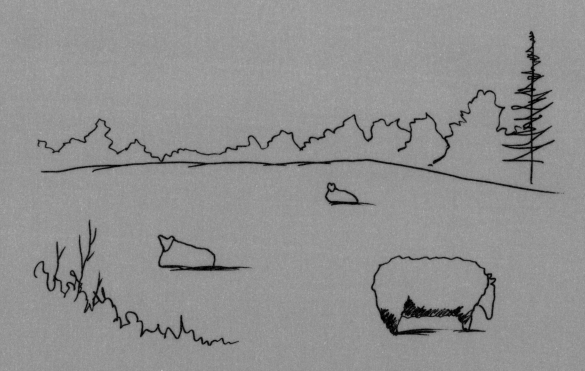

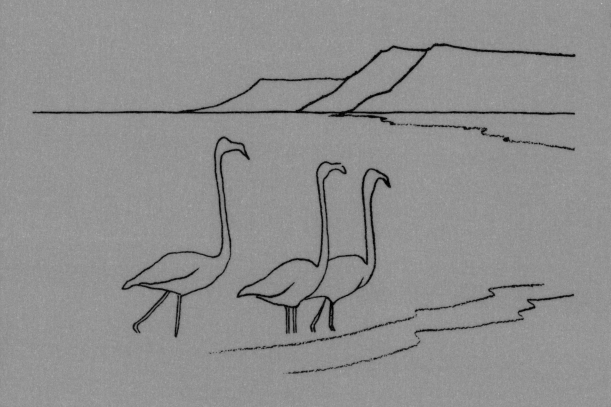

22

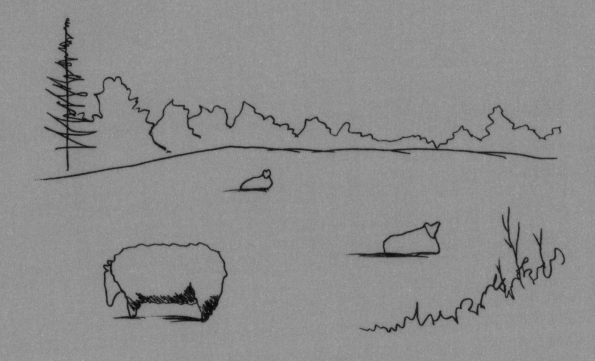

23

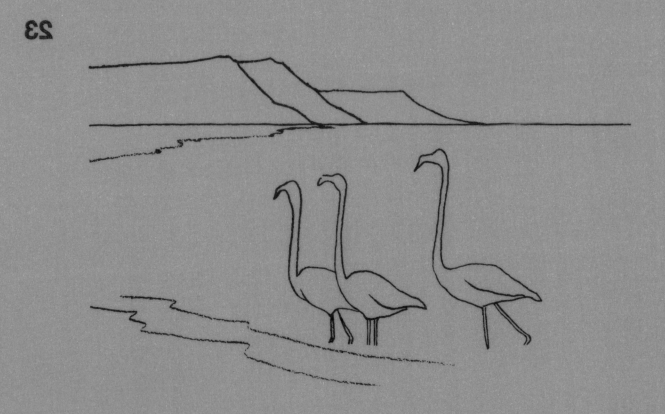

24

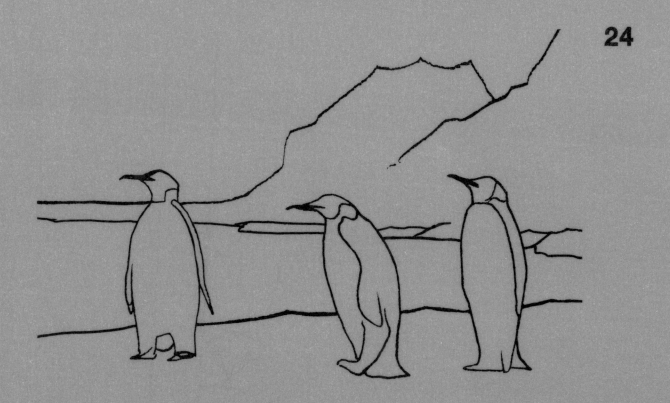

25

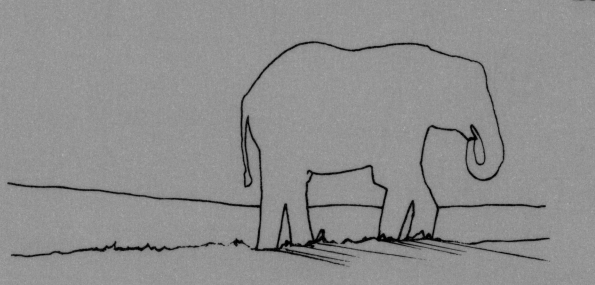

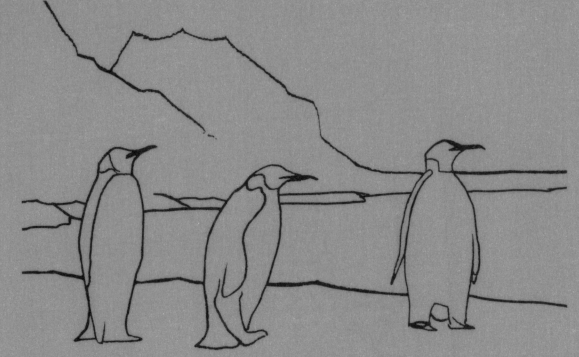

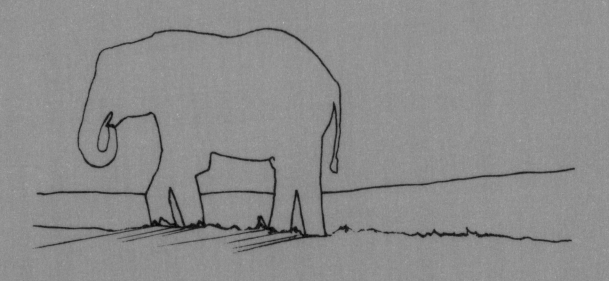

26

27

28

29

28

29

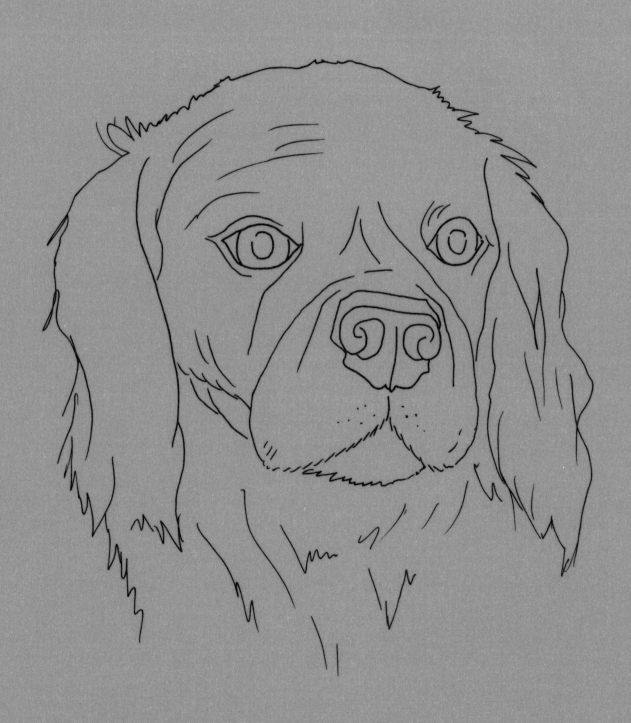

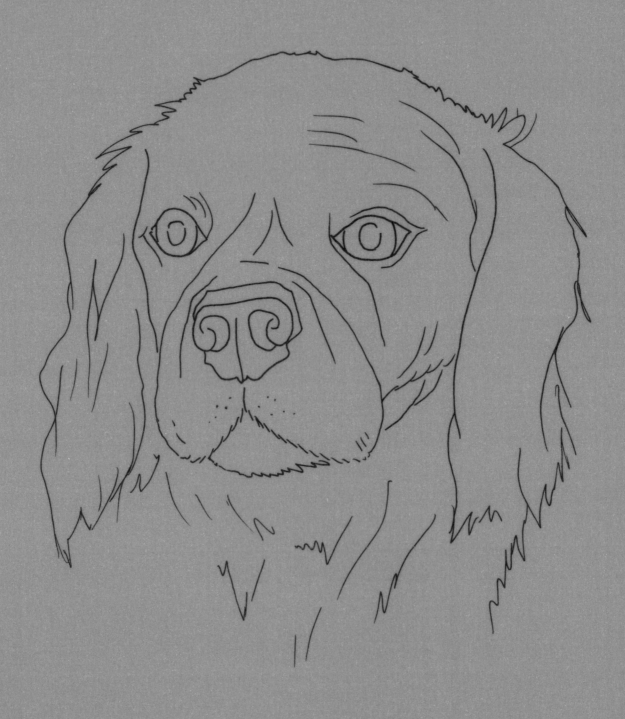

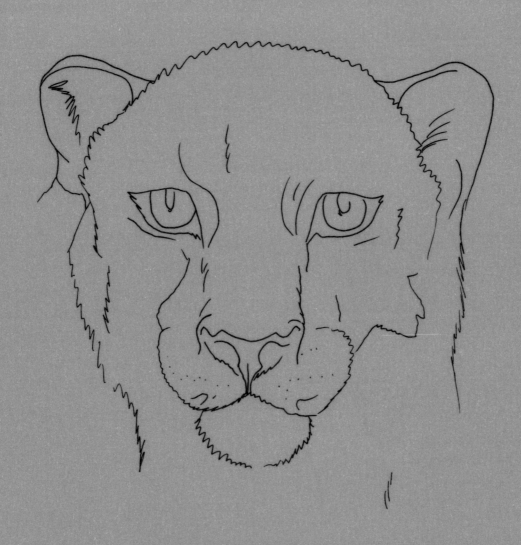

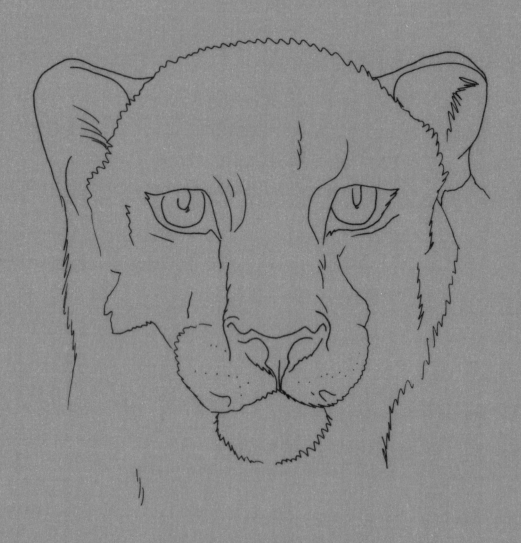

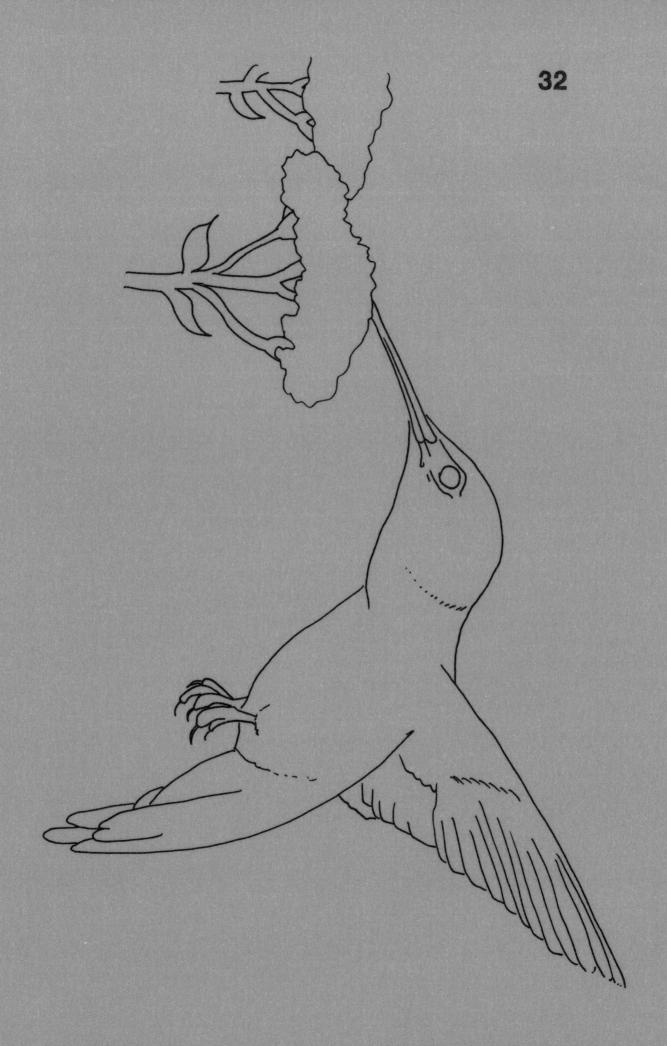

32

Ready to Paint in **30** Minutes

Animals
in Watercolour

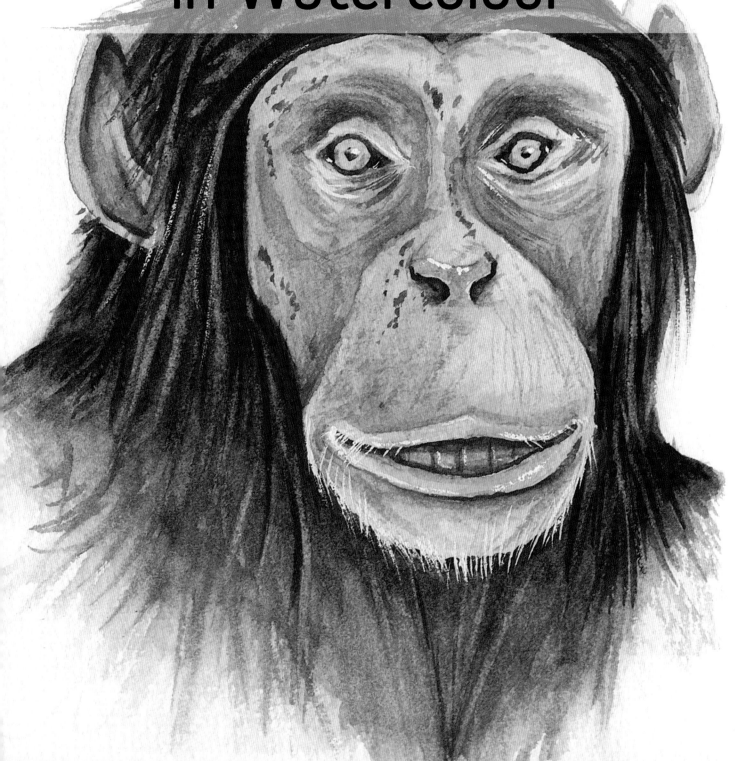

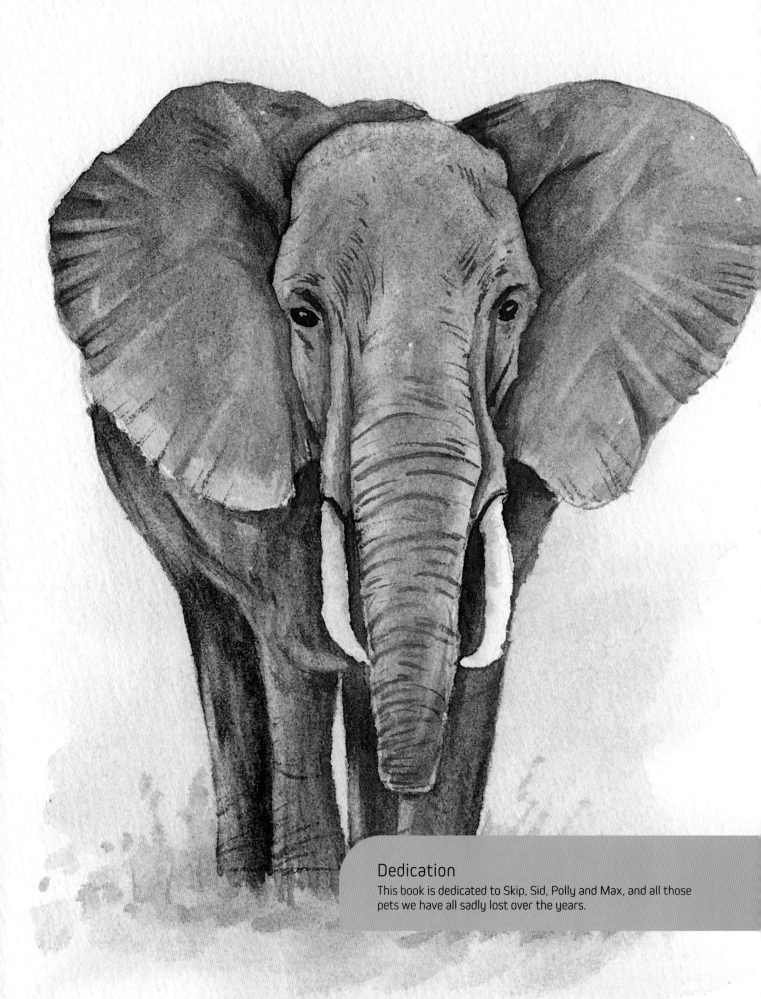

Dedication
This book is dedicated to Skip, Sid, Polly and Max, and all those pets we have all sadly lost over the years.

Ready to Paint in 30 Minutes

Animals

in Watercolour

Matthew Palmer

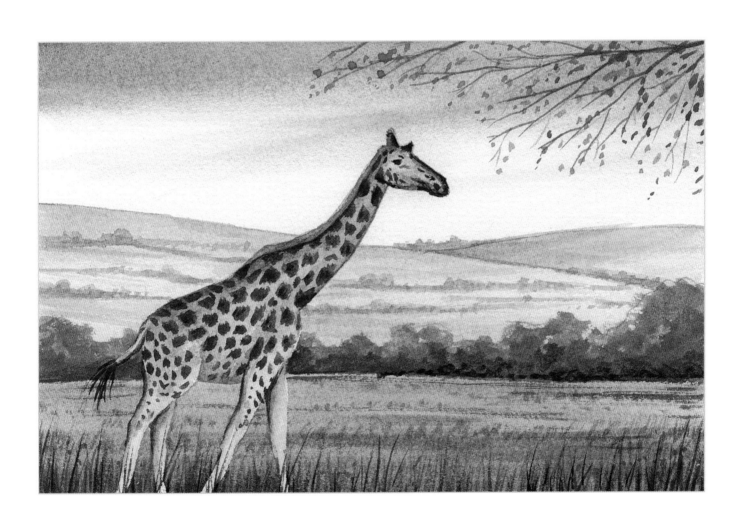

SEARCH PRESS

First published in 2021

Search Press Limited
Wellwood, North Farm Road,
Tunbridge Wells, Kent TN2 3DR

Text copyright © Matthew Palmer 2021

Photographs by Roddy Paine Photographic Studios

Photographs and design copyright © Search Press Limited 2021

ISBN: 978-1-78221-685-8
ebook ISBN: 978-1-78126-615-1

The Publishers and author can accept no responsibility for
any consequences arising from the information, advice or
instructions given in this publication.

Suppliers
If you have any difficulty obtaining any of the materials
and equipment mentioned in this book, please visit the
Search Press website: www.searchpress.com

Acknowledgements

Thanks to Katie French, Beth Harwood, Becky Robbins and
all at Search Press. Thanks to all at the SAA. A special thank
you to my parents for buying me my first paint set, and
massive hugs and kisses to my wife Sarah and son Jacob.

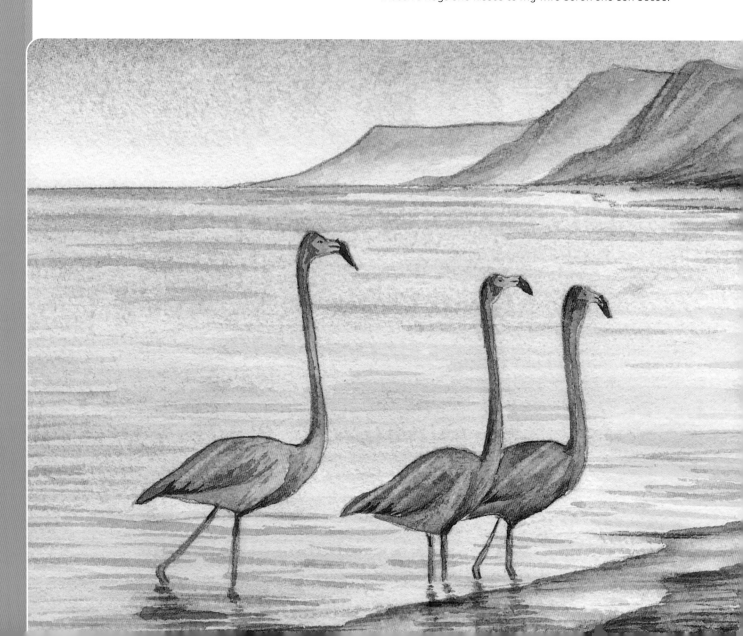

CONTENTS

INTRODUCTION

I have spent many years painting animals in watercolour, whether I'm painting commissions, teaching the subject or just painting for enjoyment. Animals rendered in watercolour are superb: I love the way you can create highlights, add wonderful dark shadows and build up the transparent layers of colour. The vibrancy of the paint really lends itself to depicting animals. But in my years of teaching watercolour, I have often noticed that painting animals is something that students find daunting. With this book I hope to take away any fear of painting animals in watercolour, and will show you essential techniques that will make your animal paintings enjoyable and straightforward.

You will find that techniques tend to cross over from one animal to another. For example, the eye of a domestic cat is painted in a very similar way to the eye of a lion or tiger. Likewise, the way in which you paint fur is similar from one animal to another, regardless of species. Animals should be fun to paint – as a subject they are one of my favourites, up there with landscapes for me. I'd like to show you that, with the right guidance, animals in watercolour can be very simple... maybe even more so than landscapes.

The idea of this book is to paint a series of 15 x 10cm (6 x 4in) postcard-sized watercolour paintings; each project will help you to develop your painting techniques. We will start with basic watercolour techniques, moving on to painting key animal features, and then textures and markings in close-up. We will paint a series of animal portraits, then look at animals in the landscape. Each project will take you about 30 minutes to complete and will teach you all the essential skills you will need. At the end of the book are three larger projects which put your new-found skills into practice.

All of the projects in this book can be painted on a medium-texture watercolour surface, which is ideal for the subject matter. I have provided tracings for each of the projects and the three final paintings at the front of the book. Working to a traced outline is a great starting point and will allow you to get straight on with the watercolour painting, although of course you're more than welcome to draw your own scenes if you want to. I use a 2B pencil for the outlines – this has a medium-to-dark lead and is ideal for use with watercolour as the pencil will shine through, which is an important part of watercolour painting.

I hope this book gives you the confidence to give painting animals a go – start with the projects here, and then why not build up to capturing your own beloved animal friends in watercolour?

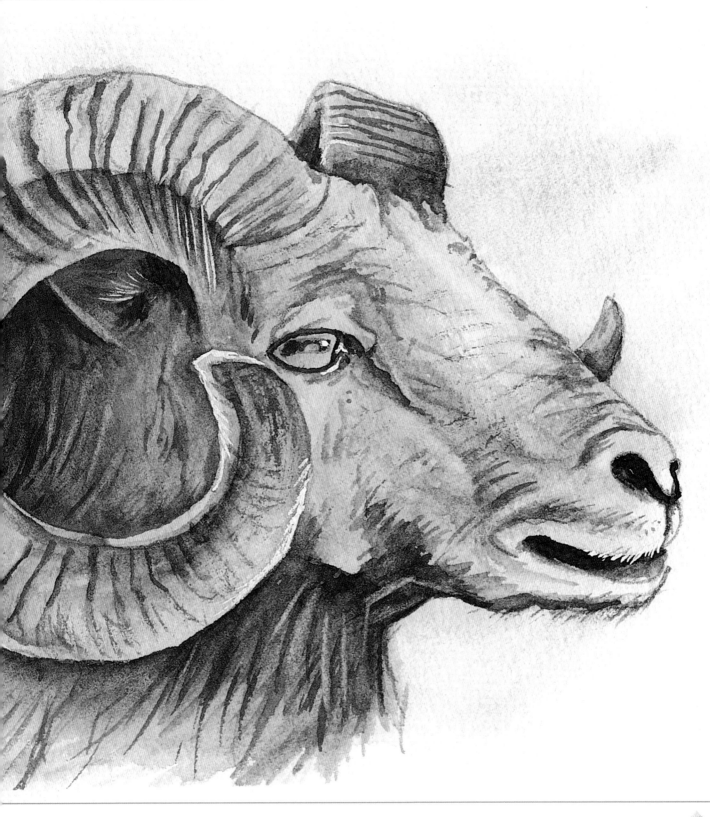

Ram, see page 52

15 x 10cm (6 x 4in)

BASIC PAINTING EQUIPMENT

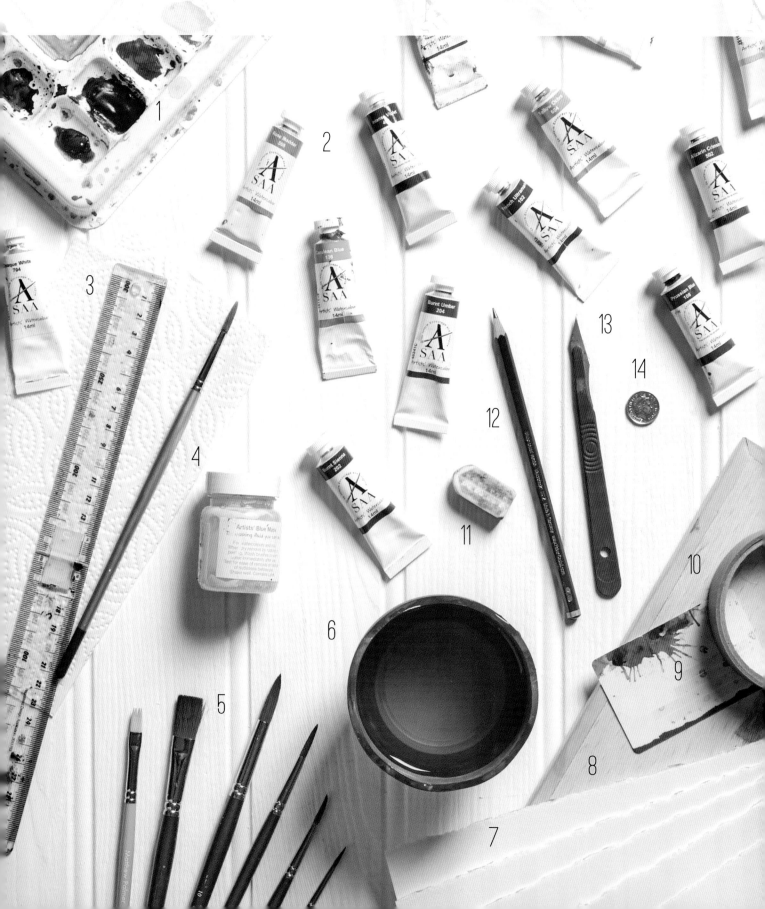

You don't need much equipment to get started in watercolours – a few brushes, some paints, a board to support your paper, masking tape and, of course, some clean water. It's also a good idea to have some kitchen paper handy for removing excess water and creating highlights.

1 Palette I use a plastic palette with plenty of wells, both for colour mixing and so I can squirt the paint into them directly from the tube.

2 Paints Tubes are by far the most useful form of watercolour; there are countless colours available and the colour can be squirted from the tube onto the palette with limited mess. Watercolour paints are also available in pan form – small, dry paints that are sold in little plastic cases, but many established artists tend to go for tubes as you have more control over the strength of colour than with pans.

3 Kitchen paper This is an essential part of a watercolour artist's kit. Use kitchen paper to wipe off any excess moisture or colour from your brush, and to lift out colour from an area of your painting to produce wonderful highlights (see page 15).

4 Masking fluid and an old brush Masking fluid is a liquid latex solution that allows you to protect areas of your painting that you wish to keep white – for example, the white sheep (pages 74–75). I advise using older brushes to apply masking fluid, as it can damage your brushes if it dries (see page 14).

5 Brushes As with paints, there is a huge array of brushes available – it can really be a minefield. Buy the best you can afford, as you get what you pay for with watercolour brushes. There are three types of brushes available: sable, sable/synthetic mix and purely synthetic brushes. Sable brushes are the highest quality and, of course, the most expensive. The main advantage of a sable brush is the hollow hair, which allows water and paint to be absorbed. Sable/synthetic mix brushes are my personal choice: the mix of the two hairs gives high water absorbency, stiffness and a lovely point to the

bristles. The final quality is synthetic: these are the most common choice and perfectly fine to use. Always go for a well-known brand for the highest quality brush.

You don't need many brushes for the projects in this book: I have used round brushes in sizes 10, 6, 4 and 2, and flat brushes (also known as square or chisel brushes) – it's good to have two sizes, a 6 and a 12mm (¼ and ½in). Flat brushes are great for removing paint and creating highlights; 6mm (¼in) is my preference.

6 Water pot You can use anything from a jam jar to a cup as your water pot. It is a good idea to have two water pots to hand – one for dirty water, one for clean.

7 Paper The sheer amount of different watercolour papers on the market is unbelievable – my advice, as with brushes, is to buy the best paper you can afford at the time. Look for papers that are one hundred per cent cotton, with a weight of 300gsm (140lb) and a NOT (not-pressed) surface. A NOT surface is a medium-texture watercolour paper. Paper is also available with a smooth or a rough surface – 'NOT' is somewhere in the middle of these two: not rough and not smooth.

Watercolour paper is available in loose sheets, spiral-bound pads or blocks.

8 Board An alternative to an easel, your board can be anything from a sheet of stiff cardboard to a piece of wood.

9 Plastic card An old store card or credit card is great for scraping away watercolour paint while still damp, to give textured effects.

10 Masking tape Use tape to fix your paper to the board. It is important to stick the paper on all four sides – this keeps the paper nice and tight, and prevents it from cockling when wet.

Masking tape is also useful for masking out straight lines, similar to masking fluid.

11 Eraser ...We all make mistakes, right?

12 Pencil I use a 2B pencil most of the time, and if I need a darker line I use a 4B – these are good medium-to-dark leads that work perfectly with watercolours and will show through the transparent paint. A 2B lead is also just the right softness to allow you to erase it without scarring the paper. It is important to keep the pencil lead sharp.

13 Craft knife A knife with a good, sharp point allows you to add highlights and texture to your paintings (see page 15).

14 Small coin To achieve a neat, round shape when lifting out a circle of paint, such as for the moon or sun (see Cat on the lookout on pages 72–73, and below), wrap a small round coin in a folded half sheet of kitchen paper, creating a handle for yourself to grip with, then press it onto the wet paint; apply a good amount of pressure to remove the colour.

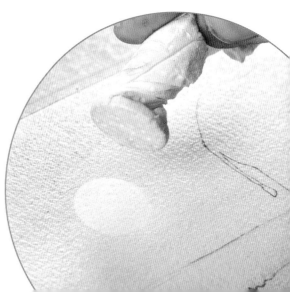

BASIC TECHNIQUES

There are numerous painting techniques that apply specifically to watercolour – whether you are painting landscapes, portraits, still life or animals. Here, we will start by preparing your palette and working out how to mix the colours you need. Then, on the following pages, we will look at applying the paint to the paper – there are various methods by which you can do this. These techniques will provide you with the tools you need for your watercolour animal paintings.

COLOUR MIXING

There are hundreds of colours in the watercolour spectrum – almost too many to account for; you can probably buy a dozen shades of blue alone. All you really need to begin with, however, are the primaries: red, yellow and blue. From these three you can mix almost any other colour.

PREPARING THE PALETTE

It is a good idea to keep a limited palette of colours – various tones of the three primary colours work well (see below). A natural grey is also a good colour to have – this is a premixed shadow colour, made from the three primary colours.

Squirt tiny spots of colour into the small wells of your palette, or onto the edge, and use damp or wet brushes to lift the paint and mix it in a larger well. I don't always add water straight to the palette unless I need a pale (watery, dilute) colour. When watercolour paint dries, all it needs is a touch of water to reactivate.

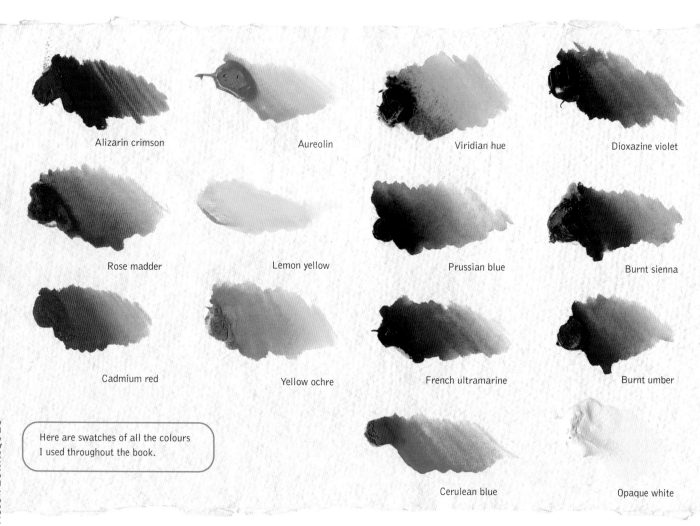

Alizarin crimson

Aureolin

Viridian hue

Dioxazine violet

Rose madder

Lemon yellow

Prussian blue

Burnt sienna

Cadmium red

Yellow ochre

French ultramarine

Burnt umber

Cerulean blue

Opaque white

Here are swatches of all the colours I used throughout the book.

PRIMARY COLOURS

Painting a colour wheel (see right) will really help you to understand how paint works. Basically, you can mix any colour apart from black and white from the primaries. I would suggest that you don't really need black anyway – it is much too dark, and pre-mixed colours (including most 'off the shelf' greys) that contain black pigment are too loud, and tend to leap off the paper; we want a dark colour to sit on the paper and recede into the painting and create depth for shadows.

The two colour wheels here show how dozens of colours can be made from just three paints. It's important to note how varying the colours even slightly can massively affect the tones mixed; there are lots of 'off the shelf' blues, reds and yellows, and variations of these can give different levels of vividness. Some colours cannot be mixed from these three, including turquoises, vivid browns and different shades of the main three.

GETTING A GOOD GREY

You'll need to mix a dark grey from the three primaries – this gives a soft colour, which is great for shadows and for creating the illusion of depth. For soft, gentle and transparent shadows use a primary mixed grey (shown in the centre of the colour wheels). For very strong dark greys, use a brown like burnt umber mixed with French ultramarine blue. This is too dark for shadows but great for the dark fur of some animals. I prefer to mix a natural grey from 70 per cent French ultramarine, 10 per cent alizarin crimson and 20 per cent yellow ochre.

When mixing a grey from the three primaries, always put the blue in first, then a tiny spot of red until the blue goes slightly purple. Be careful not to add too much red. Finally, work in tiny spots of yellow until the colour goes grey. Mistakes can happen, however: if your grey mix looks too brown, add more blue; if it goes too purple add more yellow, then a touch more blue. If your grey goes too green, add a touch of red then a touch of blue to rectify the mix. It's worth practising this tried-and-tested colour mix: my 'natural grey mix', as I call it, is the most used colour, as every painting has areas of shadow.

WORKING WITH WHITE

White can't be mixed from the three primary colours, so there are a few options for using it in your work. One option is to leave the white of the paper showing: use masking fluid (see page 14), or use dilute mixes that allow the white to show through. If you choose to use a white paint instead, go for an opaque white, such as titanium white, or even a white gouache: this will be ideal for adding highlights and fine, light details. White paint does not need to be squirted into your palette, however; use the paint fresh from the tube when it is needed, as reactivated dried white paint is no longer opaque. Also, be careful not to dilute the white too much with water – it'll appear to go on the paper ok, but then it will dry and almost disappear; just a spot of water is all that is needed.

My colour wheel, mixed from cadmium red, aureolin and French ultramarine, with natural grey at the centre.

My colour wheel, mixed from alizarin crimson, yellow ochre and French ultramarine, with natural grey at the centre.

Technique: **Laying washes**

We begin almost every project with a wash: this is simply the process of laying down paints on the paper. This can be done as a flat wash in a single colour, or a graduated wash, which changes in tone or colour as you work down the paper.

A wash can be applied using two methods: wet-on-dry or wet-in-wet. Working wet-on-dry involves loading a brush with a consistency of 50 per cent paint and 50 per cent water and applying the paint to the paper without prewetting (see below, left).

A wet-in-wet wash involves prewetting the paper with water or with a base layer of dilute paint. It is widely used in landscape paintings for skies, but could be used for a soft, vignetted background for an animal portrait (right and below right).

A cloudy sky painted wet-in-wet. Work quickly to allow the paints to mix and blend easily, and keep your brush loaded with paint (see pages 18–19).

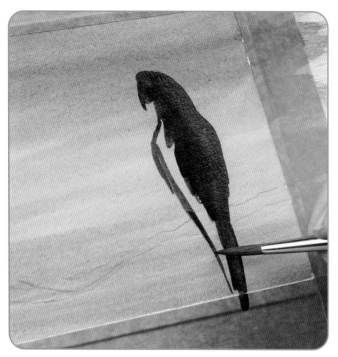

Here, a parrot is painted wet-on-dry over a graduated wash (see pages 16–17). It is essential that you paint onto a completely dry surface, otherwise your colours will run and you won't achieve a crisp outline.

A graduated wash should blend smoothly across the paper, here from blue to yellow in the sky (see pages 74–75).

Technique:
Blending away paint and softening together

It is crucial to ensure that you blend colours smoothly, and you may even need to fade a colour away almost entirely. Start by applying your colour or colours, ensuring the painted line or area is wide enough – if you make this line too thin, there won't be enough paint to blend away and you will end up with a hard line. Clean the brush then stroke or tap it twice, no more, on some kitchen paper, as water is needed on the brush; if the brush is too dry, the effect won't work. Run this clean, damp brush along the still-wet edge of the paint just applied to fade the colour out into the neighbouring area, as shown. If you are working on a large area, you may have to keep 'recharging' your brush, by repeatedly cleaning and wiping it; the wetter the brush, the more you can fade or blend away.

Feathering is a similar technique but uses an almost dry brush to create a rougher blend – for animal portraits, feathering is widely used.

Technique:
Using dry-brush

The dry-brush technique is fantastic for creating a range of animal textures, and it works especially well for fur. Simply load your brush with paint then wipe it almost dry on a piece of kitchen paper (below). Splay the bristles of your brush, then stroke the paper gently to create the dry-brush effect (right); it makes use of the textured paper surface. Start subtle, without overdoing it, then add more as you feel your painting needs it. This is a well-used technique and one to practise.

Technique: **Using masking fluid**

Masking fluid is liquid latex, which is applied wet and turns to a rubbery consistency when dry. It protects areas of the paper that you wish to keep light or white. Masking fluid goes onto the paper before any painting begins, and needs to be allowed to dry before you paint. The masking fluid can be removed once the area of painting has been completed – simply use your finger to rub away the dried fluid. Alternatively, you can use a soft eraser, but don't rub too hard over the paint as this will lighten it.

It is best to use an old brush to apply masking fluid as it can damage your brushes if it is left to dry. You can, however, cover the bristles in household soap before taking up the masking fluid, as this will protect them. Always remember to rinse your brush every couple of minutes while applying masking fluid as this will also protect it from damage.

Take care in the application of masking fluid – beginners often rush the process and then have to spend time repairing the masked area after the painting is complete. I advise that you use a coloured masking fluid, so that you can see clearly where you have applied it.

Coat the bristles of your damp brush in household soap before applying masking fluid.

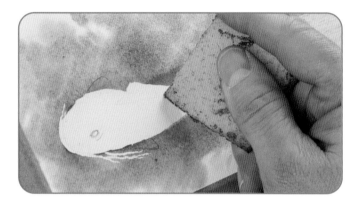

Once the paint is dry, use your finger or a soft eraser to remove the masking fluid.

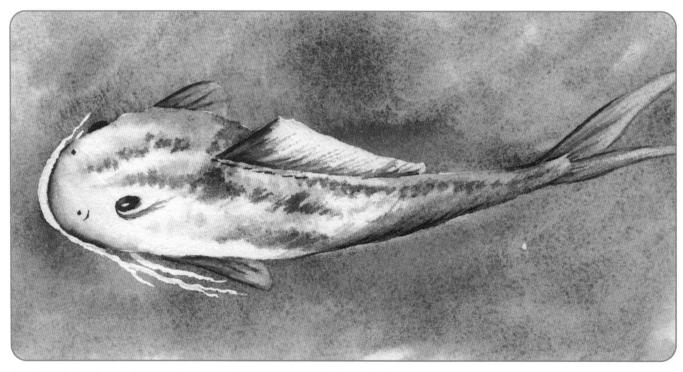

Masking fluid will allow you to create crisp edges and keep areas of the painting completely free of colour – perfect for details such as this koi carp's whiskers (see pages 20–21).

Technique: Creating highlights

There are three main ways I like to create highlights: using a craft knife, lifting out or using opaque white paint. When using a craft knife, you physically scratch the paper, revealing the white underneath. Use the point to create a bright, random highlight: this technique works well for sparkles on water, highlights on a tree or glistening fur. Don't be afraid to do this – rest assured that you won't go through the paper. I use this technique in the Swan project on pages 24–25; here I made horizontal scratches that follow the ripples on the water (shown right).

When lifting out highlights, use a clean, damp brush to carefully scrub away the paint as needed (in the image below I am lifting out a highlight in the ram's eye to make it look glossy). Then dab the picture with kitchen paper to remove the excess paint from the surface. This is also a useful technique for adding texture and depth to fur and skin.

To add highlights using white opaque paint, use a very fine brush and take your time, as these marks should be subtle and not overpower the painting. Use the paint straight from the tube with just a small amount of water added. This technique is especially good for adding shine to eyes and noses (see below right).

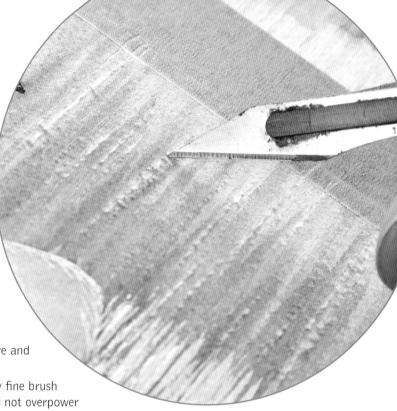

Use a craft knife to scratch away the paint on the surface to reveal the white of the paper below.

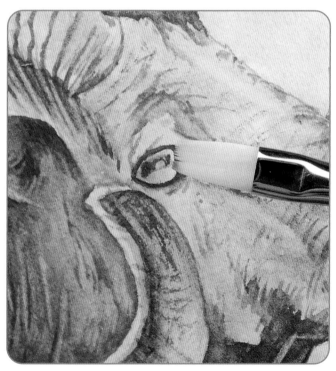

To lift out, scrub away the paint with a clean, damp brush, then dab the area with kitchen paper (see pages 52–53).

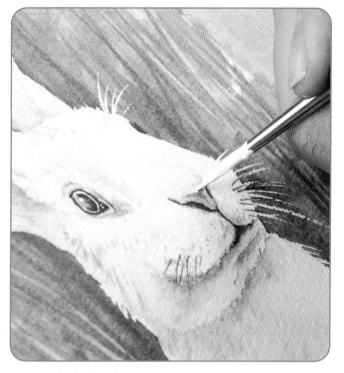

Use a very fine brush and strong opaque white paint to touch in delicate finishing touches (see pages 64–65).

YOU WILL NEED

Paint colours: aureolin, alizarin crimson, French ultramarine, yellow ochre

Brushes: sizes 10, 6, 4 and 2 round, 6mm (¼in) flat brush

Other: tracing number 1, kitchen paper

Parrot at sunset

Try out a graduated wash, allowing your paints to blend and create smooth bands of colour across the sky that will contrast well with the striking silhouetted form of the parrot. When the background is dry, use the wet-on-dry technique to create the shadowy shape of this regal bird.

1 Load the size 10 round brush with strong aureolin. Starting about two-thirds of the way down the paper, lay in the wash using horizontal brushstrokes. Work down to the bottom, allowing the colour to flow.

2 Go straight in with an orange mix of aureolin and alizarin crimson (more yellow than red). Starting just below the top of the paper, work downwards, and mix the orange in with the yellow, using brushstrokes at a slightly diagonal angle.

3 With a clean brush, take up French ultramarine. Run the colour across the top of the painting and allow it to mix with the orange and work down towards the yellow. The blue will turn the orange area slightly grey. Put in a few thinner streaks lower down the paper for a low-lying cloud effect.

4 Take up a dilute alizarin crimson on a fairly dry brush: run in a few streaks of pale red lower down in the sky. Allow to dry.

5 Mix a strong grey from French ultramarine (60 per cent), yellow ochre (30 per cent) and alizarin crimson (10 per cent). With the size 6 round brush, begin to block in the silhouette of the parrot, starting from the right-hand side of the bird and working to the left. Rotate your board if you need to. Give the wings a feathered edge with deliberate, directional brushstrokes. Make sure the bird's beak has a clear, fine point – use a smaller brush such as a size 2 round if you need to.

6 Introduce some colour into the bird's body. Take up the orange mix from the sky (see step 2), and mix it in with the grey down the left-hand side.

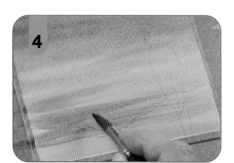

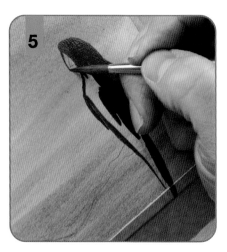

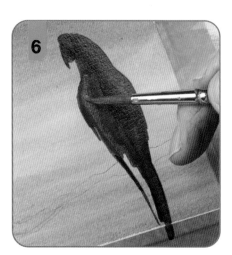

7 Run in a hint of French ultramarine over the top of the orange highlights for variation, then allow to dry.

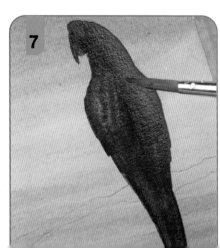

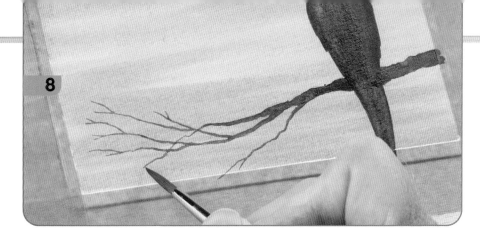

8 While the bird's plumage is drying, use the grey mix to run in the branch, using the size 4 round brush. Work straight through the parrot's tail, as you will later be adding highlights which will distinguish the parrot from the tree. Taper off the branches and run in a few finer twigs at the ends for added detail. Let the whole picture dry.

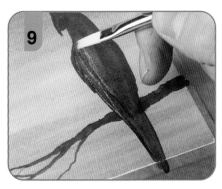

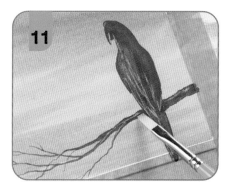

9 Dampen the tip of a 6mm (¼in) flat brush and squeeze it through your fingers to remove excess moisture. Use the tip to scrub out highlights on the left-hand side of the parrot, down the length of its wings and where it overlaps the branch, using a curved motion to create a feathered edge.

10 Carefully blot just once with a ball of kitchen paper to remove the colour, then gently blend or soften the highlights with the side of the brush.

11 Using the same technique of scrubbing and blotting, lift out some more highlights on the right-hand wing, and spend time shaping the tips of the wing feathers; lift out some light streaks along the top of the branch where it is widest. To complete the painting, use the dark grey mix and the size 4 round brush to reinstate areas of darkness to offset the highlights. Work into the wings with V-shaped motions and, with an almost dry brush, flick colour at random over the bird, following the contours of the back, neck and beak.

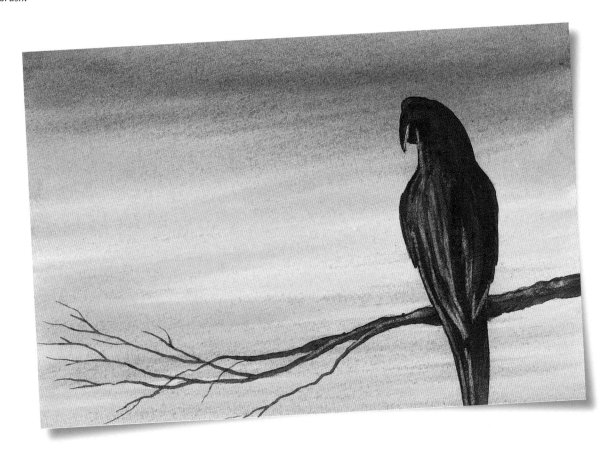

YOU WILL NEED

Paint colours: yellow ochre, alizarin crimson, French ultramarine

Brushes: sizes 10 and 6 round

Other: tracing number 2, kitchen paper

Bird in flight

Here we capture another bird, this time in flight with its wings outstretched. Use this project as a chance to build on your wet-in-wet painting skills – and don't be afraid to mix your colours in a different way to mine.

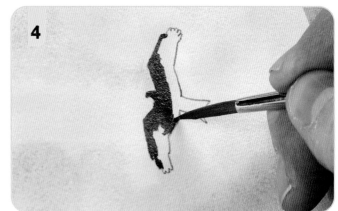

1 Wet the paper all over with the size 10 round brush, then work quickly with a dilute yellow ochre to touch in some clouds: lay the brush flat against the paper then twist and rotate it to achieve the cloud-like shapes.

2 Use a pale (dilute) alizarin crimson to put in more twists, again, laying the bristles flat against the paper. Allow the colour to mix with the yellow as you work across the sky area. Leave a few white spaces scattered here and there.

3 Clean your brush, wipe off any excess moisture, then take up some French ultramarine. Work this colour in over the top of the yellow and red cloud shapes, allowing it to mix. As it does so, you will see shades of grey appearing. When it is complete, allow the sky to dry.

4 Mix a good, strong grey from French ultramarine (60 per cent), yellow ochre (30 per cent) and alizarin crimson (10 per cent). Switch to a size 6 round brush and paint in the silhouette of the bird.

Tip

Don't forget to clean your brush and wipe off any excess moisture before you pick up a new colour.

BASIC TECHNIQUES

18

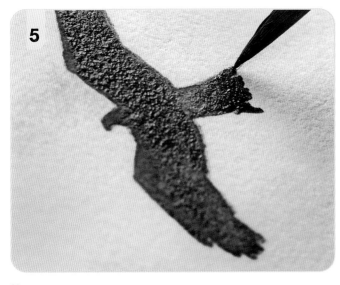

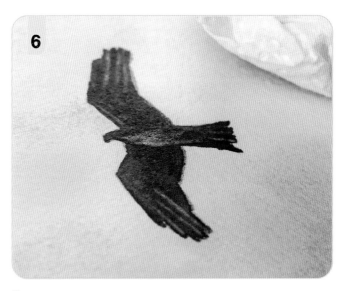

5 On the tips of the wings and the base of the tail, try to suggest individual feathers in the silhouette. Allow to dry.

6 Clean the tip of the size 6 round brush and squeeze the bristles to a point. In the same way as you lifted out highlights on the parrot with the flat brush (see page 17), lift out highlights on the underbelly of the bird with the damp round brush. Dab away the colour with a ball of kitchen paper. Finish the study with a few highlights lifted out from the wing tips and the tail.

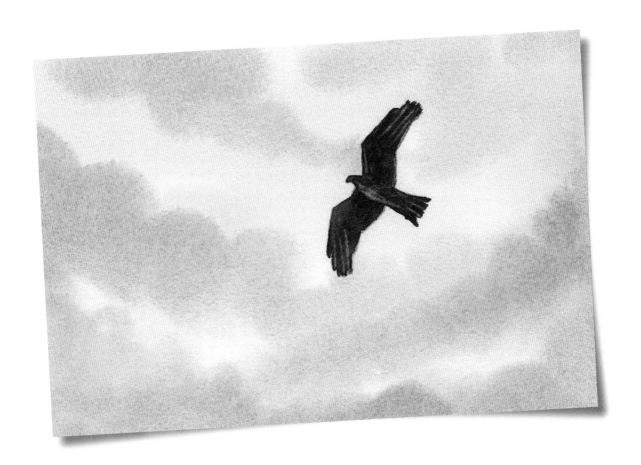

Koi carp

These graceful, delicate creatures are a symbol of good fortune in Japanese culture, and make gorgeous subjects for painting. Here, we will use masking fluid to allow us to isolate the fine whiskers and create the neat pale shape of the fish. Using a wet-in-wet vignetted background creates an ethereal setting – perfect for these beautiful fish.

YOU WILL NEED

Paint colours: aureolin, French ultramarine, alizarin crimson, yellow ochre

Brushes: sizes 10 and 6 round, 12mm (½in) flat brush, old paintbrush for masking fluid

Other: tracing number 3, masking fluid, kitchen paper

1 Using masking fluid and an old brush, carefully mask off the main body and dorsal fin of the carp, but not the side fins or the tail. Mask an outline of about 6mm (¼in) wide to protect the shape of the fish from the background. Use the tip of the brush to run in a few whiskers under the carp's head and on the top edge of its mouth.

Tip
Allow the masking fluid to dry naturally – do not use a hairdryer.

2 Wet the background with the size 10 brush and clean water, being careful to avoid going inside the fish's body but keeping the water tight against the masking-fluid outline. Make sure the background is well covered, then take up a tiny amount of aureolin, and make twisting motions with the brush tip to create a soft vignetted background effect around the body of the fish.

3 Clean your brush, then take up some French ultramarine. Apply plenty of strong blue alongside the masking-fluid outline – this will help the carp stand forward against the background later. Touch in the blue over the rest of the background, leaving some areas unpainted; the blue will mix with the yellow to create a watery green. Allow the painting to dry.

4 Remove the masking fluid from the paper by carefully rubbing it with your finger.

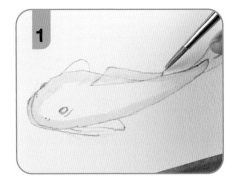
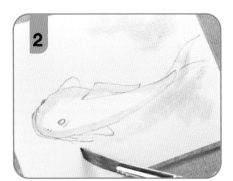
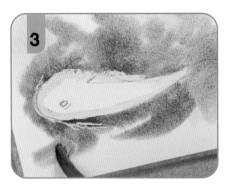
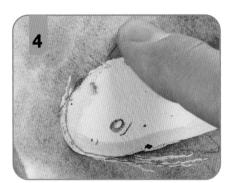
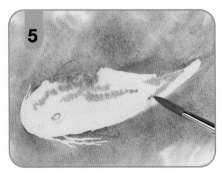
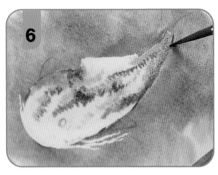

5 Dampen the size 10 brush with clean water and work over the body of the fish. Work close to the edge but avoid reactivating the blue background. Switch to the size 6 round brush. Mix orange (70 per cent aureolin and 30 per cent alizarin crimson) and, working wet-in-wet, begin to add orange details to the body of the carp. Allow the paint to bleed into the wet areas, and work quickly to avoid the colour drying.

6 While the paint is still wet, clean your brush and wipe it almost dry, then, with a strong grey mix (60 per cent French ultramarine, 30 per cent yellow ochre and 10 per cent alizarin crimson), gently add dark areas to the carp's body. Again, allow the paint to spread. Run a thin dark line along the bottom edge of the carp to give it shape then, with a clean brush, blend the dark areas into the tail. Allow to dry.

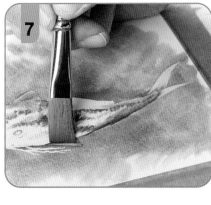

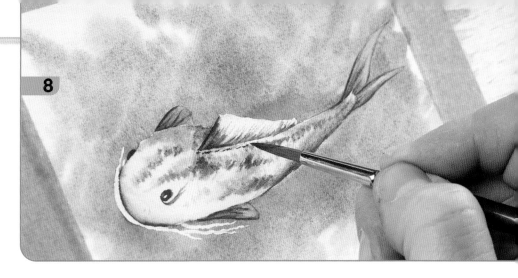

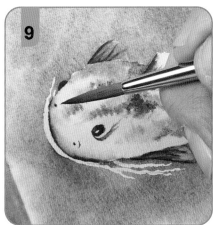

7 With a clean, damp 12mm (½in) flat brush, lift out some highlights. Use the tip of the flat brush to scrub away the paint on the tail, which is translucent. Dab the lifted-out area with kitchen paper to remove most of the colour. Do the same with the fins on the side of the carp's body, then allow to dry.

8 With the size 6 brush and the strong grey mix from step 6, add some dark shadows and detail to the mouth, leaving an area white for the lower lip. Clean the brush, tap it on kitchen paper to remove excess moisture and soften the dark areas back into the carp's face. Use the grey to dot in the fish's eyes: paint a domed shape for the far eye, and an elliptical shape for the near one with an area of light left on the inside. Still with the grey mix, work fine shadows around the nearest eye, along the side fins and along the base of the dorsal fin, and into the tail. Keep softening these shadows back.

9 Finally, add two nostrils to the face of the carp with simple dots, with a curved line behind the nearest nostril to give the impression of a dark surround.

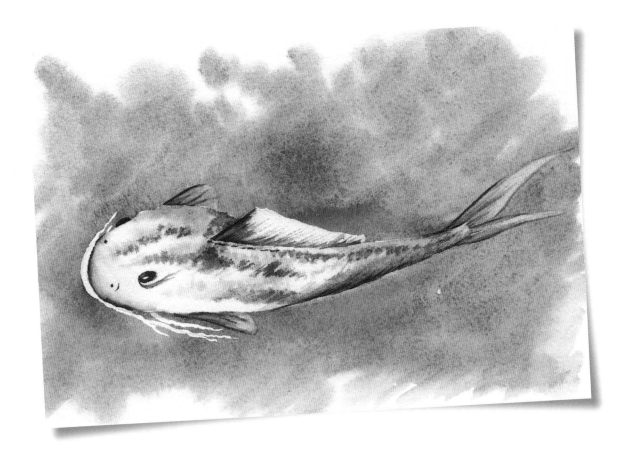

Zebra

The monochrome palette here helps to highlight the iconic black and white markings of this graceful zebra. Bear in mind that we are only painting the zebra's head here, and on a very simple background – so don't be afraid to give it a try. Take your time when painting the stripes – these will make the zebra look believable so it's important to get them right.

1 With the size 10 round brush, pre-wet the paper. Mix a very pale, dilute grey (70 per cent French ultramarine, 20 per cent yellow ochre and 10 per cent alizarin crimson) and twist the colour, wet-in-wet, onto the background as a loose vignette. Work a little over the area where the zebra's head is.

2 Strengthen the grey and run in a horizontal shadow under the zebra's muzzle, to suggest that the zebra is feeding from the ground. With the same grey on the size 6 brush, paint the inner outline of the head in a line as wide as your brush head. Clean and remove excess moisture from the brush, then blend the outline into the zebra's face.

3 With the same brush and mix, work in some shadows over the zebra's face. Add a dark shadow at the back of the jaw, working towards the neck and around the tips of the ears. Clean the brush again, remove excess moisture, then blend the shadows away to suggest the contours of the animal's head and make it look 'attached' to its neck. Work the shadow into the zebra's ears as well.

4 With a darker mix of the grey, darken the inside of the ear, then fade the grey to the right. Put some dark tips into the mane in the form of quick flicks with the tip of the brush. Make these nice and spiky, then flick the mane down into the top of the head and neck.

5 Begin to block in the area around the tip of the nose and the mouth. Soften the colour into the area. Leave a white gap for the mouth itself, then feather the area under the mouth and the chin, back up into the head.

6 Strengthen the grey once more to get the colour for the zebra's iconic dark stripes! Simply fill these in, remembering, though, that the stripes that lead up into the mane will taper off to become part of the mane itself. Achieve this effect with a quick flick of the brush at the tip of the stripe. Use a fine brush to capture the delicate stripes.

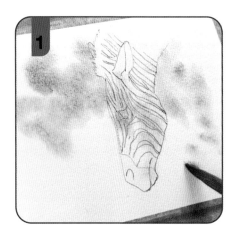

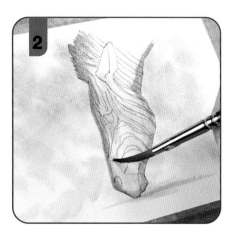

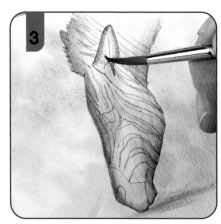

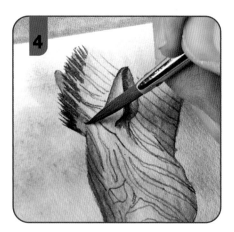

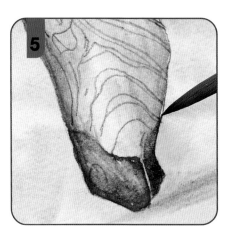

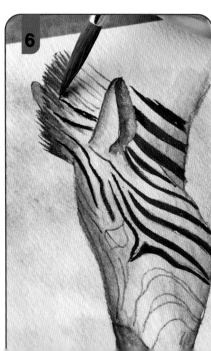

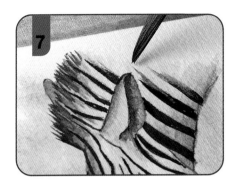

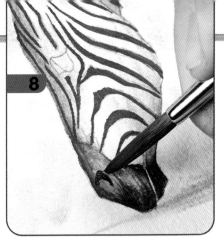

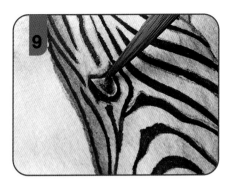

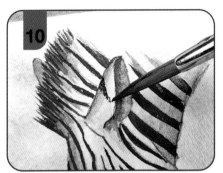

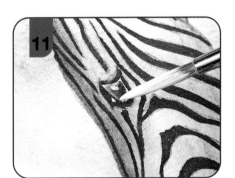

7 To add to the surrounding vignetted effect, lighten the topmost stripes on the zebra's head up and away from the head with a clean, damp brush.

8 With the dark grey used in step 6, put some darker tips into the mane. Darken the underneath of the mouth and the area of the nose that connects with the ground. The nostril can be painted in the same strength of grey – feel free to use a smaller brush here to work the nostril as an arc shape. With a clean, almost dry brush, soften the nostril downwards.

9 Surround the eye with a dark outline: build up the duct at the front of the eye, then use a clean, dry brush to feather the outline back into the zebra's face. The eye itself is lighter on the left-hand side – work in a soft, dark back-to-front L-shape in the right-hand corner and soften it into the eyeball, leaving a fine outline between the eye and its surround. Allow to dry.

10 While the eye is drying, you can put in a few finishing details. Extend the mouth into the lighter part of the muzzle with two diagonal lines. Gently soften the lines upwards. Add a couple of fine triangular marks to the top-left side of the ear, following the curve.

11 To complete the painting, take some opaque (or titanium) white directly from the tube on a fine brush such as a size 2 round. Dot in a white highlight towards the left of the eye, and into the duct on the left-hand side. Finally, run a thin line of white around the outer edge of the nostril, and out from the mouth.

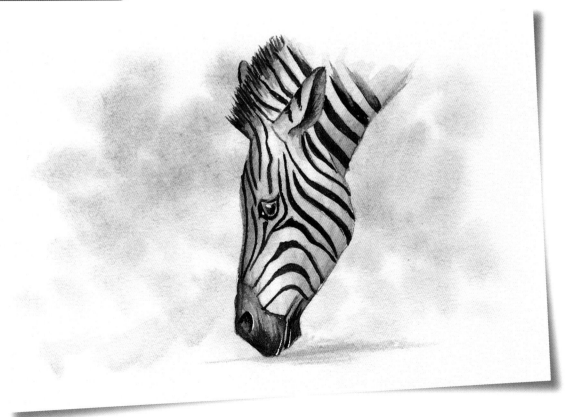

Paint colours: viridian hue, French ultramarine, alizarin crimson, yellow ochre, aureolin, opaque white

Brushes: old brush for masking fluid, sizes 10, 6 and 2 round

Other: tracing number 5, masking fluid, craft knife, kitchen paper, plastic card

Swan

White animals present a new challenge: how do you create a dimensional, textural creature with only a limited amount of paint? Here, we'll use masking fluid and some very delicate shadows to bring the white highlights of the swan to life. Plus, we'll create sparkles in the water by scratching out some of the paint.

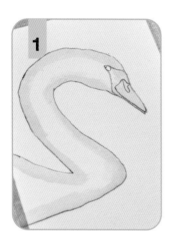
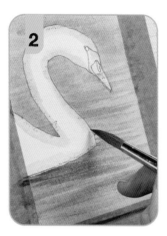
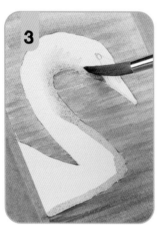
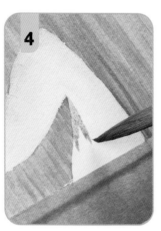
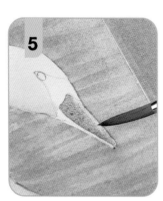
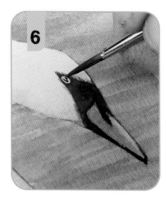

1 Mask off the inside edge of the swan, including the beak, with an outline of around 1cm (½in) wide. Let the masking fluid dry naturally.

2 Wet the background, avoiding the swan. Using the size 10 brush, run a pale mix of pure viridian hue over the paper from the top downwards. Work up to the edge of the swan but do not overlap the masking fluid. Switch to a turquoise mix of viridian hue and French ultramarine and work upwards from the bottom until the blues meet and blend. Soften any harsh lines with a clean, damp brush. Add some darkness at the base of the swan's body with a grey mix of French ultramarine, alizarin crimson and yellow ochre, on a fairly dry brush. You may wish to rotate your board at this point. Work in some horizontal lines lower down and then further up on the paper. Allow to dry, then strengthen the grey and put in some fine horizontal ripples in turquoise. Layer over the ripples in grey, and allow to dry again.

3 Rub off the masking fluid with your finger. Then, using the size 10 brush, add shadow to the underside of the swan using the pale grey, with a touch more yellow ochre in it to warm the colour. Use a clean, damp brush – with no excess moisture on it – to blend the grey shadows into the body of the swan until they fade away completely.

4 Put the same warm grey into the V-shape where the wings meet the neck. Again, rotate the board if you need to. Clean the brush, tap it almost dry again, then soften the colour in.

5 Mix aureolin with alizarin crimson for a vibrant orange, and paint in the beak using the size 6 round brush. Leave a line of white along the top of the beak where it meets the water, and another above the chin. Use a clean, damp brush to soften the orange into the beak and allow to dry.

6 In a darker grey, paint around, above and beneath the beak, and around the eye. Work in some more dark tones over the top of the beak. Feather the edge of the grey with a clean, almost dry brush, so that it blends into the white feathers. Paint in the eye using a size 2 round brush and a very dark grey, in a narrow horseshoe shape.

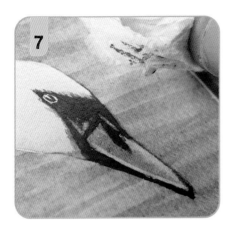

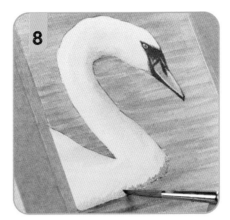

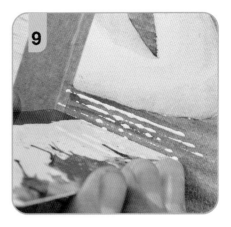

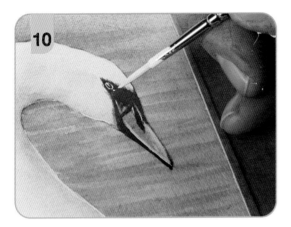

7 Wipe the size 6 brush almost dry, then lift out some highlights where the dark grey meets the orange of the beak – put in a thin highlight at the top of the beak, and blot with kitchen paper to lift out the colour.

8 Mix a pale grey. Still using the size 6 brush, add some stronger shadows around the fold of the neck, then drag away the grey with a clean, damp brush. Add a little more shadow where the swan's neck meets the water then work all the way around the body of the swan, with a diagonal brushstroke, fading away the colour as soon as you put it in.

9 Put in some pale grey on the back of the foremost wing to separate it from the far wing. Apply opaque white fresh from the tube to the edge of a plastic card. Keep just a tiny amount of water on your brush. Hold the card at right-angles to the paper and press it on to create white ripples in the water. Move from the middle of the paper and work downwards, until you run out of paint – at which point, reload the card and start again.

10 Using the size 2 brush and the same opaque white, add some more detailed highlights to the water to give the reflection a more definite shape. Add a few white details around the outline of the swan and around its beak (refer to the finished painting, right). Finally, put in a tiny dot just to the side of the eye. The very last thing to so is to add some sparkle to the water. Do this by gently scratching back to the white of the paper with a craft knife (see page 15).

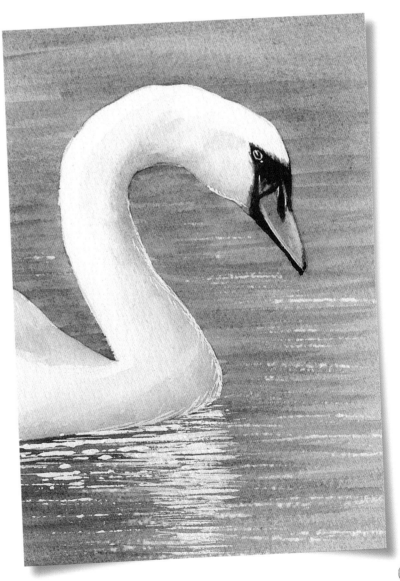

KEY FEATURES

Whether it is the enchanting eyes of a cat, the texture of a dog's fur or the fantastic feather markings on a bird, attention to detail is what will bring your animal paintings to life. The most important area to get right is the eyes as, without question, they are the first thing people look at and comment on. I have spent many years painting animals, and have developed techniques for painting different areas of detail. This section of the book will take you through my years of experience and focus on some key animal features.

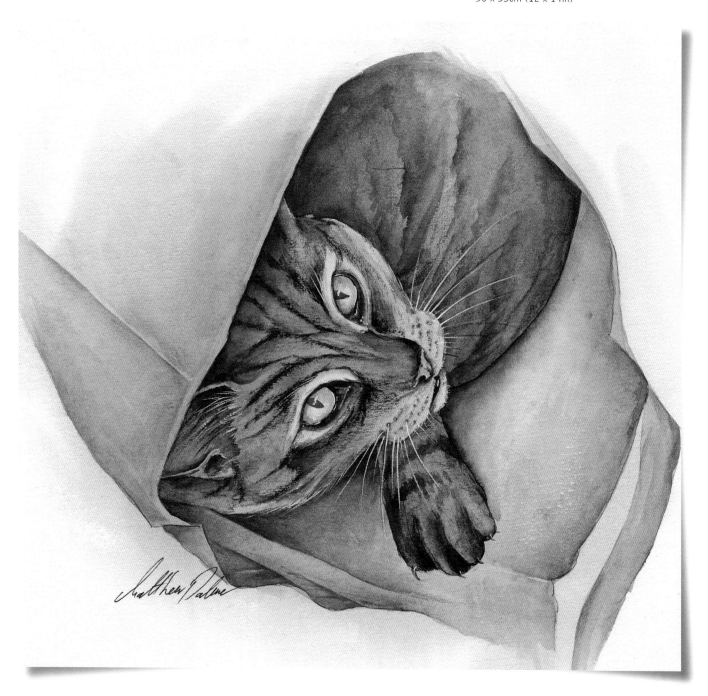

Cat in a Paper Bag
30 x 35cm (12 x 14in)

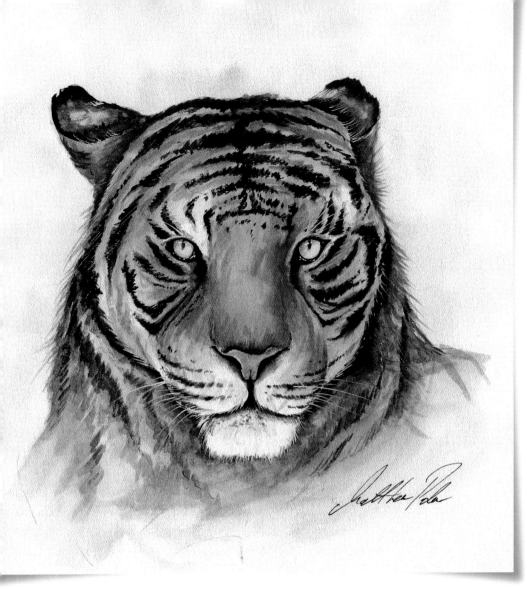

Cats have particularly piercing eyes, so it is crucial to make sure you capture a believable shape and add just enough highlight to give a glossy shine, without overdoing it. The eyes of the tiger, shown left, and the cat, shown opposite, are painted in much the same way, and I will go into detail about this on pages 28–29. Do as I have done, and start by concentrating solely on the eyes, without adding in the rest of the head. Really allow yourself to focus on getting the details accurate, and start again if you aren't happy with what you've painted.

Fur is a crucial element of many animal paintings, and it is a really good idea to practise painting different types of fur. The cat and tiger shown here have very characteristic striped markings, which need to be captured accurately; the dog, shown below, has much longer, shaggier fur. You'll need to think carefully about the types of brushstrokes that will give you the effect you want, and remember to always use the smallest brush you have available for painting in delicate details such as whiskers.

Tiger
32 x 38cm (12½ x 15in)

Skip the Dog
33.5 x 41cm (13 x 16in)

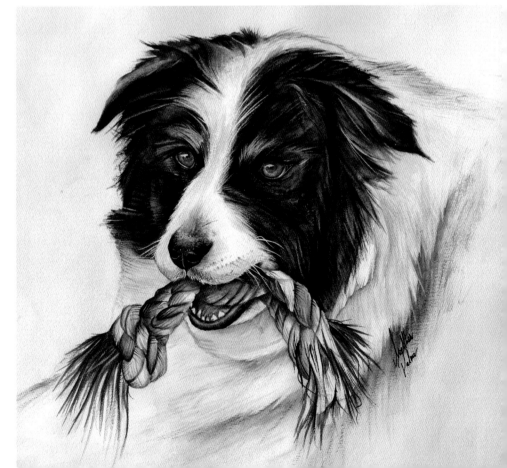

Cat's eyes

YOU WILL NEED

Paint colours: lemon yellow, aureolin, French ultramarine, alizarin crimson, yellow ochre, opaque white

Brushes: sizes 6 and 4 round

Other: tracing number 6, kitchen paper

Tip
Use a fine brush for the tiny details in a cat's eye.

To capture the characteristic features of some animals accurately, it can be helpful to practise them first before launching into a full painting. Here I have focused on recreating the shine and intensity of cats' eyes; should you wish to complete this piece, the instructions for painting the rest of the cat's face can be found on pages 30–31.

1 The green of the cat's eye should be a pale mix, comprised of lemon yellow (60 per cent), aureolin (20 per cent) and French ultramarine (20 per cent) along with lots of water. Outline the inside of the eye with the green mix using the size 6 round brush; fill it in so there is slightly more colour on the right of the eye than the left.

2 Clean the brush, tap off any excess moisture on kitchen paper, then use water only to fill in the central area of the eye.

3 While the eye is still damp, pick up a pale grey mix of French ultramarine (70 per cent), alizarin crimson (10 per cent) and yellow ochre (20 per cent), then run the colour along the top of the eye. Allow the colour to spread and form the shadow caused by the cat's eyelid. Run the grey along the bottom and the right of the cat's eye, then, with the tip of a clean brush wiped almost dry on kitchen paper, feather the edge of the grey so that it 'melts' into the eye. Allow to dry, then repeat steps 1–3 for the cat's other eye.

4 Once both eyes are dry, use a strong grey mix (60 per cent French ultramarine, 30 per cent yellow ochre and 10 per cent alizarin crimson) to put in a fine outline.

5 Fill in the area underneath the eye with the strong grey, leading down towards the nose. Do this on both eyes, then bring the point of the eye closest to the ear up into a sharp point.

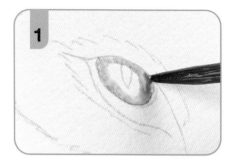

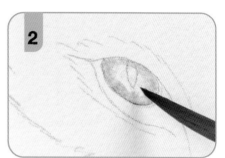

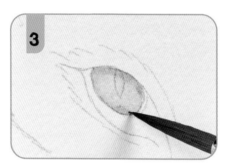

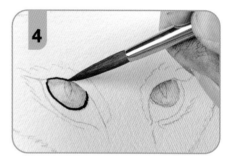

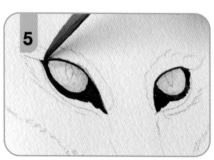

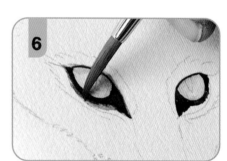

6 With a clean, damp brush, feather the darkness of each eye surround into the fur of the cat using tiny flicks with the point of the brush.

7 Paint in the pupils, still using the strong grey mix, but the smaller – size 4 – round brush. These go in as an elliptical outline first, with the outline of the top thicker than at the bottom. Soften the darkness into the whole shape of the pupil with a clean, almost dry brush, ensuring the outline is not obvious.

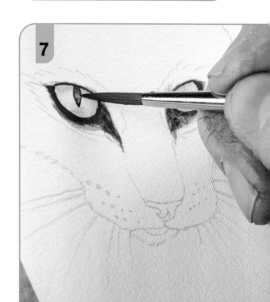

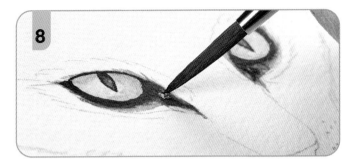

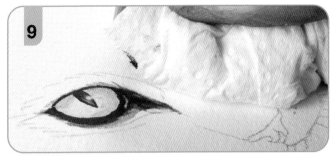

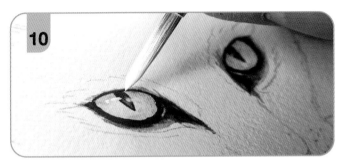

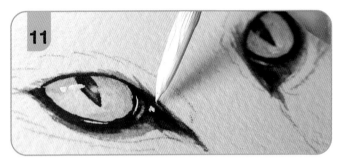

8 Use the same dark grey to go back around the eye, making sure the outline of the eye itself is strong and dark. Dot in a few spots within the tear ducts for extra detail.

9 Clean the brush, wipe it almost dry, then lift out a glazed highlight over the top of the pupil, curving off to the right. Dab away the colour with kitchen paper, and do the same on the other eye.

10 Take up opaque white, straight from the tube, on the size 4 round brush; mix in a tiny bit of water on the bristles. Dot in a highlight slightly above the pupil in a sausage shape and a dot – the stronger the better. Repeat for the other eye.

11 Finally, put in a very thin highlight in white around the edge of the eye, just below the black surround, then a final dot on the tear duct. This will bring some life to the eye and help suggest moisture in the tear duct. Repeat for the other eye.

The painted cat's eyes

In the next project you will learn how to develop the animal's face further with the addition of other facial features, fur and markings.

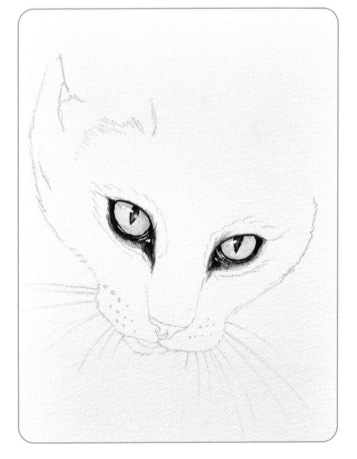

TAKING IT FURTHER

This process of painting in a cat's eyes can be applied not only to the projects on pages 30–31 and 32–33, but also to the painting of the tiger on pages 34–35. The angle of the tiger's head is different to the tabby cat, but the principles of outlining and highlighting the eye can still be applied.

Peering tabby

YOU WILL NEED

Paint colours: rose madder, yellow ochre, burnt sienna, French ultramarine, alizarin crimson, burnt umber, opaque white

Brushes: sizes 6 and 4 round, 6mm (¼in) flat brush

Other: tracing number 6, kitchen paper

This study of a tabby cat's face is a continuation of the study of the eyes on pages 28–29. Here we will focus on the markings and details of the face, and build up the cat's features around the eyes. If you want to take the skills you learn here further, why not try to paint the Cat in a Paper Bag painting on page 26.

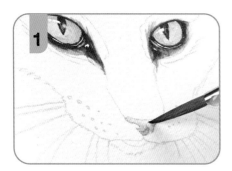

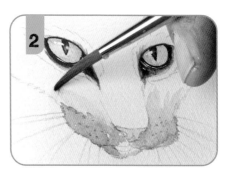

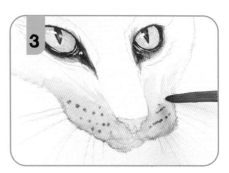

1 Paint in the nose with a pale pink mix (80 per cent rose madder and 20 per cent yellow ochre) – use a fine brush such as the size 4 round for this. Soften the colour with a clean, damp brush, and allow to dry.

2 Switch to the size 6 brush and make up a tan mix (60 per cent yellow ochre and 40 per cent burnt sienna). Fill in the mouth and whisker areas, making sure the outer edge of the face is slightly spiky to represent fur. Leave the actual area of the mouth white, then soften the tan of the cat's muzzle up into its face with a clean, damp brush.

3 While the muzzle area is still damp, go in with a strong grey (60 per cent French ultramarine, 30 per cent yellow ochre and 10 per cent alizarin crimson) and put in the dots for the bases of the whiskers. The grey should spread slightly into the damp tan areas. Clean your brush, squeeze the wet bristles, then run the brush over the dots to soften them and 'bed' them into the face.

4 Mix up a brown (about 55 per cent burnt umber, 35 per cent yellow ochre and a dot of French ultramarine – don't mix in too much blue or you will get grey). Paint in the bridge of the nose, working up towards the eyes, and under the eyes, leaving plenty of light around them. Work up into the forehead, making directional brushstrokes to indicate where the fur sweeps up towards each ear. Keep dampening your brush and tapping it on kitchen paper to keep the bristles clean and damp, and soften any harsh lines that appear. Fade the top of the head up towards the top of the paper. Feather the left and right sides of the nose into the surrounding fur. Allow the fur to dry.

5 Mix a darker grey (with more blue in the mix) and use the size 4 round brush to add detail and darkness. Start off inside the nostrils, which go in as outlines. With a clean, damp brush, feather out the dark areas into the centre of the nose to create shadows. In the same dark tone, run a thin line across the top of the pink of the nose and up the left of the nose towards the eye in an L-shape.

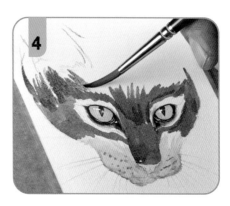

Feather the line outwards to become part of the nose. Use the same mix again to add shadow to the mouth in a broken line, then soften the line downwards. Add a few flicks with the tip of a clean, damp brush to make the mouth look more furry.

6 In the same dark shadow grey, paint in the markings below the eyes and along the side of the nose – leave a gap just below each eye. Soften the dark markings into the cat's face on both sides.

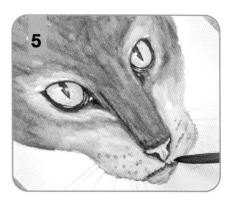

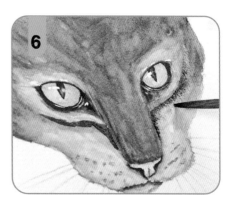

7 With the same dark mix, add the black flesh part of the mouth in the form of a thin line. Add a couple of shadows to the sides of each cheek with textured hair-like markings. Clean and wipe the brush, then feather the markings into the fur. Add darkness to the back of the ear, then soften it to the inside of the ear and away at the top to help create the vignetted effect, and at the bottom so it blends into the fur. Apply more paint to the inside of the ear, if necessary, making sure it's nice and dark, but leaving the edge of the ear light on the right-hand side (make sure the darkest parts match the darkest areas around the eyes). At the bottom of the ear, add a few flicks of the brush to create a hairy edge, then clean the brush and soften the paint up to the top. To the left, the ear has a curved fold; soften this down into the fur. Add more grey behind the ear; wipe the brush on kitchen paper, then work the grey down into the fur.

8 With the dark mix, start to add the dark fur markings with a dry brush. Pinch the bristles slightly open and lightly tickle the brush against the paper. Start to the left of the left-hand eye: add strong, dark markings, working up towards the ear, then apply darker stripes below the eye to add depth. Spend time working and building up texture in random areas. With the driest of all brushes, and as little paint as possible, tickle in areas of fur texture around the nose or in any areas that look flat. Work around the jowls inwards, on both sides. Clean the brush, wipe it almost dry, then soften the lines so that they disappear into the fur. Add a couple of extra dark lines around the surround of the eye to 'attach' the eyes to the picture.

9 Paint in the whiskers with the dark mix. Bear in mind that they taper towards the end, and that cats do have a lot of them! Rotate the board for a better angle and remember that less paint will result in a more successful whisker. Some come from the black spots, but also add a few smaller whiskers at either side of the mouth.

10 Finish with highlights to give movement and shape to the fur. Clean then squeeze a 6mm (¼in) flat brush through your fingers, then lift out some highlights, starting around the nose, coming down from the brow and next to the eyes. Remove the paint with kitchen paper. Lighten around the light edge of the ear. Add a few highlights between the stripes, and add a few highlights to the fur over the darkness of the ears. Spend time with the tip of the flat brush to do this.

Take up opaque white, straight from the tube, on the size 4 round brush; mix in a tiny bit of water on the bristles. Add fine hairs over the top of the ear into the darkness of the inner ear. Also add a few lighter eyelashes above the eyes and a few tiny hairs right on the edge of the top of the mouth as it overlaps the darker lower lip. Finally, use a tiny bit of white on the edge of the nose to add a highlight and shine.

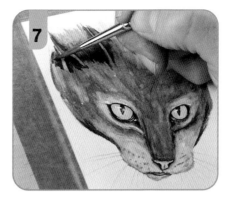
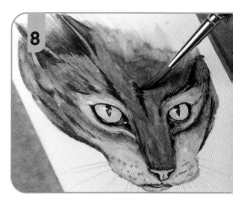
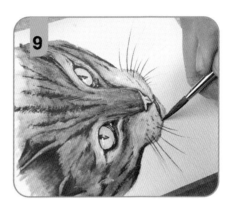
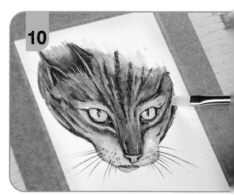
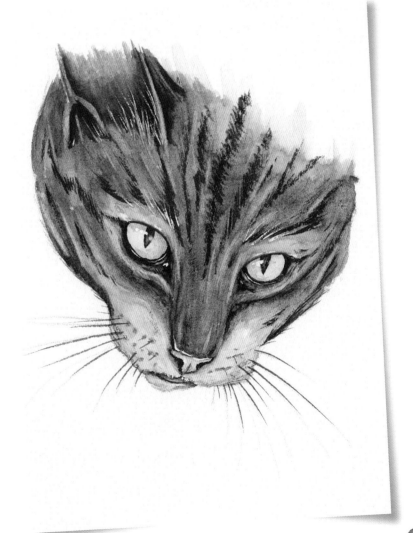

YOU WILL NEED

Paint colours: yellow ochre, burnt umber, burnt sienna, French ultramarine, alizarin crimson, lemon yellow, opaque white

Brushes: sizes 10, 6 and 2 round

Other: tracing number 7, kitchen paper, masking tape

Curious kitten

Use this project to practise painting a playful cat's eye, nose, mouth and fur markings. The masked-off areas allow you to focus on the cat's face, without needing to complete the whole body. If you have your own curious cat, or know someone else who does, why not substitute the markings and colours to replicate that cat.

1 Remove some of the stickiness from the masking tape by running your fingers over it a few times, or sticking it to your clothes and then removing it. Put tape on the two edges either side of the cat. Using a size 10 brush, wet the central area, but don't make it so wet that moisture seeps under the tape. With a pale, watery yellow ochre, paint in the areas above the cat and then down onto the top of its head, then work around the eyes, the jowls (mouth area) and down to the bottom of the paper; it doesn't matter if you go over the eye.

2 Pick up some pale, watery burnt umber on your brush, tap off the excess on kitchen paper, then add to the lower background with a twisty brushstroke action. Use the same mix to add a few darker areas to the cat, starting across the bridge of the nose. Flick your brush back in to the yellow ochre to blend the colours. Add some of the burnt umber under the eye, working down towards the jowls and add it to the top of the cat's head in the same way. There is a tiny bit of neck showing: run in the burnt umber here, too.

3 Mix up a darker brown (70 per cent burnt sienna and 30 per cent French ultramarine). Tap off any excess, then start to build up some of the darker markings. Go across the nose and above the eye, using the point of the brush; leave a lighter area immediately above the eye. Darken the neck. Put in a few strokes in a V-shape from the bridge of the nose towards the top of the head. Finally, add a line of the colour across the top of the head to make the cat stand out against the background. Clean the brush, squeeze it flat between your fingers, then use it to blend in the dark brown mix – smooth out any hard edges. Allow to dry.

4 Mix a strong grey (60 per cent French ultramarine, 30 per cent yellow ochre and 10 per cent alizarin crimson). Using the size 6 round brush, start by adding a dark outline around the right-hand eye, making use of the point of the brush to fill in the corner of the eye. Paint the darkness inside the mouth and nostrils, making sure the colour is still nice and strong. Clean the brush well, wipe off any excess water, then gently feather the edge of these areas, brushing away from the eye, nostril and the top of the mouth. Keep recharging the brush with small amounts of water, then tapping off the excess. Add a tiny bit of dark grey to the left-hand eye, to give the impression of the edge of the eye socket, then feather away. Add the same dark mix underneath the chin; do this in a negative-painting style to create the shape of the chin and make the face stand forward. Fade down with a damp brush. Using water, wet the jowls to add spots where the whiskers grow from. Drop in strong grey dots while the paper is still wet to allow the paint to spread like ink.

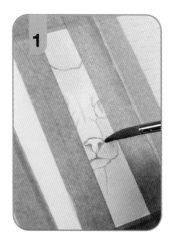

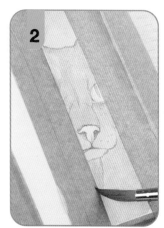

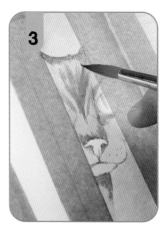

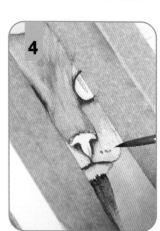

5 While the paint is still wet, drag a damp brush, squeezed through fingers, through each 'row' of spots to create a subtle line. To create the fur markings you need a dry brush, wiped on kitchen paper; you will use the side rather than the tip, and you should pinch the brush flat to splay out the bristles. Add strong grey fur markings, using small flicking motions to create V-shapes across the forehead. Put in as many markings as you need.

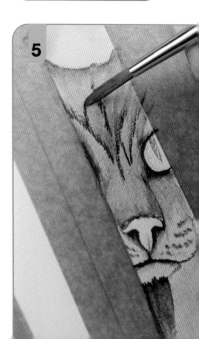

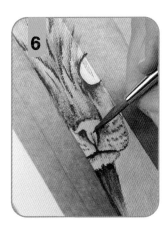

6 Using the strong grey and a dry brush, stroke along the bridge of the nose, following the contour of the fur – this gives a broad dry-brush effect. You may want to practise this on scrap paper first. Repeat this below the eye, and to the bottom of the mouth and nostrils, brushing towards the jowls, to give texture to the fur. Create the pinky-peach colour for the nose (80 per cent alizarin crimson and 20 per cent yellow ochre), then simply block in the area. While the paint is damp, wipe your brush and pick up the strong grey: add a tiny line from the mouth up the centre of the nose; dot it in to help the nose look more realistic (speckled).

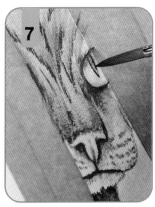

7 The green of the cat's eye is 70 per cent lemon yellow and 30 per cent French ultramarine, with plenty of water. Paint the outline of the eye first, clean the brush, then fill in the area. While damp, pick up the strong grey and add a shadow across the top of the eye, caused by the eyelid. Add a few spots of this colour under the eye, then allow to dry. Use the dark grey to paint in the slit-like pupil – apply it as an outline first, then clean and wipe the brush almost dry before filling in the area. Leave to dry.

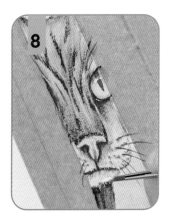

8 Apply the whiskers with a size 2 round brush and the strong dark mix; rotate the board if you need to, and use a quick flicking motion. Also add whisker-like lashes above the eye in the same way. Next, use a damp size 2 brush to lift off a few light areas on the cat. Start by working between a few of the dark stripes, rubbing your brush against the paper then dabbing with kitchen paper. Lift out highlights anywhere you feel necessary to give more shape and form to the eye area. Across the top of the eyeball, lift out a soft horizontal highlight. The final highlights can be added with opaque white paint. Use a tiny amount on your brush to add a line and dot to the eyeball to make it look glossy; a spot of white just in the tear duct brings the eye alive, while a tiny spot on the bridge of the nose makes it look shiny. Finally, add a few little white whiskers coming down over the mouth area and on the chin.

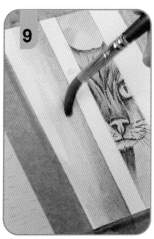

9 Remove the tape carefully – a hairdryer can be used to soften the adhesive if need be. With a dilute mix of the strong grey and the size 10 brush, paint a line down the left side of the door front. With a clean, wiped brush, blend the shadow to the left. On the right-hand side, darken the top and bottom corners of the door. Clean and wipe the brush, then blend the paint to the left to give shadow and form to the door. Using the same colour and the size 6 brush, paint some recessed panels – these are simply two L-shapes, blended away to give the door shape. Further detail can be added to give a woodgrain effect; using the same colour and a dry brush, follow the direction of the wood and have go at painting a knot.

10 To give more depth to the kitten and make the door stand forward, use the size 6 brush and the same grey used in step 9 to paint a wide line down the side of the door on each side. Don't be worried about painting over the kitten – as long as the paint is dry, it'll be fine. Use a damp brush to blend away, ensuring your brush isn't too dry. There is a chance the paint on the kitten may slightly blur. If so, once dry, just use the size 2 brush to paint some of the darker details back in. You can avoid this blur by blending the grey colour quickly and by not 'scrubbing' the brush in the same location. It's well worth adding this shadow as it really finishes off the scene (refer to the finished painting, right).

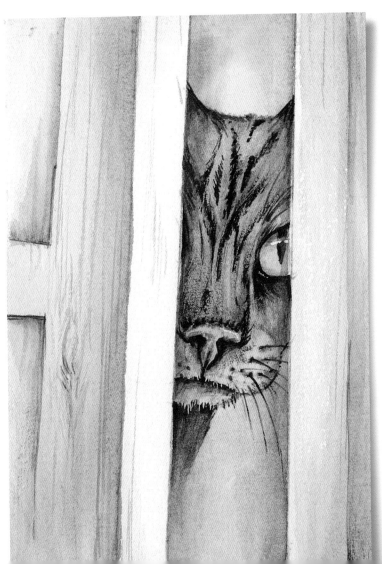

Tiger

Here the tiger's eyes are worked in a similar way to the cat's eyes on pages 28–29 – the only differences are the angle of the tiger's face and the shape of the tiger's pupils, which are round, rather than vertical slits. Refer to the finished painting and the instructions for the cat's eyes to get this picture started. If you want to take the skills you learn here further, why not try to paint the Tiger painting on page 27.

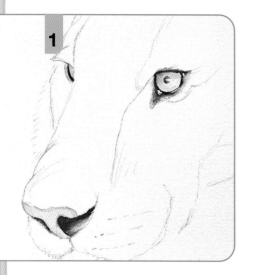

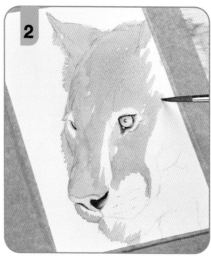

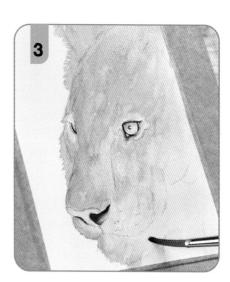

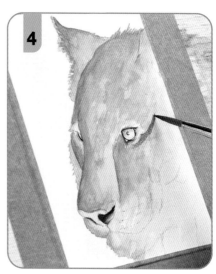

1 Paint in the tiger's eyes following the sequence and general techniques shown on pages 28–29, but bear in mind that the tiger does not have such a pronounced dark outline to the eye – it should be softened to give a finer outline. When the eyes are complete, paint in the nose with a pale pink mix (80 per cent rose madder and 20 per cent yellow ochre) – use a fine brush such as the size 4 round for this. Soften the colour with a clean, damp brush, and allow to dry. Paint in the nostrils with a strong grey (60 per cent French ultramarine, 30 per cent yellow ochre and 10 per cent alizarin crimson); apply the paint to the upper and left-hand edge of the right nostril, then soften the colour down.

2 Block in some of the fur on the face – work all the way down the left-hand edge with the size 6 round brush and a golden mix (80 per cent yellow ochre, 10 per cent burnt sienna and 10 per cent French ultramarine). Ensure that you make the edges quite spiky to accentuate the furry profile of the tiger's face. Leave the side of the nose, right-hand muzzle and right-hand jowl unpainted.

3 With a pale yellow ochre, work down to the right-hand jowl. Take the colour down, almost off the bottom of the painting, then work around the edge of the nose and behind the eye. Make sure the yellow is more transparent (dilute) than the mix from step 2. Scrub the colour into the paper so the two shades mix together, then fade the colour off the edge of the painting for a vignetted effect.

4 Using a darker brown mix (50 per cent yellow ochre, 40 per cent burnt sienna and 10 per cent French ultramarine) and the size 6 brush, work in some dark areas. Paint along the left-hand edge of the nose, up as far as the forehead, then clean the brush, tap it off, then use water to soften the paint to the right. Paint to the right of the nose down towards the mouth in the same way. Below the left-hand eye, paint in the 'cheek' of the tiger, then soften the paint up towards the eye. Paint from above the left-hand eye up towards the ear, then past the ear towards the top of the head. Right at the top of the head, use the tip of the brush to put in some flicks for the fur. Continue across

the forehead to the back of the right-hand ear, then soften the paint towards the nose. Paint in the tip of the left-hand ear, using dry brushstrokes for a 'hairy' effect, before softening the paint down the ear. Finally, add a dark marking to the right of the right-hand eye, like an upside down bird. Soften this down and away into the fur.

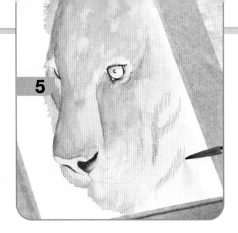
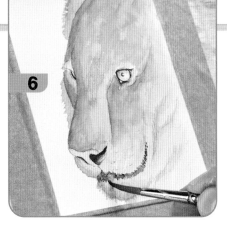
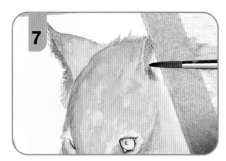
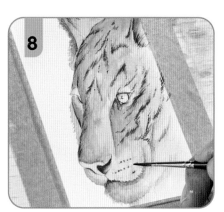

5 Use the same dark brown to add some textured markings to the tiger's cheek and chin using the tip of the brush – this gives the impression of long, lighter hairs in the fur. Use a dry brush and then soften the cheek markings downwards and the chin markings upwards. Allow to dry.

6 Add some dark grey (see step 1) to the brown: darken the inside of the mouth with a spiky line, similar to negative painting. Bring the mouth up to the right to give him a slight smile. Clean and wipe your brush, then soften the paint down at the base of the mouth and away at the top and down to the right.

7 Darken the inner left-hand ear by painting a dark line at the base and adding long hair lines to the left – this will make the tall hairs appear set back. Repeat for the other ear, using the paint to negatively suggest the lighter hairs at the front.

8 Paint in the stripes as for the cat on pages 30–31. Pinch the number 6 brush dry, then use the strong grey to lightly sweep from the left of the nose across it to give texture to the fur. At the very tip of the nose, create texture using the spiky hairs of the brush. Apply the dry-brush stripes by tickling the brush across the paper around the eyes, spilling down into the cheeks and fur: form arrowhead shapes at the top of the nose, working up over the head. Make use of the side of the brush for extra texture. Once the stripes are in place, add dark finishing touches: apply dark grey inside the mouth where it meets the slit under the nose. Add whisker spots around the jowls with the size 2 brush: dampen the paper first and put in the spots wet-in-wet. Squeeze the brush through your fingers and drag the brush through the lines to bed them in. With quick flicks, apply the whiskers.

9 Apply further whiskers and fine hairs around the mouth with quick flicks of the size 2 brush to build up texture. Add tall hairs around the tops of the ears, the inner ears, at the top of the head, near the left-hand eye and above the eyes. With the same brush, add a tiny bit of grey over the pink of the nose to create shadows around the nostrils. Soften the grey back towards the inside of the nose. Use the size 6 brush to lift out a few highlights to the left of the nose, following the curve. As for the tabby cat, lift out a few lighter lines in between the stripes to give extra texture and depth. Use opaque white paint to add your finishing touches: add white hairs to the top lip, and add a few highlights to the pink part of the nose around the nostrils. At this final stage it is worth making sure the stripes are nice and dark – a dryish, strong grey mix (30 per cent burnt umber and 70 per cent French ultramarine) will work well. Use the side of the size 2 brush so that you can utilize the texture of the paper. Finally, use some of the orange from the earlier steps and add any final hair/fur stripes. (Refer to the finished painting.)

YOU WILL NEED

Paint colours: French ultramarine, alizarin crimson, yellow ochre, burnt umber, opaque or titanium white

Brushes: sizes 4 and 2 round

Other: tracing number 9, kitchen paper

Dog's eyes

A dog's eye is simpler to paint than a cat's eye and the main difference is that a dog has a round iris and pupil. Take your time to practise making the eyes look lifelike and then, if you want to, you can continue to create the portrait of a Jack Russell puppy on pages 38–39. You can also use what you learn on these pages to paint in the eyes of the Alsatian on pages 62–63. Use small brushes for smaller details.

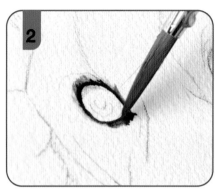

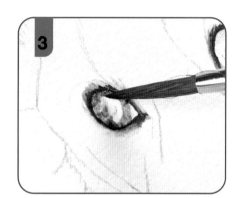

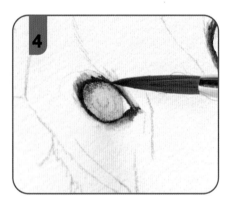

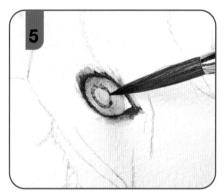

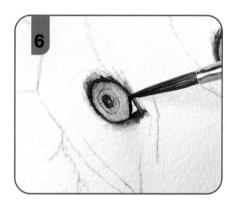

1 Mix a strong grey from 70 per cent French ultramarine, 20 per cent yellow ochre and 10 per cent alizarin crimson; with a fine point on your size 4 round brush, work an outline around the inside of the eye. The side closest to the nose tapers to a teardrop point.

2 With a clean, damp brush, feather the outline of the eye outwards into the face of the dog. Repeat these two steps on the other eye and allow both to dry.

3 Mix a pale brown (80 per cent burnt umber and 20 per cent French ultramarine) and outline the eyeball, leaving a white corner where the eye meets the nose. Soften the brown into the centre of the eye with a clean, damp brush, retaining an area of light in the bottom corner of the eyeball that will make it look round.

4 Apply a grey shadow at the top of the eye for the shadow of the lid, then repeat steps 3 and 4 on the other eye. Drop in a couple of dark spots at the base of each eye, then allow to dry.

5 Switch to a medium grey mix (a more dilute version of the step 1 mix) to paint in the outline of the dog's round iris. With a clean, damp brush, soften the grey into the iris. Do the same on the other eye.

6 Using the strong grey again, use a size 2 round brush to put in the pupil. Apply this as a C-shape to begin with, then develop this into a near-complete circle. Soften the C-shape outline into the round pupil to give more depth and roundness to the eyeball. Put a dark line into the inner edge of the eye where the white corner has been left, to separate the iris and pupil from the corner of the eye. Repeat on the other eye.

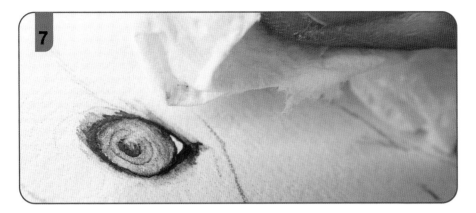

7 Lift out a stroke of highlight over the pupil and iris to the edge of each eye with a clean, damp size 2 brush, then remove the colour with a dab of the kitchen paper.

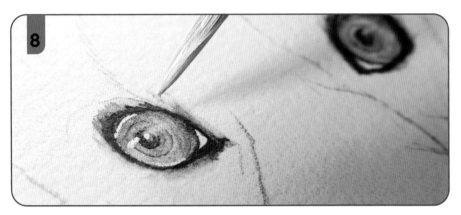

8 Using opaque white (or titanium white) straight from the tube with a damp brush, stroke in a highlight with a single dot next to it, running from the left to the right of the eyeball. Keep the paint nice and thick. Use the same white to put in a very fine line around the bottom of the eye where it meets the darker surround, to add a shine. Mirror this with a highlight at the top of the eyeball, then complete the eyes with a tiny white dot in the dark grey tearduct. Repeat for the other eye.

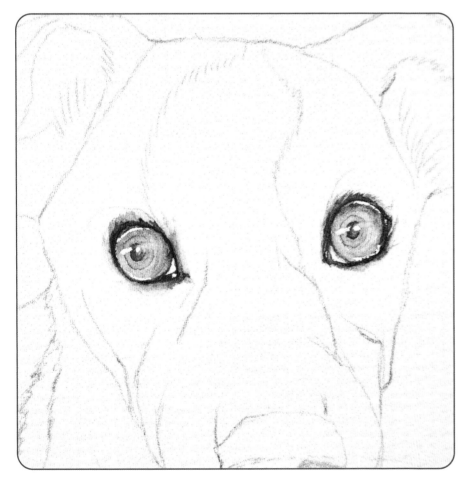

TAKING IT FURTHER

In the next project you will learn how to develop the animal's face further with the addition of other facial features, fur and markings.

Paint colours: French ultramarine, alizarin crimson, yellow ochre, burnt umber, opaque white

Brushes: sizes 6, 4 and 2 round

Other: tracing number 9, kitchen paper

Puppy

Paint the eyes as per pages 36–37, then continue this portrait following the instructions below. The key things to focus on here – and indeed when trying to make any dog painting look believable – are adding shine to the eyes and nose, and texture to the fur.

1 Use the size 6 brush and pale grey (70 per cent French ultramarine, 20 per cent yellow ochre and 10 per cent alizarin crimson) to paint in the body, making the head stand forward. Paint underneath the head, down the side of the neck and right-hand leg, then down and across the top of the back. Clean and wipe the brush, then use plenty of water to blend the grey down, dragging it down away from the head. Fade the colour away completely.

2 With the same damp brush, drag a few areas of grey upwards onto the head to help subtly bed the shadow in slightly. With the same grey, create some shape to the nose/muzzle. Start with a V-shape to the left of the snout, working up to the eye. Clean your brush, wipe it almost dry and then drag the colour up. Do the same on the right side, following the lines on the sketch. Apply some of the grey across the top of the head, working down to the white area, then soften downwards as before. Allow to dry.

3 Using a pale brown mix of yellow ochre with a touch of burnt umber, paint in some tan-coloured areas, starting on the left edge just to the left of the eye. Paint in the small brown patch above the eye, and the small areas just below it. Repeat on the opposite side to create a mirror image. Clean your brush, wipe it almost dry, then soften the colour so that it disappears into the head of the dog. For the ears, add a good amount of this colour on the inside of the ear and work it towards the head. Create a mid-brown mix (70 per cent yellow ochre and 30 per cent burnt umber) and add this at the base of the ears. Repeat for the other ear, then soften the paint as before. Dilute the yellow ochre mix to half strength and apply over the top of the nose and around the left and right sides of the mouth; fade this colour into the fur of the dog.

4 Working down the neck, add a few hints of pale yellow ochre mix around the shoulders of the dog. This should be very transparent to take away the harshness of the white. Allow to dry.

5 Mix a strong grey from 60 per cent French ultramarine, 30 per cent yellow ochre and 10 per cent alizarin crimson for the dark tones in the fur. Start to paint the tips of the ears (the left-hand ear has a fold) and work towards the head, then down towards the sides of the head past the eyes. Make the strokes slightly spiky to describe the fur. Work around the eyes, leaving a slight white gap underneath. Work under the eyes towards the tear duct, then down towards the jowls.

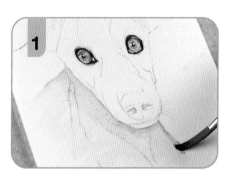

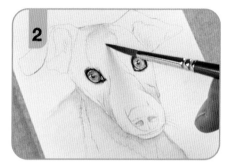

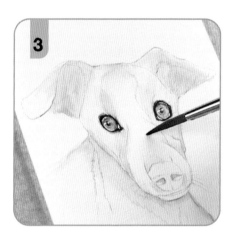

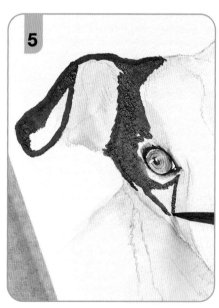

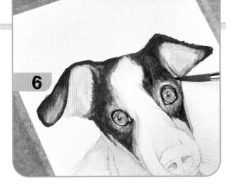

6 Before the paint dries, clean and wipe your brush, then soften the dark areas, feathering the grey so it blends to the inside of the ears, down the head and below the eyes. Keep recharging the brush with water and slightly feather the edges where the dark grey meets the tan. Avoid leaving any hard lines. Remember that the right-hand ear is slightly different as it has no fold at the tip.

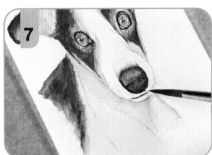

7 Use the same dark grey along the back of the dog. Work in the same way as before: block in the colour then fade it down with a clean, damp brush. Gently feather the edges and don't drag the colour too far. The top edge of this area can also be slightly feathered with a dry brush to make it look more like dog hair. Add a touch of burnt umber to your grey mix to darken it, then paint in the outline of the nose. Fill in just the tip of the nose, the nostrils and around the bottom edge, then clean and wipe your brush and soften the areas together. Allow to dry. At the top edge of the nose where it meets the fur, flick a delicate line of paint, working upwards towards the top of the head so it 'attaches' the nose to the head. Use the same colour for putting in the dark lip of the dog with a size 2 brush, before softening each end of the mouth into the fur of the muzzle towards the jowls to give some character.

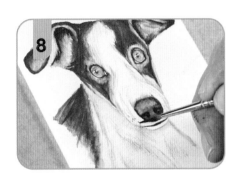

8 This same grey is great for adding further dark areas: apply it at the base of the ears to 'attach' them to the head, around the eyes and to the dog's back. Dry your brush and splay the hairs then, using the grey mix from step 5, put in some hairy lines to shape and form the body under the chin and through the neck; follow the contour of the dog and use very little pressure. Paint around the muzzle following the curve of the nose up to the top of the head, working over the white areas. Rotate your board if you need to. With the dark grey, add darkness to the nostrils. Soften as before, feathering the nostrils to the outer edges. Dampen the area around the jowls then, with a size 2 brush and medium grey, add spots for the whiskers, allowing the paint to spread.

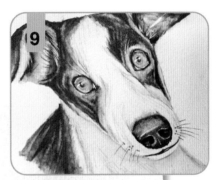

9 With a medium grey, on a dryish brush, add in the whiskers; dogs don't have as many whiskers as cats, but put in a few strokes in one direction then repeat on the other side, to give life and character. In the same way, add flicks of hair just above the eyes and inside the ears. With a size 4 brush, lift out some highlights across the bridge of the nose (muzzle) from one side to the other and underneath the nostrils. Lift out further areas in the dark hair: create a line to separate the ear from the head, add a few muscular lines around the eyes, plus a thin line that runs up the centre of the nose. Using the size 2 brush and a tiny bit of opaque white, add touches of white along the top edges of the nostrils to give shine to the nose, along with a broken highlight over the tip of the nose. Add a little spot of white on the lower lip then finish with a few white hairs inside the ears and over the eyes to suggest lashes.

10 To finish the painting off, add a final shadow underneath the head. Use a size 6 brush and the pale grey from earlier – take this right round to the right of the body to make the head stand forward. This greatly improves the composition of the painting. Blend this away with a damp size 6 brush, working down into the body. Once dry, add any final texture or contour lines using the same pale grey. (Refer to the finished painting.)

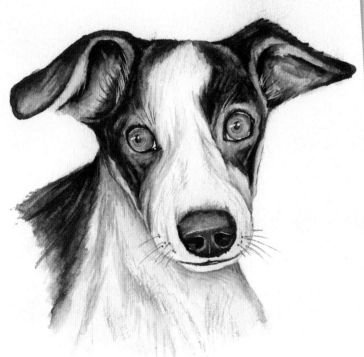

YOU WILL NEED

Paint colours: burnt sienna, French ultramarine, rose madder, yellow ochre, alizarin crimson, opaque white

Brushes: sizes 10, 6, 4 and 2 round, 6mm (¼in) flat brush

Other: tracing number 10, kitchen paper

Highland cow's muzzle

There are lots of competing textures here: the shaggy fur, the wet tongue, the glistening, dimpled nose. You'll need to approach and paint each area differently in order to create the different visual effects.

1 Use the size 10 brush to wet the background. Create a pale brown mix (90 per cent burnt sienna and 10 per cent French ultramarine) and use the size 6 round brush and your mix to suggest the long, sweeping hair surrounding the cow's muzzle. Bring the colour in around the mouth area, slightly over the edges of the nose.

2 Create a pink mix (90 per cent rose madder, 10 per cent yellow ochre). While the paper is still damp, paint in the nose and the top lip and the starting point of the tongue. Don't worry about the background: this colour will blend in.

3 Create a darker brown mix (80 per cent burnt sienna, 10 per cent alizarin crimson and 10 per cent French ultramarine) and add in further suggestions of the long, sweeping hairs and around the bottom of the mouth. Add a few flicks at the edges to help create the vignetted effect.

4 Mix a strong grey (from 60 per cent French ultramarine, 30 per cent yellow ochre and 10 per cent alizarin crimson) and, with a dry brush, add a few darker areas to the hair and mouth. The paper should be almost dry, so this is a good time to put in subtle shadow detail to the sweeps of the hair. Work around the back of the mouth area with this grey and lightly flick it away into the background in a negative-painting method to make the mouth stand forward. Clean the brush, tap off the excess and soften away the grey so it's more like a shadow and less like a grey outline. Focus on the muzzle and use a damp brush to help the grey disappear into the vignetted background. Allow to dry.

5 With rose madder, add more colour to the tongue and nose, outlining the top of the nose and the top and bottom of the tongue. Soften the areas into the nose and the tongue, then allow to dry.

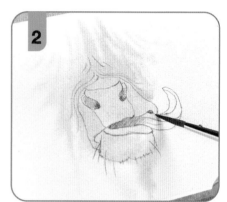

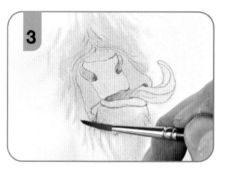

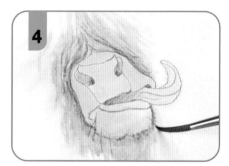

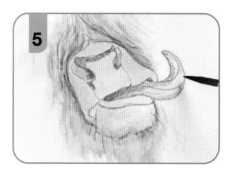

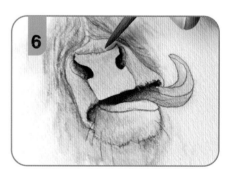

6 Use the strong grey mix inside the mouth, curving it around the bottom lip and across the base of the tongue. Make the edge more spiky as it heads towards where the hair is, and build it up where the lip curls around the tongue. Soften the dark area down over the bottom of the mouth and along the tongue, making it gradually lighter as it fades out. Apply the same dark grey to the nostrils. Clean and wipe the brush, then feather the grey from the nostrils out to the sides, making sure that you don't go over the top of the flesh of the nose. Work this grey along the edges of the nose and blend out. Use a medium grey to put a line across the top of the nose, then add a line of short, hair-like brushstrokes to it, which point up towards the centre of the cow's muzzle; this makes the nose look as though it's going 'back' into the face.

7 When the shadow below the bottom lip is dry, use a clean brush to flick medium grey down over the bottom of the muzzle. Use the same colour to paint the flat top edge of the tongue in a crescent moon shape. Clean and wipe your brush dry, then soften the paint to the left, within the tongue outline, to create a definite curl. Paint in the bottom of the tongue in same way and soften back towards the mouth. Use a stronger grey to make the top edge of the shadow on the bottom of the tongue a bit deeper. With a very dilute pale grey, run a thin line down the centre of the light part of the tongue to give the impression of all the ridges and folds.

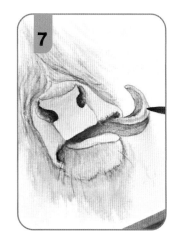
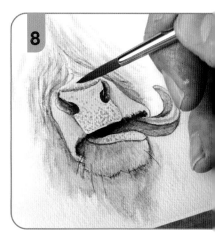

8 Use a medium to pale grey to put lots of little dots, almost like stippling, over the pink part of the nose. Spread these dots out as you move upwards. Apply these dots to the bottom lip as well. Add a few dots across the top of the nose where it meets the hairy part of the muzzle. Clean and wipe your brush dry then lift out tiny highlights on the inside of the nostrils where they stick out on both sides, coming down and curling inside the nose.

9 Mix the pink from step 2 with some dark grey to create a darker pink, then, using the size 4 brush, darken the outer edges of the nostrils then feather back the edges. Use the same colour to add a few dots over the top of the nostrils, at the bottom of the nose and on the bottom lip. Use the dark pink to add sharpness and contrast to the tongue by making sure both the outlines and inner lines are nice and crisp. Add some grey to the dark brown mix from step 3, rotate the board if need be and add some short hairs with a size 2 brush on the bottom lip and chin. Also add a few hairs at the sides of the nose and above it, following the contour wherever possible.

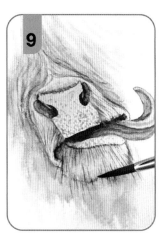
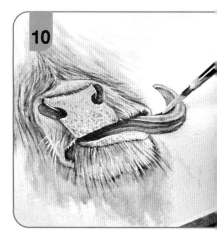

10 Use the 6mm (¼in) flat brush to lift out some highlights at both edges of the mouth, creating a thin line to help the mouth stand out. Lift out highlights on the top of the pink part of the nose and across the top of the bottom lip. Also lift out a few lines on the bottom of the tongue to give it more definition and lighten the side of the tongue a touch to give it more shape and form. Put a highlight at either side of the nostrils and at the base of the nose, right on the edge. Use the opaque white and the size 2 brush to add highlights around the top of the bottom lip; also add a few dots to make the mouth look glossy. Add very thin white highlights to the top and bottom of the tongue and to the base of the nostrils over the pink. Add white dots across the top of the nose where it meets the hair and inside the nose itself to help the texture. Add little highlighted curls inside the nostril to make it look shiny. Finally, add white hairs under the bottom lip over the chin, white whiskers from the muzzle and a couple of white flicks on the hairy part of the top lip to finish.

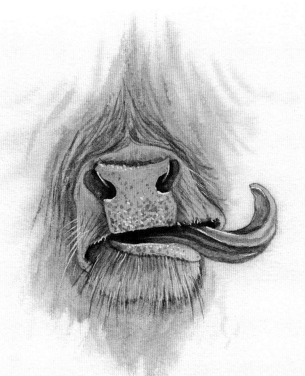

Cockerel's head

As with the Highland Cow in the previous project, this painting will give you lots of different textures to experiment with, from the smooth beak and the textured, folded wattle and comb to the soft, layered feathers.

YOU WILL NEED

Paint colours: burnt sienna, alizarin crimson, aureolin, lemon yellow, French ultramarine, yellow ochre, cadmium red

Brushes: sizes 10, 6, 4 and 2 round, 6mm (¼in) flat brush

Other: tracing number 11, kitchen paper

1 Create a deep orange mix (90 per cent burnt sienna and 10 per cent alizarin crimson) and use the size 10 brush to paint in the left side of the neck and the back of the head. Create a paler orange mix (80 per cent aureolin and 20 per cent alizarin crimson) and fill in most of the neck, as shown, before softening the inside area, allowing the colours to mix.

2 Clean the brush and squeeze it to a paddle shape. With the side of the brush, lift off some colour for the feathers, following the shape of the neck. Keep lifting the brush and squeezing it. If the paint is too dry, use a damp brush to scrub the colour away.

3 Use the size 6 round brush to drag some of the reds and oranges up into and behind the wattle. Create a yellow-green mix (90 per cent lemon yellow and 10 per cent French ultramarine) to paint in the eye: outline with the yellow-green, then soften it into the centre with a clean brush.

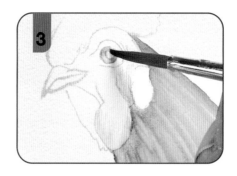
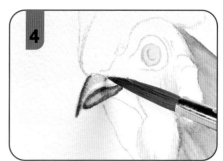

4 Mix a strong grey (from 60 per cent French ultramarine, 30 per cent yellow ochre and 10 per cent alizarin crimson) then paint in the beak: outline the top, bottom and centre, then smoothly soften the lines inwards. Drop a hint of the yellow-green into the beak and work it into the grey to blend it in.

5 Create a medium to strong red mix (80 per cent cadmium red with 20 per cent alizarin crimson) and, using a dry size 6 round brush, fill in the comb, wattle and other fleshy red parts, avoiding the earlobe; apply the paint so that it is quite patchy, and paint up to but not over the eye. Clean and wipe the brush then smooth the colour in and allow it to dry. Use the 6mm (¼in) brush to lift out highlights along the comb, separating every section of the comb with a highlight. Highlight around the eye with a slight curve pointing down to the beak. Lighten the wattles on the right, add a few highlights pointing towards the beak, and a couple on the left-hand edge pointing to the beak. Lift out V-shapes to suggest feathers all across the neck area. Allow to dry.

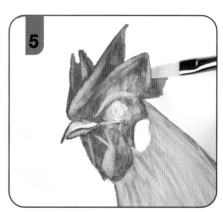

6 Using a size 4 brush, add some of the dark grey mix to the head: apply an L-shape down the front of the comb towards the beak and across the top of it. Add grey underneath the beak to separate the wattles, then follow the smooth curve of the right-hand wattle to create a 'hollow', not too close to the edge. With a clean brush, blend or feather the grey lines into the red; soften up from the top of the beak and to the left across the wattle. Add a thin dark grey line to the base of the beak at the bottom, across and underneath the eye. Also add a good strong dark outline around the eye, adding a small point at each side. Clean and wipe the brush almost dry, then soften the greys into the reds, being careful not to spread the grey too far. Allow to dry.

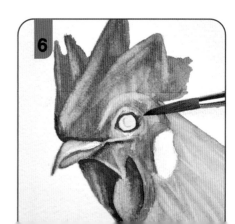

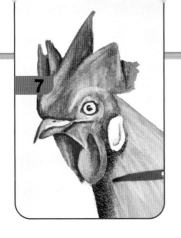
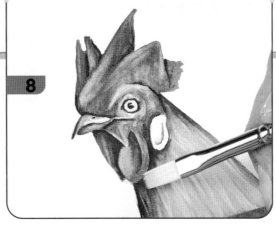
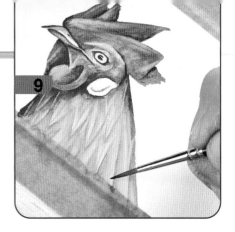

7 With strong grey, strengthen the line between the mandibles of the beak then feather the paint down over the lower one. Add a tiny spot for a nostril on the upper mandible and a C-shape to the very centre of the eye. To make the comb look three-dimensional, add and then soften the shadows between each fold, working above the lifted-out areas or to the side of them. For the earlobe: add a dark grey J-shape that follows the inner lower right edge, then soften the line up towards the eye. As you get towards the eye, work blended grey around it, keeping the light area around the eye. Use the size 6 brush to add larger shadows to the left side of the neck, and under the wattle. Working to the left of the earlobe and underneath it, make the line slightly thicker where it meets the neck. Clean and wipe the brush, then soften the grey down, blending it into the red of the feathers. Keep refreshing the brush to keep the grey smooth and blended, but don't make the shadow area too large.

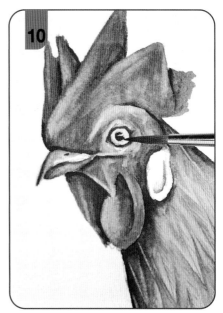

8 Use the same grey at the back of the neck, curving it down around the dome at the back of the eye. Clean the brush then soften the grey down the neck into the feathers and up into the comb. Use the 6mm (¼in) brush to lift out some feathery V-shaped highlights from the left-hand grey area, to help create the feather texture. Allow to dry.

9 Add a touch of grey to the deep orange from step 1, and add shadows to the feathers. Using the size 6 brush, work next to the highlighted areas in a negative painting fashion: darken some areas to make the light areas stand out. Soften the lower points of the feathers downwards towards the bottom of the painting and the upper points up towards the head to 'bed' the feathers in. Continue to add shadows here and there as needed, softening them in as you go; as one area dries, more can be added in to layer the feathers. Allow to dry, then use the size 2 brush and the same colour to add a few dry brushstrokes up the centre of the feathers (much like the skeleton of a leaf). Rotate the board and put in little downward flicks to make a few prominent feathers using the tip of the brush.

10 Finally, add a touch of pale grey with a size 2 brush to add shadow to the left of the eye to make it look more spherical.

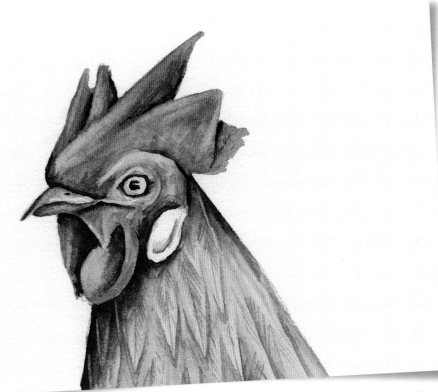

TEXTURES AND MARKINGS

To make an animal painting believable, it is important to try to capture the huge range of textures possible: woolly fleece, smooth feathers, tufty fur, wrinkled skin, scaly feet and sharp claws – all will require different approaches and techniques. Here I'll show you how to capture a large range of animal textures, to equip you with the skills you need.

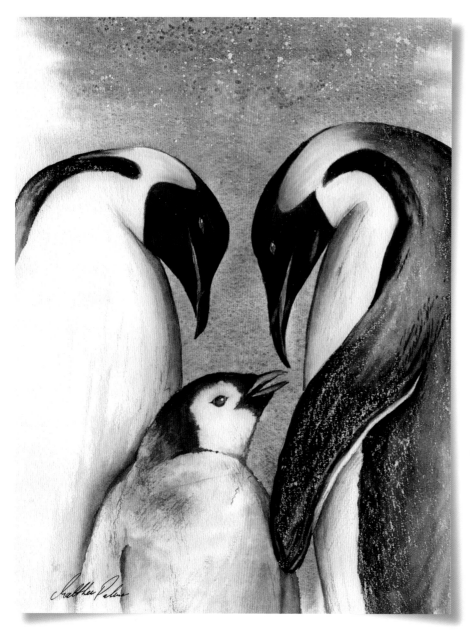

P-p-p-pick up a Penguin
32 x 40cm (12½ x 15¾in)

Whether it is the rough texture of a penguin's wing (shown opposite), the smooth gloss of a butterfly's wing (shown left), or the ruffled grandeur of a cockerel (shown below), it is vital to try to accurately capture the texture you see before you. For smooth finishes you will need to work on blending and feathering seamlessly; for rough textures you will need to use dry-brush techniques or experiment with wax resists. Feathers will require precision, with both smooth blends of paint and abrupt demarcations of shadow. I will take you through painting a wide variety of different animals to show you how I approach different textures: I would encourage you to try out the projects in this book and then experiment with any techniques you particularly enjoy, to hone your skills and take them further.

Tortoiseshell on Flowers
26.5 x 35cm (10½ x 13¾in)

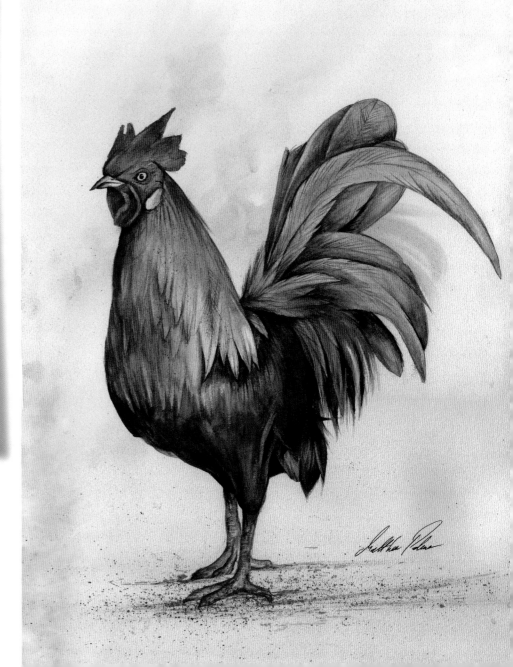

Cockerel
34 x 45cm (13¼ x 17¾in)

YOU WILL NEED

Paint colours: cerulean blue, French ultramarine, burnt umber, alizarin crimson

Brushes: sizes 10 and 6 round

Other: tracing number 12, clear wax candle

Penguin's wing

Using a wax candle as a resist gives a really tactile effect to paintings, and in this case helps to suggest water sparkling on this penguin's wing. You could also use this technique when representing the skin or scales of, say, crocodiles, whales or even frogs, but carefully consider the scale of the piece you are working on first – you may have to use very delicate and considered strokes for smaller creatures.

1 Using a size 10 round brush, put in a flat wash of cerulean blue in the two areas of background to the left of the painting, then allow to dry.

2 Ensure the candle is clean by rubbing away the excess first on scrap paper. Run in a light glaze of candle wax on the dark parts of the wings and body in vertical lines. Carefully follow the shape of the wings and don't apply too much pressure – allow the candle to skim the paper surface.

3 Mix a medium grey from 70 per cent French ultramarine and 30 per cent burnt umber; use the size 6 round brush to run in a shadow down the left side of the penguin's body and under its wing. Keep the width of the shadow line similar to the width of the bristles of the size 6 brush and keep in mind that the wax may begin to show through. Clean and dampen the brush and smooth the colour down to the right.

4 Mix a touch more burnt umber into the grey to strengthen it. Switch back to the size 10 brush and paint over the top of the bird's wing – the wax should certainly show through here. Leave the bottom edge of the wing unpainted.

5 Work down into the penguin's body in the same dark grey.

6 Lighten the grey/burnt umber mix slightly. With a drier brush, blend the lighter grey in with the darker grey over the wing. Work towards the right-hand edge of the paper. Drag the colour the rest of the way so that it recedes off the paper and suggests a variety of tones. Do the same on the penguin's body and spend plenty of time blending the dark into the lighter areas.

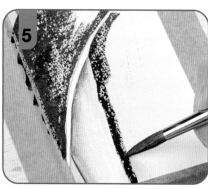

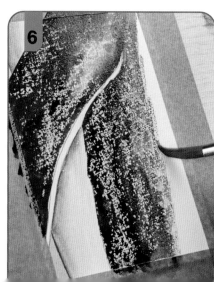

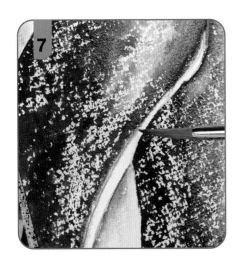

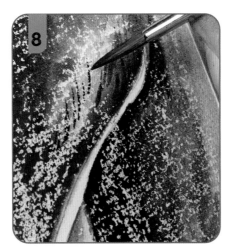

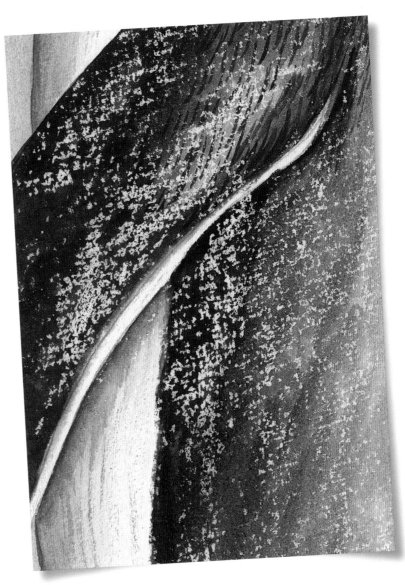

7 Clean off the size 6 brush and wipe it almost dry. Run the brush along the edge of the wing where it meets the white underside to reactivate the grey paint. Ensure you achieve a feathered effect here, then clean and dampen the brush again to soften the edge of the wing.

8 Make up a strong, even mix of French ultramarine and burnt umber, with more paint than water. Using the size 6 brush still, add some shadow and feather details under the wing. Work in a strong line under the penguin's 'armpit' (underneath the top of the wing), then, with a clean, damp brush, blend the shadows into the waxed areas. This will give the wing more 'lift'. Put in some diagonal flicks over the top of the wing for added feather detail, curving the brush upwards to shape the finer outer feathers.

9 Take up the medium grey mix from step 3 again, and strengthen the shadow on the bird's belly directly under its wing. With a clean, damp brush, soften the shadow downwards to shape the area.

10 Finally, with a fairly dry brush and the bristles slightly splayed, brush in some dry-brush texture over the white of the penguin's belly to give more texture to the feathers here.

YOU WILL NEED

Paint colours: yellow ochre, aureolin, French ultramarine, alizarin crimson, viridian hue

Brushes: old brush for masking fluid, sizes 10, 6 and 4 round, 12mm (½in) and 6mm (¼in) flat

Other: tracing number 13, kitchen paper, masking fluid

African elephant

We're all familiar with the tough, baggy, wrinkled-looking hides of elephants. The trick here is to position your shadows and highlights carefully in order to suggest all that texture, plus the shape of the animal. Take your time when painting the ears and trunk, as these contain the most textural detail and will help bring your elephant to life on the page.

1 Mask off the tusks. Wet the paper with a size 10 brush, then lay in horizontal brushstrokes in yellow ochre, working over the elephant's lower body and trunk, and from the top of the head to the top of the paper, to achieve a soft, faded background.

2 Go straight in with a green mix of 70 per cent aureolin and 30 per cent French ultramarine around the elephant's feet, for grass, with the size 6 round brush. Allow the paint to spread, then soften the colour down with a damp brush to help the green 'disappear'. Dilute the green and hint at foliage in the background on both sides of the elephant, to suggest depth within the painting. Then switch to the size 4 brush and use the same dilute green mix to put a few extra flicks into the foreground grasses. Work between the legs to ground the elephant.

3 While the background is still damp, pick up the size 6 round brush again. Mix a strong grey with yellow ochre in it (60 per cent French ultramarine, 10 per cent alizarin crimson and 20 per cent yellow ochre), and begin to work into the elephant's back legs, before moving to the front legs. Keep your strokes tidy up against the trunk, and go right over the masked-off tusks. Work up as far as the ears.

4 Make up a metallic-grey mix from equal parts viridian hue and alizarin crimson, and work the darker colour alongside the grey you have just laid in. Clean your brush on kitchen paper and add in a concrete-grey mix (50 per cent yellow ochre, 10 per cent alizarin crimson and 40 per cent French ultramarine). Work this into any paler areas left on the legs to create some variety. Then, still working wet-into-wet, pick up the strong grey from step 3 and put in shadows next to the trunk and tusks, under the ears and onto the legs to separate them. With a clean, damp brush, soften off the darker shadow areas, then allow to dry.

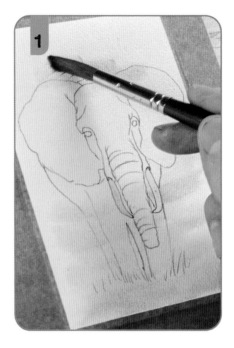
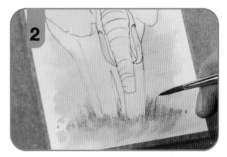
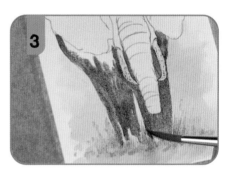
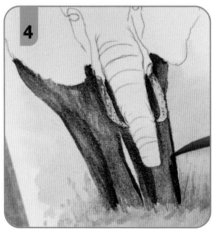
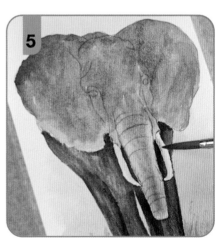

5 Working down from the top of the head, use the same grey mixes to build up varied tones in the elephant's face, keeping the bottom of the face quite light and mixing in a little more yellow ochre at the tip of the trunk. Leave a white edge around the bottom edges of the ears and the sides of the trunk – blend the surrounding colour into those areas with a clean, damp brush. Spend time blending the greys – smooth the paint on the trunk to the left and right so there is no white left. Remove the masking fluid from the tusks. Paint down the inside edges with yellow ochre, then soften outwards to give an ivory colour. Pick up the grey with ochre mix (from step 3) and put in a few spots on the tusk for shadow detail. Allow to dry.

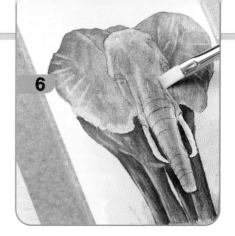
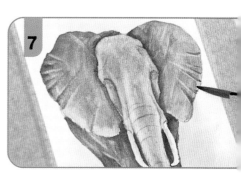
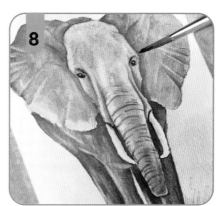
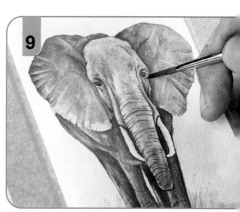

6 Using the 12mm (½in) flat brush, lift out highlights along the left flank, following the curve of the body. Lighten the left-hand edges of all the legs, then work all over the body – lifting out here and there to create a rough, textural surface. Soften your highlights by dragging them to the left. Next pick up the 6mm (¼in) brush and lift out highlights on the head, starting above the tusks to create a muscular shape. Lighten the edges of the head to distinguish it from the ears. Shape the top of the head with highlighted patches and create radiating highlight lines on the ears which replicate wrinkles, creases and folds. Highlight the left-hand side of the trunk, right up to the forehead, for shape, form and muscular tone; repeat on the right-hand side.

7 With the size 6 round brush and the dilute dark grey from step 3, add the textural shadows. Run a dark line from the back of each eye down to the area where the tusks emerge. Soften these lines outwards with a clean brush, away from the trunk. Paint in a shadow over the top of the ears and around the head to make the head stand forward; work all the way down from top to bottom. Clean the brush then soften the shadows away into the ear. Touch in radiating lines at the edges of the ears next to some of the fold highlights; soften the shadows towards the head. Add some further shadows to the join between the ears and the head, and try to remove all hard lines. Touch in some darkness underneath the chin, then fade away to soften.

8 Using the same dark grey, paint a series of curved strokes down the length of the trunk to indicate its rounded shape – bring the lines in from both sides of the trunk. Dampen the brush, wipe it, then rock the brush over the top of the strokes to soften them. At the bottom of trunk, where it curves, put a reverse L-shaped shadow across the bottom and up the right-hand side to give the appearance of a curve. Soften the shadow up the trunk. Put a tiny shadow to the outside of the trunk as it meets the head to help the trunk stand out, then soften it. With a small brush and strong grey, touch in a thin line where the tusks enter the flesh. Paint the eyes in as an outline with a lighter area in the centre, then add a dark line just above the eyes, where the brows would be. Clean the brush, wipe it almost dry then feather down the shadows at the tops of the tusks and above the eyes.

9 Touch in a few random crease and fold lines around the face with a dry brush and grey paint to give the elephant extra character. Add dry flicks above and below the eyes where the hide is very tough and creased. Put a few extra creases in the trunk using the same technique, working in from the edges and making convex lines. At the edges of the ear, touch in flicks pointing towards the head – as though you are working around a clockface. To finish, add a few lines to the lower legs, working from left to right.

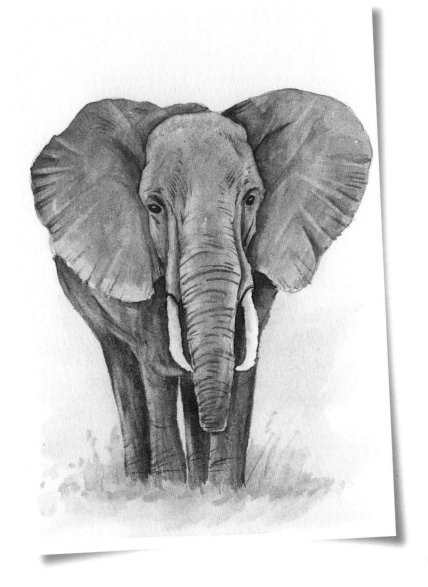

YOU WILL NEED

Paint colours: aureolin,
French ultramarine, yellow ochre,
alizarin crimson, burnt sienna,
opaque white

Brushes: sizes 10, 6, 4 and 2 round

Other: tracing number 14,
kitchen paper

Lamb

In order to paint white objects you often have to use a surprising number of colours. Here we will focus on making a lamb's white fleece look fluffy and full of bouncy texture. Go gradually with the colour if you are nervous about putting in too much; step back and look at your work from a distance at regular intervals to help you accurately judge your progress.

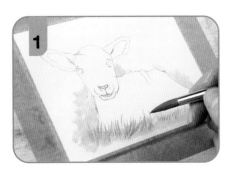

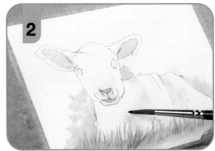

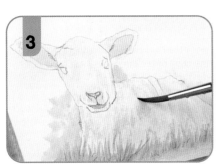

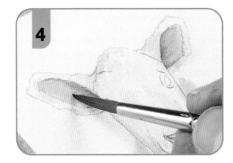

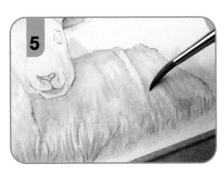

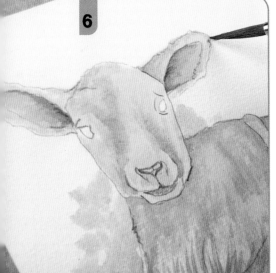

1 Wet the whole painting with the size 10 brush. Create a light green mix (70 per cent aureolin and 30 per cent French ultramarine) then, working with a relatively dry brush, apply the paint across the foreground and background, around the lamb, using small zigzag movements of the brush. With a darker green mix (equal parts aureolin and French ultramarine), add in a few flicks of grass around the base of the lamb using the tip of the size 10 brush, or a finer brush if you prefer.

2 The pinky-peach colour is a mix of 60 per cent alizarin crimson and 40 per cent yellow ochre; add to the insides of the ears. By this stage, your paper should be drying slightly: add more of this colour around the mouth and nose, and add hints of it in the main body of the lamb, following the direction of the fleece. Clean and wipe the brush, then soften the paint in to suggest the woolly texture.

3 Create a warm pale grey (50 per cent French ultramarine, 40 per cent yellow ochre and 10 per cent alizarin crimson) and apply it to the head and body of the sheep – following its contours – using the side of a dry size 6 brush. Once one section of fleece is dry, work over the top for additional texture, tickling the brush over the paper surface. With a pale rusty colour (80 per cent burnt sienna and 20 per cent French ultramarine) and a dry brush, continue to add texture to the fleece in the same way, but in fewer areas than before; work over the top of the head and into the ears and either side of the muzzle. Allow to dry.

4 Build up the shadows next with a size 6 brush. Add more red to the pinky-peach mix, then work around the top inside edge of each ear. Wipe the brush, then soften the paint towards the outside edges. Pick up grey (60 per cent French ultramarine, 30 per cent yellow ochre and 10 per cent alizarin crimson) on a damp brush and add some a small amount of dark shadow to the inside of each ear. Soften the grey until it becomes part of the pink.

5 Slightly dilute your grey mix, then add dark shadows underneath the head and down the left side, then across the top of the back. Make sure the line is soft but not smooth over the fleece; then soften completely down into the lamb's body – this will make the head stand forward. Use this grey to add random flicks of colour to the body, where it meets the grass, to give shape and form. Put some 'folds' into the fleece, then soften the grey into the fleece.

6 Use the same grey to add shadows to the face, on the left of the mouth and muzzle first. Work up towards the top of the head and over the eye, heading for the centre. Feather the edges away with a clean, damp brush, into the head but following the shape and contours around the eye. Repeat on the opposite side, but make the shadows paler as the light is coming from the right. Darken along the tops of the ears and where they touch the head, then soften away.

7 Use the same grey to add shadows to the top and sides of the eyes before feathering the lines away. It is important to ensure that all exposed areas of the lamb touching the background are darkened: spot along the edge of the face and the top of the head, and across the bottom of the ears. Use the same grey with a dry brush to add fleecy texture to the body: spot the brush randomly around the fleece to shape the neck, folds and creases. Add to the face as well, but bear in mind that the wool on the face is more like hair, so it should follow the facial contours with diagonal flicks. Allow to dry.

8 Mix a strong grey (60 per cent French ultramarine, 30 per cent yellow ochre and 10 per cent alizarin crimson) and use a size 4 brush to add detail to the eyes, mouth and nose. Start with the mouth, which is a hard line feathered downwards. Repeat to paint in and then feather down the nostrils. For now, add the eyes as solid dark shapes – highlights will be added later. Wipe the brush dry then use the tip to lightly blend the corners of the eyes into the head to help 'attach' them. To complete the eyes, carefully add a thin line of grey under each eye.

9 Using the grey from step 8, add further shadow detail by lightly stippling at the base of the mouth; use an almost dry brush to soften this backwards into the head. Apply the same dark grey inside the ears to suggest a few long hairs over the pink areas. Dilute the mix slightly to create a medium grey, then add a few darker shadows into the fleece in a few areas to create markings and separation – work upwards from the grass, and flick the brush as you create your lines. Wipe the brush and soften away into the fleece, keeping the lines hard on one side and softened on the other. At this point, make sure the shadow to the left of the body under the head is nice and dark – to help the head stand forward – and on the other side of the head and into the body; add further colour if you need to, then soften away. Add further flicks of texture into the wool, all over the body and face.

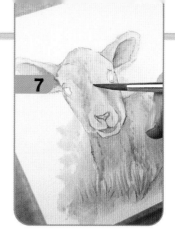
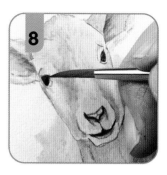
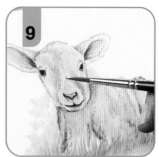
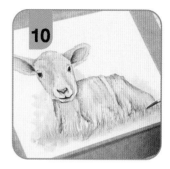

10 Return to the pink mix from step 2 to deepen the colour of the nose; add tiny spots of pink around the mouth, and a few pink hairy lines inside the ears to help give texture. Use a size 2 brush to add a few tall grasses with dark green (equal parts aureolin and French ultramarine), overlapping the body of the lamb – use a slightly drier brush and quick flicks to skim the paper surface.

11 Once the eye is dry, clean and wipe the excess moisture off a tiny brush, then lift out soft highlights over the tops of the eyes before dabbing with kitchen paper – this will give extra life to the eyes. Use opaque white paint to pop in the eye highlights and a tiny spot of white in the corner of each eye, to make them sparkle.

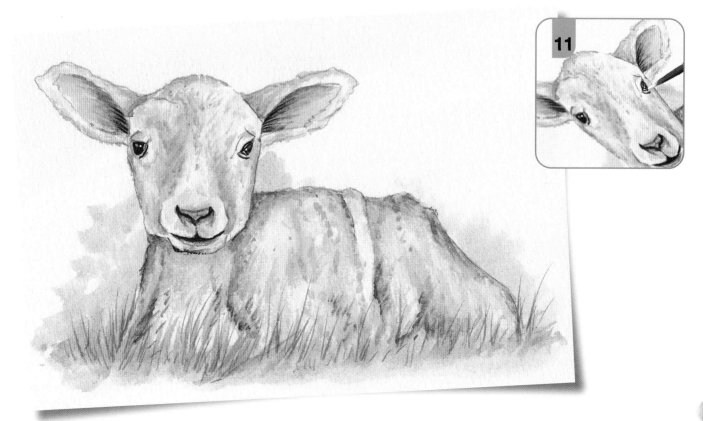

YOU WILL NEED

Paint colours: aureolin,
French ultramarine, burnt sienna,
alizarin crimson, yellow ochre,
opaque white

Brushes: sizes 10 and 6 round,
6mm (¼in) flat

Other: tracing number 15,
kitchen paper

Ram

We will use a few different techniques here to make the horn look rough, ridged and gnarly, including shadow work, lifting out highlights and adding spots of opaque white. You don't need to be too careful about how you apply the dark ridged lines to the horns here – in fact, the more random and irregular they are, the more lifelike they will look.

1 Use the size 10 brush to wet (but not saturate) the entire paper. Using a green mix (60 per cent aureolin and 40 per cent French ultramarine), touch in a little vignetted background; work around the edge of the head, allowing the paint to spread a little.

2 Go straight in with a rusty brown mix (80 per cent burnt sienna and 20 per cent French ultramarine) while the background is still wet. Work colour into the ram's head and horns, allowing the paint to spread, following the contours and taking the paint over the eyes. Use a little burnt umber on its own across the forehead, around the bottom of the chin and behind and inside the horn. Allow the mixes to blend together on the paper, wet-in-wet. Mix a sandy tone (70 per cent yellow ochre, 20 per cent burnt sienna and 10 per cent French ultramarine), and use this to follow the shape of the horns. Work around the eyes and the side of the head, then finish off with a yellow ochre glaze on the left of the horn, down the top of the head and around the mouth. At the left edge of the picture, soften the paint away and fade it into a vignetted edge. Allow to dry.

3 Using the size 6 round brush, work in some dark shadows around the inside of the curl of the horn with a strong, warm grey (50 per cent French ultramarine, 40 per cent yellow ochre and 10 per cent alizarin crimson). Clean then wipe the brush on kitchen paper, then use water to soften the area completely away, working towards the right side of the picture. Fade it in smoothly, revisiting the dark colour and recharging the brush if need be. Use the same colour to add darkness to the outside of the horn from the underneath and under the head towards the mouth and neck area; soften the colour in as before, tapering it off around the back of the horns. Use the damp brush to soften the colour into the main area of the head and the fleece. On the underneath of the neck add a few flicks of long hair to indicate the main fleece of the ram.

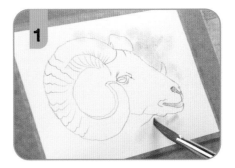

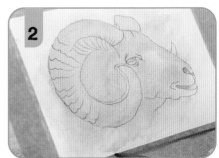

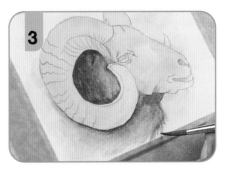

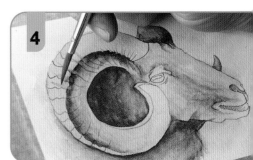

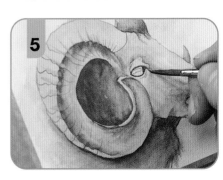

4 Still using the warm grey, add a couple of darker shadows around the top of the eye and down onto the muzzle. Apply touches to the left of the mouth to help suggest the muscular face shape. Feather away, working into the facial features and following the contours. Use the same colour again to make the point of the rear horn recede into the background: add paint around the right and bottom edges, then feather away, rather than blending completely smooth. Also paint the top of the rear horn in the same way. Add in a few dry-brush flicks at the bottom of the horn to help 'attach' it to the head. Use a pale grey (70 per cent French ultramarine, 10 per cent alizarin crimson and 20 per cent yellow ochre) to add some shadow to the front horn. Start from the head and paint in a line down the centre which gradually works its way towards the edge of the horn at the base. Clean the brush and feather the shadow inwards. With the same damp brush, drag off some lines towards the outer edge from the hard grey line; we will emphasize these later.

5 At the top of the horn, as it curls up to the eye, add a similar shadow. Clean your brush, then work the shadow into the horn. The hard edge left behind can be feathered with a damp brush; ensure the brush is not too wet. With a slightly stronger grey (70 per cent French ultramarine, 10 per cent alizarin crimson and 20 per cent yellow ochre), add a dark outline to the eye socket, as well as a little dark vein that runs away from the eye towards the nose.

6 Add this same mix to the inside of the mouth and nostrils – as it is strong, there is no rush to blend it away. Clean your brush then feather these lines away from the feature – away from the eye, working into the fleece, towards the bottom of the chin for the mouth, and towards the tip of the nose from the nostril.

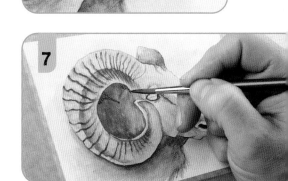

7 With the same dark grey, add to the craggy detail on the horns, painting over the outer and shadowed parts; all the paint should be blended in towards the left. Bear in mind that the lines get closer together as the horn gets closer to the head, and at the tip of the horn the lines will almost disappear. Use a clean, damp brush to skim over the left-hand sides of these lines to soften them out to look more natural. Don't spend too much time on each one: just use a light glaze to soften the grey in, recharging the brush every so often. Also use the strong grey to add in a few marks to give the impression of the ram's ear underneath the horn.

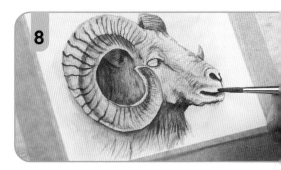

8 With the same grey, darken the neck with strong shadows – use negative painting, adding darkness to create the shape of the chin. Add some dark flicks for long hairs in the fleece on the neck and around under the horn. Tap away the excess colour and, as the brush dries, work into the head using small, dry marks to give shape around the mouth and chin. Work from the top of the head down in the same way, creating a curve to indicate the shape of the forehead with a series of quick flicks. Use dry brush to add small textural marks to the head to create a fluffy effect. Add a few lines on the rear horn, and also block in the strong shadow on its left-hand side, to indicate where the horn curves. Clean the brush, then feather away any marks that stand out too much. Continue adding long hairs to the fleece inside the curl of the horn and inside the ear. Splay the hairs of a dry brush and darken and add a bit of texture to the horn itself. With very fine marks, add a little hairy beard to the ram's chin.

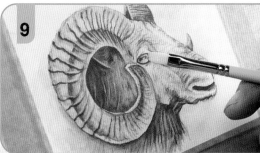

9 Add more yellow to the green from step 1 to brighten it, then paint in the left side of the eye, before softening the colour towards the right. While the area is damp, pick up some strong grey on the tip of the brush and drop in the brick-shaped pupil. Using the 6mm (¼in) flat brush, lift out some long hair-like highlights in the fleece of the neck area, and inside the horn – less is more here. Continue to lift out highlights at the base of the neck, around the mouth and into the nose to give some shape. Lift out highlights on top of each of the dark stripes on the dark side of the horn – this makes the texture jump forwards; also lift out a highlight that runs down the ridge along the curve of the horn. Lift out a highlight on the partially obscured ear to make it stand forward, then lift out a little highlight that runs along the left-hand edge of the rear horn. Lift out a small highlight to the right of the eye, using the corner of the brush.

10 Add a dot of white at the edge of the pupil, at the corner of the eye and as a line underneath to make the eye shine. Add a few spots over the top lip to indicate overhanging hair. A few tiny dots of white along the edge of horn and on some of the ridges will help them stand forward. Finally, touch in a few fine ear hairs. (Refer to the finished painting.)

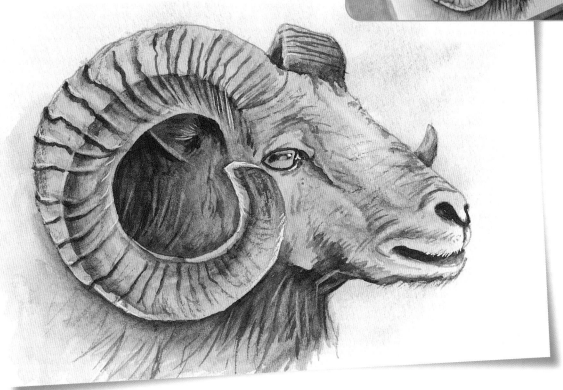

YOU WILL NEED

Paint colours: aureolin, cerulean blue, French ultramarine, burnt umber, viridian hue, opaque white

Brushes: sizes 10, 6 and 4 round, 6mm (¼in) flat

Other: tracing number 16, plastic food wrap, kitchen paper

Great tit

When capturing a bird's feathers, it's important to remember that there isn't just one type: here, the great tit has smooth feathers on its wing, downy feathers near its bottom, and textured feathers on its belly. Focus here on how you use your brush to blend and smooth the paint in different ways.

1 Use the size 10 brush to apply strong to medium aureolin across the bird's back and most of the way across its belly. Wet the background, then twist in some touches of cerulean blue, followed by some touches of green (70 per cent aureolin, 30 per cent French ultramarine). Apply some plastic food wrap and wrinkle it over the background and on the yellow of the bird to create texture (also see page 59). Leave in place for about five minutes before removing it.

2 With a size 6 round brush and strong aureolin, strengthen the yellow on the bird. Clean the brush then use water to blend in the colour. Ensure the colour is lighter towards the back of the bird; use the same damp brush to feather away any harsh lines.

3 Create a medium grey mix (30 per cent pale watery burnt umber and 70 per cent French ultramarine), and paint a jagged line along the base of the twig. Pick up a pale brown mix (70 per cent aureolin and 30 per cent burnt umber) and paint along the top of the twig: the bottom third should be grey and the top third brown. Blend the brown and grey together with a damp brush. Fade away both ends of the twig for a vignetted effect. While the paint is still damp, pick up dark grey (70 per cent French ultramarine and 30 per cent burnt umber) and tap off the excess. Beneath the claws, add curved shadows, and along the length of the twig add curved rings, working up from the bottom of the twig, to indicate the shape. Allow to dry.

4 Create a blue mix for the wings (from 70 per cent French ultramarine and 30 per cent cerulean blue). Using the size 6 round brush, start with the tail feathers first. Work up through the wing with a slightly curved brushstroke into the wing itself to shape the feathers. Go underneath towards the belly and down under the bird, tapering off before meeting the feet. Fill in the large wing, keeping within the shape. As the blue meets the yellow, green will appear. This is fine as the great tit has a green tinge to its wings. Before you meet the neck, pick up a turquoise mix (70 per cent French ultramarine and 30 per cent viridian hue), and add a hint of this at the top of the wing; blend it in. At the tail feathers, blend in the blue line towards the right of the bird and underneath to the soft down feathers. Blend in the blue to the yellow and fade it. Soften the right-hand side of the wing where it meets the yellow; greens will happen naturally here. Feather in the hard edge at the top of the wing with flicks of the brush to ease it into the yellow. Don't be afraid to recharge your brush by cleaning it.

5 Pick up the dark grey on a dry brush and add dark lines to the back of the wing, working from left to right across the feathers. These lines should taper off to the right. Clean and wipe the brush dry, then feather in the tips of the lines so they disappear. Use strong dark grey to paint in the head: loosely fill in the area around the neck and the head, leaving a white space for the eye. The line should gradually taper down the breast of the bird and also come away from the neck across the top of the wing. Clean and wipe the brush, then feather the areas together. Fill in any white lines you might have left but make sure the brush is almost dry and gently tap the edge of the dark as it attaches to the yellow. Drag the grey down the back of the neck then rinse your brush and feather the edge. As you work, your brush will pick up some of the grey: use this to put in some flicks over the yellow areas, following the direction of the yellow, creating a feathery effect on all yellow areas. When you reach the downy feathers at the bottom, slightly overlap the background to make them look more fluffy.

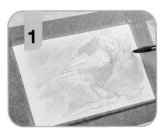

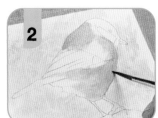

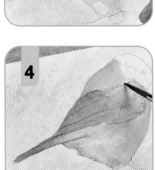

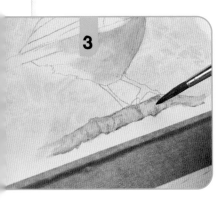

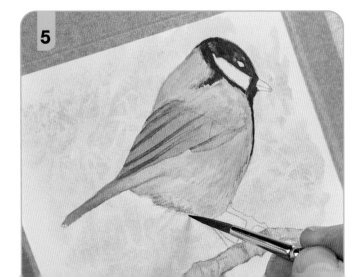

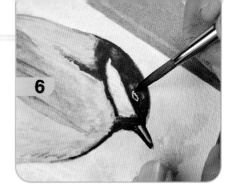

6 Use a size 4 brush and strong grey for the beak. Work the bottom half of the beak as a complete outline; for the top, simply add a thin line on the top edge. Fill in the bottom section with a damp brush, then fade down the top section to create a lighter section in the centre of the beak. The eye is very fine: paint in a tiny backwards C-shape in the middle of the white.

7 Paint the left-hand and top edges of the legs with strong grey; take the bird's left leg further into the body. Clean and wipe the brush, then soften the leg into the body and drag the grey paint over the legs to create the scaly texture. Where the legs sink into the feathers, tickle the colour to soften it; smudge it a bit. Paint the claw of the bird's right foot in the same way – apply the paint underneath and then drag it upwards. Use extra touches of strong grey on the legs and feet to enhance the scaly effect. Add a few darker areas of dry brush to the twig to give it some extra texture, especially in the area where the bird is standing.

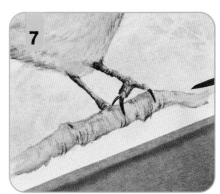

8 Use the size 6 round brush with strong grey to add darkness to the underside of the wing, from the top of the tail feather across to the base of the wing, gradually tapering off the width of the line as it moves towards the head, and taking it up into the underside to give shape to the feathers. Clean and wipe the brush, then soften the grey downwards and towards the head. Use the same grey to add a few 'steps' in the downy feathers at the bird's bottom, to show that the feathers are layered; soften away into the soft downy feathers. At the yellow base of the back, put in a 'V' of shadow using a dry brush. Clean and wipe the brush, then soften the grey into the yellow so it disappears – don't take away too much yellow. Then create a strong, thin line across the top of the wing, to indicate the very top feathers. Clean and wipe the brush, then feather the left-hand side of the line away and back towards the tail feathers. Paint in some more defined grey lines from the back of the wing over the ones laid in the previous stage, and add in a small section of dark dry-brush marks at the top-right of the wing. Allow to dry.

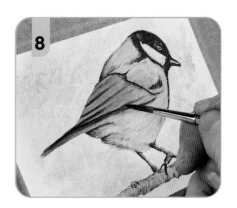

9 Using the clean, damp flat brush, lift out highlights from the yellow, down the bird's head and back and around the belly and breast, following the contours. Lift out highlights from the wing: start at the lower edge where the dark shadow was added, as this creates greater separation and lifts the wing up, but continue to lift out highlights at random from the tail feathers and across the wing. Highlight as light as possible: lift off a second time to get down to the white paper. With the size 4 brush and opaque white, add a bold, flicked edge to the bottom of the top feathers, brushing towards the head. Add a tiny bit of white to the side of the eye and make sure the beak has a white line through the centre. Add some white lines next to the grey lines of the wing, add some white flicks into the belly feathers, and some touches into the soft down feathers for extra texture. (Refer to the finished painting.)

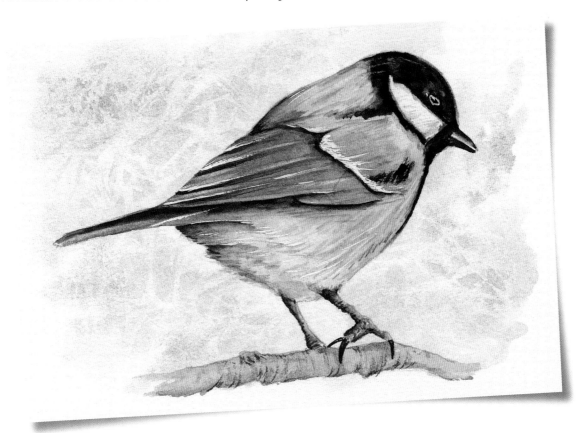

PORTRAITS

My favourite way to paint animals in watercolour is as portraits. Often, just the head and shoulders is all that is needed. A very simple background, or no background at all, will allow you to focus your energy on the detail of the main subject, and if you leave the background light it can really help the animal stand forward.

This section of the book will show you how to paint detailed animal portraits, bringing together all of the techniques used in earlier sections of the book. If you are interested in creating an abstract, marbled background for your portraits, see page 59.

Woodpecker
28 x 38cm (11 x 15in)

Kingfisher
35 x 40cm (13¾ x 15¾in)

I have used a different background painting style for the portraits shown here, opposite and overleaf. Below, for the snowy setting, I sprinkled salt grains onto the wet background to suggest the gently falling snow. Paint the background first, to prevent getting salt on the squirrel. The kingfisher, left, is nestled in a background created using plastic food wrap (see page 59), as the abstract shapes this creates help to suggest distant foliage, but don't draw attention from the bird itself. The woodpecker portrait, opposite, and the robin portrait, on page 58, have soft wet-in-wet backgrounds, which allows the focus to fall on the birds.

Red Squirrel
33 x 39cm (13 x 15¼in)

Robin on a Tap
40 x 52cm (15¾ x 20½in)

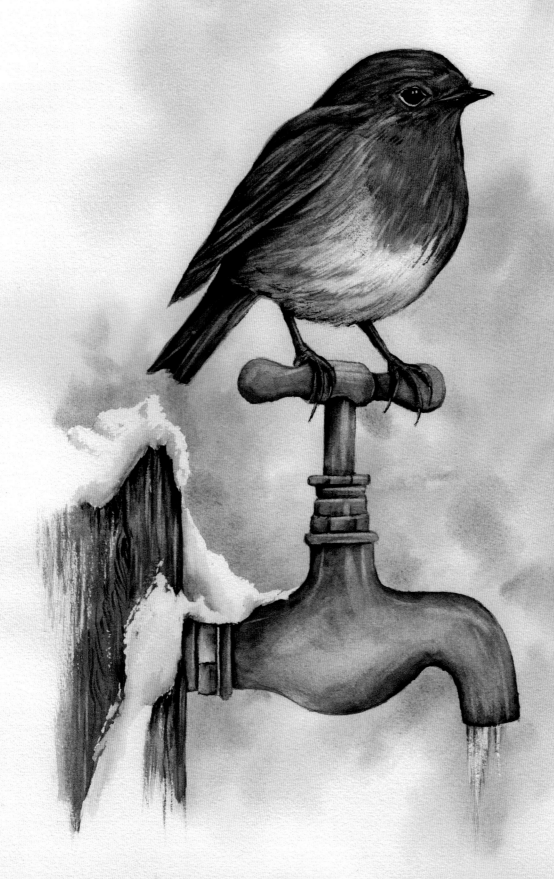

PAINTING A 'MARBLED' BACKGROUND

If you just want to give a suggestion of colour as a background, rather than leaving the paper blank, try using plastic food wrap to add some interest and texture. I used this technique for the Great tit on pages 54–55, but it would work really well for any pet portrait where you don't want the background to distract from the focus of your painting, or for any animals in water.

1 Wet the whole background with a medium-sized brush such as a size 10 round. Take up your first colour (here I used cerulean blue) and twist the colour into the background. Hold the brush at a slight angle to the paper, to allow the paint to spread. Avoid working too close to the edges for a more effective vignette.

2 Touch in your next colour on top (here I used some pale burnt sienna).

3 Continue to add in further colours; I added a light green mix of yellow ochre and French ultramarine with plenty of water (3a), and then touched in a darker, stronger green over the top (3b).

4 Apply some plastic food wrap over the top of the paint – wrinkle it as much as you like: the more creases, the more interest you will create. Allow the paint to dry naturally underneath the plastic wrap for between five and ten minutes.

5 When the paint has dried, carefully peel back the plastic wrap to reveal the textured background.

Drawing a portrait from a photograph

Capturing the likeness of a pet, or indeed any animal, can be difficult, so you may want to use a favourite photograph as the basis for your portrait. Following a few rules can make the process of sketching simple.

If you have the facility to scan and print, then printing the photo the same size as the painting makes things easier, but this isn't essential.

MEASURING WITH YOUR PENCIL

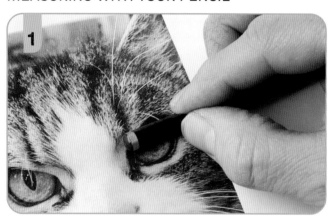

1 Using the base of your pencil and fingers, measure the length or width of the essential features of the animal, such as its eyes and nose. You should also measure the spaces between the features in the same way. If you manage to capture these features correctly, your painting will work a treat as these will be the focal points.

2 Then move this to your watercolour paper and either copy size for size, or enlarge say twice or one-and-a-half times larger. Pick one feature to start with – say, the right eye – then use this for ongoing reference throughout the sketch. So compare the width of the nose to the width of the eye and work outwards accordingly. Working like this, feature by feature, makes scaling up and getting perfect proportions so much easier. This technique is my number one trick for sketching and, of course, it works on any scene from animals to landscapes, ensuring everything is the correct size and shape.

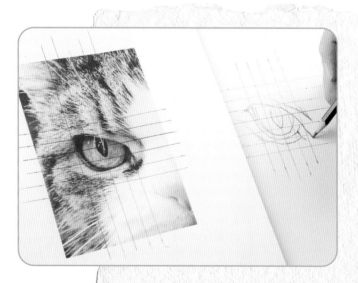

USING A GRID

A classic and fail-safe way to sketch animals – or any scene – is to use a grid system. This is especially good for artists who may struggle a bit with drawing. Print out your photograph and draw a grid over it, making the grid even, with, say 1cm (½in) spaces, horizontally and vertically. I normally draw all the vertical lines first. Repeat to create the same grid on your watercolour paper, but make the grid larger, so, 2cm (1in) – this will double the size of the animal on your sketch. Simply plot the drawing in the correct square, treating each square like a mini drawing, making the copying process easier. Use faint pencil lines on the watercolour paper so you can easily erase them. If you don't want to draw directly onto your photograph, make a grid on tracing paper or acetate using marker pen and lay this on top of your photograph.

CREATING A LINE OF SYMMETRY

1 Animal portraits tend to be very symmetrical, with the nose and mouth acting almost as a line of symmetry. So a good starting point is to draw a straight line through the centre of the nose – this can, of course, follow the angle of the head, e.g. if the cat is looking to one side, the central line will follow the bridge of the nose, on more of an angle than if the cat is facing forward.

2 The eyes of the animal portrait will be an equal distance from either side of the central line, unless the animal is looking to one side, but nine times out of ten this rule works, and both eyes need to be exactly the same shape and size, just mirrored. The white highlights also need to be in the same place on both eyes, and the pupil is nearly alway central.

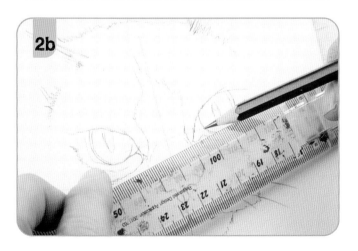

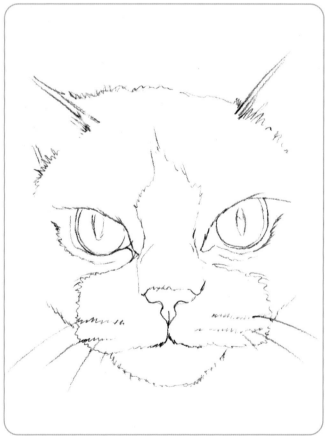

For the final drawing of Daisy the cat, use faint pencil lines to add the grid, or guideline, to allow easy removal with an eraser.

Paint colours: French ultramarine, aureolin, yellow ochre, burnt umber, alizarin crimson, opaque white

Brushes: sizes 10, 6, 4 and 2 round, 6mm (¼in) flat

Other: tracing number 17, masking fluid, kitchen paper

Alsatian

Like all healthy dogs, this alsatian has a thick coat, a wet nose and bright eyes. Take time to practise blending the characteristic light brown and dark grey fur – as the tonal difference is great – and have fun using the dry brush to create a wonderful shaggy coat… just be careful not to overdo it!

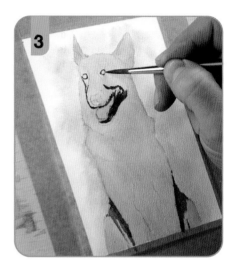

1 Mask off the dog's teeth using the size 2 brush. Wet the paper, then – with a size 10 brush – twist in some French ultramarine to create a lightly vignetted blue sky, keeping the colour nice and pale. When you get down as far as the dog's shoulders, switch to a green mix (70 per cent aureolin and 30 per cent French ultramarine) to cover the rest of the vignetted background.

2 Create a tan mix (80 per cent yellow ochre and 20 per cent burnt umber), then work over the majority of the dog, including the ears. If the size 10 is too large, change to a smaller brush. Mix up a rusty mix (60 per cent burnt umber and 40 per cent yellow ochre); paint this inside the ears and down the edges, working into the dog's head. Add this same colour down the left-hand side, letting it blend into the background. Touch it in around the collar, up the brow of the nose and into the forehead. With a size 6 round brush, take a pink mix (70 per cent alizarin crimson and 30 per cent yellow ochre) and paint in the tongue. Don't allow the colour to spread too much into the surrounding colour – tap the brush on kitchen paper first to prevent this.

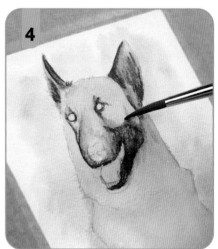

3 Still using the size 6 brush, mix up a strong grey (60 per cent French ultramarine, 30 per cent yellow ochre and 10 per cent alizarin crimson). Add darkness to the inner edges of the dog's legs (these are markings, not shadows). Carefully touch in the colour around the mouth, jaw and muzzle. Outline and add dark touches around the eyes.

4 Add the same dark grey to the top edges and insides of the ears, then blend in the dark tones all over the face with a clean, damp brush; blend the grey around the nose, mouth and eyes, keeping the eyes light. Spend a good amount of time blending in the dark grey. Allow to dry fully.

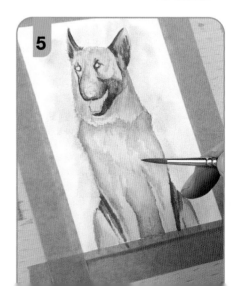

5 Use a brown-grey (70 per cent burnt umber and 30 per cent French ultramarine) to put in shadows between the front legs. Also add this colour to the outside of the back legs and slightly up the edge of the left and right sides. Add a textured, uneven line below the neck where the collar will sit. Clean your brush and soften all these areas in. Add more of the brown-grey down each side of the dog's head and body, and underneath the light part of the mouth. Use a dry brush to add texture: flick in dog fur to mould the shape of the head and give character to his body. Work around the eyes and the ears in the same way to indicate fur texture.

6 Remove the masking fluid. Use a size 4 brush and a dilute, pale grey to strengthen the shadow areas in the dog's body, starting with a dark base to the belly to make the legs stand out. Add a little muscle shape as you work higher up; clean the brush and soften the colour up into the body. Darken the fur at the collar, then soften it down and put in extra shadow under the mouth, working on the neck, making sure the mouth stands forward. Add flicks of paint for shadows on top of the nose, working up the head and making a feature of the muzzle. Use this pale grey to add a lot of little hair-like flicks on the body; the more you put in, the more life your dog will have.

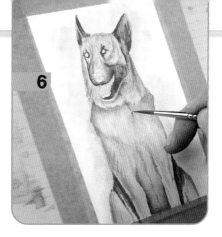

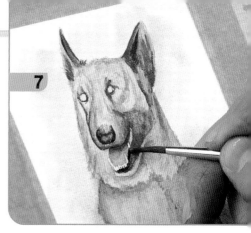

7 With the pink mix from step 2, darken the left edge of the tongue, working down to the teeth. At the back of the tongue, add some grey to darken the pink, then soften the two colours together, making sure the inside of the mouth is quite strong and dark – soften the grey down to the tip of the tongue. Use the same dark grey to add darkness to the inside of the right-hand ear and to darken the nose. Start by working an outline to the nose, with a thin line tapering off on either side. Soften the darkness inside the ear and fill in the nose area. Use the same dark grey around the nostrils and the eyes, making sure that the surrounds to the eyes are very dark. Add a thin dark line next to the teeth to sharpen them up. Touch in a few dark spots around the jowls. Add in a few random flicks to represent the fur around the mouth. Allow to dry.

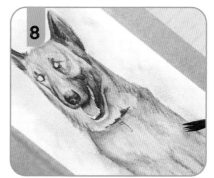

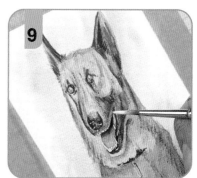

8 Use a strong dark grey with a dry brush and scuff the surface of the paper to strengthen the dark markings around the mouth, at the base of the ears, across the body and on top of the head – be careful not overdo it though, or the dog will look dirty! Add in a hint of a collar and the outline of a simple tag.

9 Use pale burnt umber for the eyes: touch in a C-shape to start with, then soften to the right. Allow the paint to soak in a little, then pick up strong grey and apply the pupils, also as C-shapes. While the eyes are drying, use your flat brush to lift out some highlights: start around the mouth area to emphasize the gums so that they stand forward against the dark inside of the mouth. Lift out a few highlights along the edges of ears, on the inside edges of the front legs to help them stand forward, and a few across the body. Use a clean brush and water to lift out a highlight over the top of each eye. Take the white paint on the size 2 brush and, without adding too much water, add highlights to the eyes: add a tiny spot in the corner of each pupil, and a delicate curved line under the dark eye surround as well to give extra life. Whiten the teeth if you want and then add light touches around the nostrils. Highlight the gums, using very delicate white spots, and around the lower teeth, plus add a little shine to the dog tag. As a finishing touch, use strong grey to add any final spots or flicks to the fur.

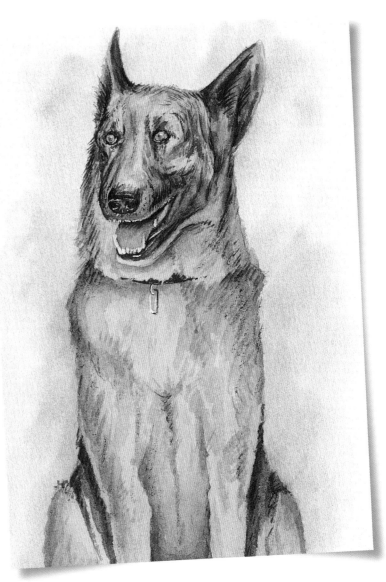

YOU WILL NEED

Paint colours: aureolin, French ultramarine, alizarin crimson, yellow ochre, opaque white

Brushes: sizes 10, 6, 4 and 2 round, an old brush for masking fluid, 6mm (¼in) or 12mm (½in) flat

Other: tracing number 18, masking fluid

Rabbit

Here we need to capture the shape and form of the rabbit's fur and whiskers, as well as its glossy eye. We will use a combination of masking fluid and touches of opaque white to make the pale colour of the rabbit really stand out against the background. The key thing here is to ensure that you really blend in your pinks and greys to take away the harshness of the white paper and give just a suggestion of soft colour.

1 With masking fluid, create a soft, 6mm (¼in) wide outline all around the inside edge of the rabbit to protect the face from the background paint. Use a size 2 brush to mask off the whiskers around the nose and mouth, and above the eyes. Make little flicks with the masking fluid to emphasize the hairy edge of the fur. Allow to dry. Wet the background with the size 10, right up to the masking fluid. Working fairly quickly with a strong, thick aureolin, put in a few spots across the background to represent out-of-focus yellow flowers. Then go straight in with a light green (70 per cent aureolin and 30 per cent French ultramarine); don't worry about cleaning your brush. Touch in the green around the yellow, being careful not to go within the masking-fluid edge. Either fill the paper or work it into a vignette.

2 Mix a strong dark green (50 per cent aureolin and 50 per cent French ultramarine) and touch plenty in around the edges of the rabbit: this will make the rabbit stand forward. It will start out looking like a halo then will spread and soften. Put some into the corners of the paper. Use a clean, damp brush to twist the colours together. Without cleaning your brush, create a dark grey mix (60 per cent French ultramarine, 30 per cent yellow ochre and 10 per cent alizarin crimson) and put some darkness into the background near the whiskers. Clean and dry the brush, then soften the grey into the surrounding green.

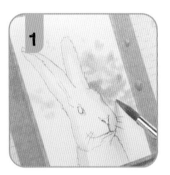
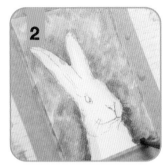
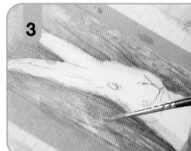

3 Take up the size 2 brush and strong dark green, and add some tall grasses in the background – the rabbit should be nestled in the grass. Use plenty of dark green shades to help the rabbit stand forward. Spot in some more really strong yellows to add some extra interest to the background. Use the aureolin almost straight from the tube. Allow to dry.

4 Remove the masking fluid. In the background, lift out a few lighter grasses using a flat brush to give additional layers of texture. Create a pink mix (60 alizarin crimson and 40 per cent yellow ochre) and start by adding a hint of this colour to the left-hand edges of the ears. Use a clean brush to soften and smooth this down into the white to create a sliver of colour. Using the same pink, paint in the nose and add a tiny bit across the mouth and around the eye, then soften the pink back into the white. Once dry, put a second coat over the nose and the bottom corner of the outer eye. With the tip of the brush, add a vein-like structure to the inside of the left-hand ear. Allow to dry.

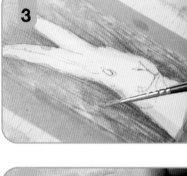

5 Create a pale peachy mix (90 per cent yellow ochre and 10 per cent alizarin crimson) and use the size 6 round brush to work it under the mouth towards the neck and across the top of the head over the eye, then add a little into the ears. Soften these areas with a damp brush until they almost disappear, leaving just enough colour against the harsh white. Allow to dry. Next we need to create some shadows using a warm grey (50 per cent French ultramarine, 40 per cent yellow ochre and 10 per cent alizarin crimson). Touch in some grey at the base of the left side of the right-hand ear to separate the ears – soften it upwards and over the pink. Working upwards from the eye, apply the grey to the inside of the left-hand ear. Soften the paint towards the bottom of the ear where it meets the head so it blends to nothing; any hard edges can be softened with diagonal flicks. Touch in the grey under the mouth and around the jowls and cheeks; blend completely away down to the left. Across and down the left-hand side of the chest, paint in some diagonal lines of darkness. Use plenty of water to spread the colour down. When the left-hand ear is dry, darken it slightly on the inside and then soften away.

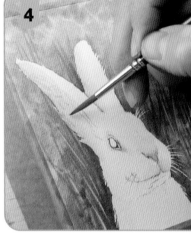

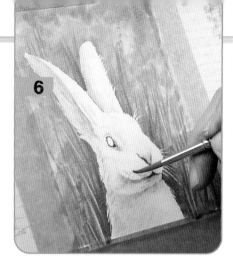

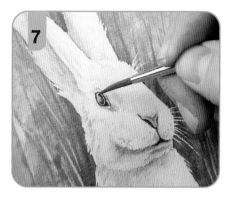

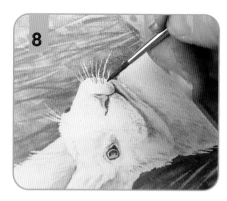

6 Change to the size 4 brush and pick up the strong grey again. Paint this inside the nostrils, rotating the board if you need to. Find the line that joins the nose to the mouth then continue this down and to each side to create the 'lip' of the rabbit. Clean and dry the brush, then feather the paint away into the white fur; soften the lip down, and the nostrils out to each side. Use the same grey to put in a dark surround to the eye, over the pink and following the shape pointing down towards the bottom corner. Gently feather the edge so the harsh line outside the eye feathers away but stays sharp on the inside of the eye. Using the size 6 round brush and the warm grey from step 5, add some shadow to the underneath of the chin then soften it down. Use the colour to put in the texture of fur as flicks around some of the facial features. Go up into the ears and all over the face – anywhere you think it is needed to mould the shape of the head. Add little spots around the mouth area.

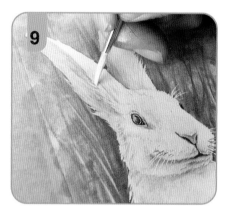

7 Pick up the strong grey again on the size 4 brush. The nose needs a little V-shape of the grey to make it look sharper. Add a tiny shadow halfway between the mouth and the neck to make the lips stand out. Clean and dry the brush, then soften the paint. Paint in the left-hand eye as a backward C-shape, leaving a thin light line between it and the surround. Rabbits' eyes have a pinky red tinge (especially white rabbits), so add a tiny hint of pink to the left-hand side of the eye, darkening it with red if you need to, and allowing it to blend with the grey. Touch in the very edge of the other eye.

8 Using a fine size 2 brush and strong grey, wipe off the excess then paint in the whiskers where they cross the face; use very fine, delicate flicks on both sides.

9 Clean the size 2 brush, then use the opaque white to touch in some highlights on the eye to make it shiny. Add a tiny dot on the tear duct and some delicate strokes on the tip of the nose. Rotate the board and flick in some white whiskers to the left of the rabbit's face. Add a touch of white to the bottom lip to make it stand forward, and add some nice long hairs to the inside of the ears. Spend some time adding in further white details: you might want to add a few more hairs sticking out over the green, and some little white dots around the muzzle.

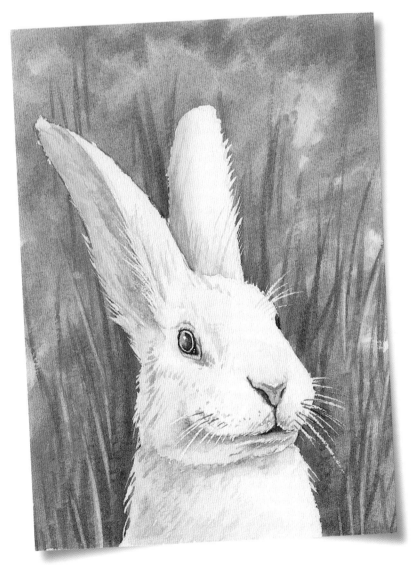

Chimpanzee

I felt that this majestic chimpanzee needed no background. In fact, leaving the paper blank helps when you want to create a vignetted effect with the animal's fur – as here, with the hair at the neck and chest. Take your time creating long, tapering hairs, adding dry-brush texture, and lifting out and adding in highlights. All these finer details will help to bring your chimpanzee painting to life.

1 Create a pink mix (50 per cent alizarin crimson and 50 per cent yellow ochre) and use the size 10 brush to apply it to the ears and face, avoiding the eye areas and the teeth. Add some of the colour around the chest area. Clean and wipe the brush, then scrub the colour so it blends and disappears into the hair, eyes and teeth: work it in to create a nice, base background. It will take some scrubbing, as the red will stain the paper. If you need to, pick up more of the colour and spread it around, making sure you haven't missed any areas around the chin.

2 While the paint is still wet, work in a tan mix (60 per cent yellow ochre and 40 per cent French ultramarine) using a size 6 round brush; follow the contours of the eye sockets, paint over both ears, and down either side of the muzzle. Soften the paint with a clean, damp brush. Using a very pale pink (90 per cent alizarin crimson and 10 per cent yellow ochre), deepen the colour on the lips and inside the ears. Put in two C-shapes for the eyes using the tan mix. Soften the eye colour, then leave to dry.

3 Put in the dark hair next, in strong grey (60 per cent French ultramarine, 30 per cent yellow ochre and 10 per cent alizarin crimson). Work around the edge of the face, creating a clean line and being careful around the ears. Apply the hair in long strokes and then flick away the ends. Clean and wipe the brush, then soften down the hair at the bottom to help with the portrait effect. Dilute the grey slightly then take your time putting in individual strands of hair around the neck and shoulders.

4 Glaze over the tops of the hairs to bed them in. Where the dark hair meets the cheeks/muzzle, soften the surrounding grey; drag a small amount up onto the face, then soften the edges while following the contours. Repeat at the centre top of the head to soften some of the colour down.

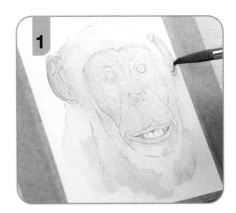

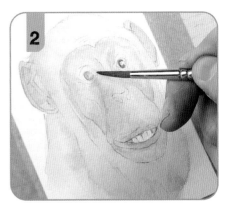

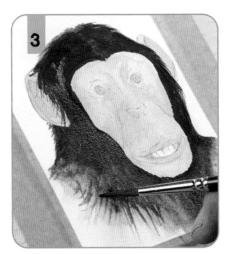

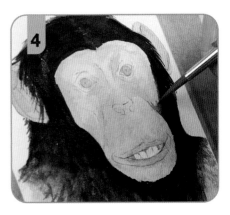

5 Use a darker pink mix (40 per cent alizarin crimson, 50 per cent yellow ochre and 10 per cent French ultramarine) for the facial features and to give structure to the face. Work around the sides of the muzzle, at the sides of the nose and up round the eye sockets; scrub the paint in to make sure it blends. Take the colour over the cheeks and above the mouth then soften in. Add more above the top lip and on the top edge of the bottom lip; soften in. You'll see the character starting to come through. Work inside the ear in the same colour, leaving the outer edge pale, then blend down. Allow to dry.

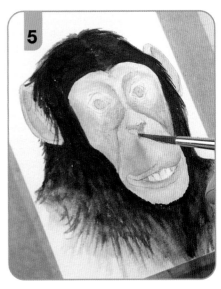

6 Lift out highlights using the flat brush: follow the shape of the hair around the head; define and lift out strands across the top, at the sides of the face and down into the neck. Create a dilute grey, then darken the eye sockets, leaving plenty of light around the eyes still, then soften out. Use this same colour to 'mould' the face with further areas of shadow – below the cheekbones and around the muzzle and brow bones. Paint in some dark grey under the mouth and to the left-hand side, to accentuate the bottom lip; also add some dark grey to the inside edges of the ears, then soften with water.

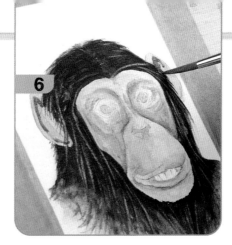
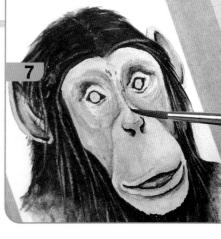

7 Add lots of thin grey lines to give wrinkles and character to the face – especially around the eyes. Touch in the nostrils with very dark grey, then add some inside the mouth, above the teeth. Soften the grey out of the nostrils and down over the teeth. Next apply this same colour under the bottom lip to make it stand forward. Clean and wipe the brush, then soften the paint down. Use the same strong dark around the eyes, following the round shape but making it pointed at both sides. Add in a few dark lines going around each eye above the lid. Put further darks inside the top and bottom of each ear to indicate its shape, then gently soften the areas of darkness around the eyes and in the ears. Add dry dark grey markings here and there around the nose and central part of the face.

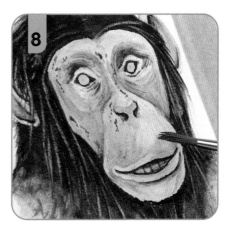
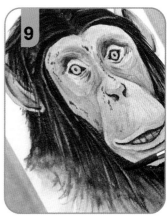

8 Use the dark grey to add very thin lines between the teeth. Dilute to a pale grey, then use this to darken the area above the top lip, then soften back into the face. Use a strong grey and a dry brush to add further wrinkles around the eyes. Take the tan mix on a splayed dry brush and tickle the surface of the paper to give shape and form, following the contours of the face. The key here is to have very little paint on the brush and to lightly skim the paper surface.

9 Paint the pupils with very dark grey, creating a C-shape in each eye, then darken around the irises. With a clean, damp brush, soften the pupils to complete the dark circles. While the brush is almost dry, tickle it around the eyes to soften the dark edges and give more character. Mix some burnt umber with the strong grey and add darker shadows between some of the hairs – this will give a real sense of depth to the hair. Add extra hairs here and there, including behind the ears, and extend the ends of the hairs if need be, to taper them off sharply.

10 Using the size 2 brush and water, lift out a tiny highlight in the centre of each eye. Finally, add a touch of opaque white paint wherever there is a highlight: put in some fine whiskers on the chin, add a highlight on each pupil and add a spot in the corner of the tear ducts. Touch in a few spots at the tip of the nose and on the lips to give more shine. Finish with some fine whiskers and some fine white hairs mingled in at the top of the head, coming away from the centre parting. (Refer to the finished painting.)

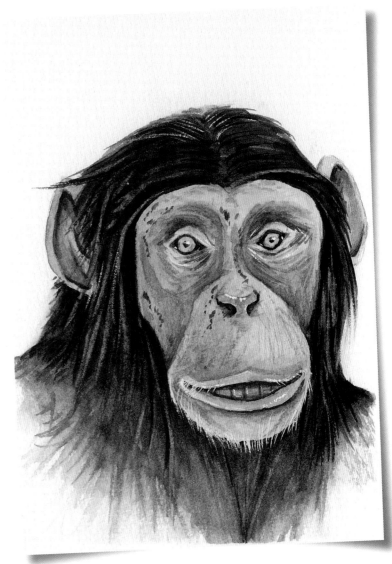

Meerkat on guard

Concentrate here on adding in fine fur detail – too much will look unrealistic, so try to keep the lines fine and tapering, using quick flicking motions with your brush. Practise beforehand on a scrap piece of paper if you're nervous.

1 Use the size 10 brush to wet the paper. Create a pale sandy mix (90 per cent yellow ochre and 10 per cent burnt umber) and paint a vignette-style background (not all the way to the edges), using a twisting stroke. Once this has been applied, make the mix stronger, and after you have picked up the paint on your brush, tap away excess paint on kitchen paper. Carefully paint around the edges of the animal first before blending in to the centre with a clean, damp brush. Try to leave a lighter area around the mouth and nose. With a rolled-up piece of kitchen paper, remove highlights from the month and neck – this will only work while the background is damp. If the paint is too dry, use a damp 6mm (¼in) flat brush to lift out the paint (see page 15). Allow to dry.

2 Using a brown mix (80 per cent burnt umber and 20 per cent French ultramarine) and a size 6 round brush, give a spiky, fur-like outline to the meerkat. It helps if you slightly flatten your brush and splay the hairs a touch. This outline wants to be quite wide so once the fur edge is created, use normal brushstrokes to paint a wider area, about 1cm (½in) wide, within the outline of the meerkat, working towards the centre. Quickly, and with a clean, damp brush, blend towards the centre. This needs to be a smooth blend so keep going until the paint completely disappears; keep refreshing the brush as you work. Fade away to the bottom to continue the vignetted effect. Allow to dry.

3 Using the same colour and brush, paint a shadow under the chin, about 1cm (½in) deep. It's important to blend this in, just as in the previous step.

4 Again, using the same brush and colour, paint around the eyes – make the marks nice and wide, then blend away, being careful not to paint too much into the nose area.

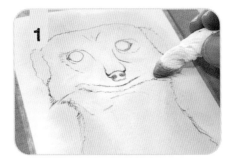
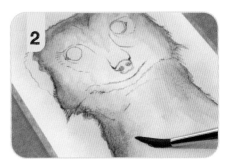
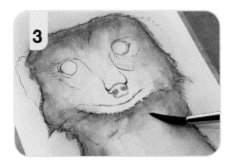
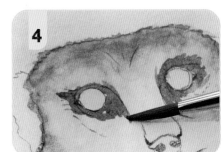

5 With the same colour and brush, paint along the sides of the nose and blend back towards the top of the head then leave to dry. Create a slightly stronger, browner mix of the sandy colour (70 per cent yellow ochre and 30 per cent burnt umber). Pick up the paint on the size 6 round brush, tap off the excess, then splay the bristles and paint in textured dry brushstrokes using the side of the brush. Use the dry strokes wisely, following the shape of the meerkat. Work down the left and right sides of the neck, and try to add shadowed areas to the fur. Paint extra texture at the edges, applying a little pressure with the tip of the splayed brush – this helps to create realistic fur. Add in extra fur anywhere you feel it is needed.

6 Using this same colour and a size 2 brush, paint in lots of small hairs, again following the shape and contour of the meerkat, under the chin, around the eyes, down the sides and anywhere you feel needs texture. Be quick and spontaneous with your brushstrokes to give life to your meerkat.

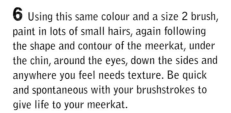
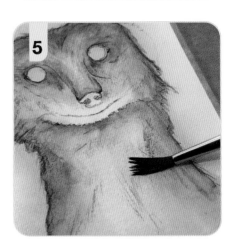
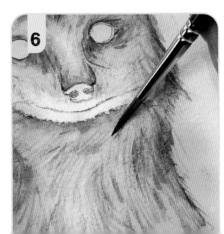

7 The dark markings on a meerkat are distinctive. Mix a strong grey mix (60 per cent French ultramarine and 40 per cent burnt umber). Using either the size 6 or size 2 brush, paint a wide 6mm (¼in) outline around the eyes, carefully painting down next to the nose, making the paint wider in this area. With a clean, almost dry brush (wiped on kitchen paper), lightly feather this paint into the head; avoid feathering too much away over the nose – try to keep a clean line next to the nose, especially on the left-hand side.

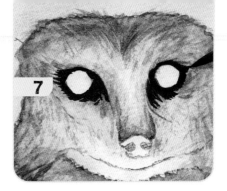
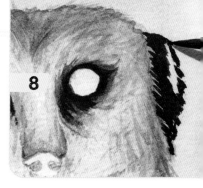

8 Using the same colour and brush, paint the dark ears. Brush the paint to the head, like a grassy edge – this gives the feeling of the lighter head fur meeting the dark ears. Repeat on both sides. Allow to dry.

9 Gently feather the 'grassy edge' to the light fur of the head. Use the dark colour and size 2 brush to paint some fine spiky hairs from the outsides of the ears.

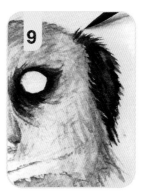
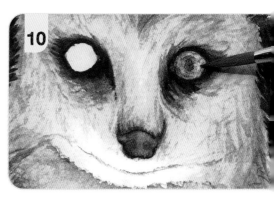

10 Outline the wet nose using the same strong dark, then blend into the centre with the brown mix (70 per cent yellow ochre and 30 per cent burnt umber), ensuring this colour isn't too strong. With the size 2 brush, lightly feather the top of the nose towards the snout. Once all is dry, mix a colour for the eyes (80 per cent burnt sienna and 20 per cent French ultramarine). With a pale wash, simply paint the entire right eye, then quickly pick up the strong grey and spot in the pupil – keep the paint strong and make sure the background paint is still damp to allow the dark to spread. To tidy this up, clean and dry your size 2, then feather the edge of the dark pupil, ensuring it stays round. Repeat for the left eye, then allow to dry.

11 With the strong grey and the size 2 brush, paint in the mouth, then feather down and slightly away at the edges. Paint the strong grey inside the nostrils, then take this slightly up the left and right sides of the nose, again feathering outwards. To paint a few spots between the nose and mouth, dampen the area first with the size 6 round brush then spot in the strong grey with the size 2 brush; allow the paint to spread slightly. Once dry, paint dark whiskers from these spots: with a slightly dryer brush and the strong grey, paint them in quickly for a tapered effect, using the fine tip of the brush. Don't forget the whiskers above the eyes. Use this same brush and dry colour to paint in more fur markings: paint in the dark hairs that form the triangular detail on the top of the head, the dark lines in the neck area and lots of random textured lines on the head.

Use the 6mm (¼in) flat brush to lift out a horizontal highlight across the right-hand side of each eye: use the brush damp and scrub, with the tip flat, then dab off with kitchen paper. Lift out further highlights across the fur, wherever you feel they are needed. Use the size 2 brush and strong opaque white to paint a few white hairs around the ears and mouth, especially overlapping the dark mouth on the upper lip and bottom of the chin. Paint the tiny highlights in the eyes (two spots on each eye), matching the position on both eyes. Paint some fine lines around the edges of the eyes and a few lines in the tear ducts. Adding a few spots of opaque white to the nose, will give a moist look. Finally, add any random white hairs you feel will work. (Refer to the finished painting.)

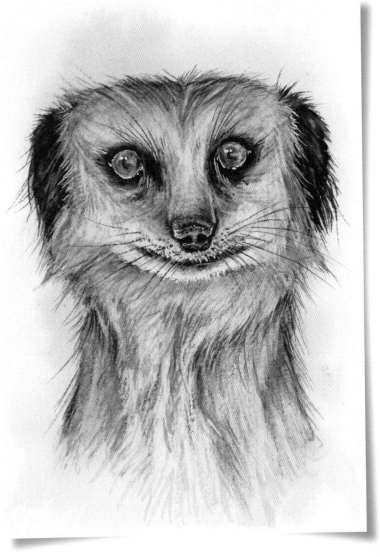

ANIMALS IN THE LANDSCAPE

When painting landscapes I will often add animals to the scene, as they add a great sense of context, scale and detail. It might be a sheep in a field or a bird on a fence; it could be as small as a bird flying in the sky, or as detailed as a stag walking through a woodland. If smaller animals are to be added to your landscapes, add them towards the end of the painting. A larger animal, like a stag in a woodland scene, would likely be the focal point of the painting so would be introduced from the beginning. This section of the book will guide you through adding animals to their natural habitats to create interesting and believable paintings. For three of the following paintings (pages 84–89), I have separated the instructions for the background and animal so you can choose whether to include the background or not.

Flamingos
27 x 36cm (10½ x 14in)

Small Copper Butterfly on Flowers
42 x 32cm (16½ x 12½in)

In these two examples, the butterfly (below), and flamingos (opposite), are very clearly the focal points of the paintings, even though in reality they take up very little space on the painting as a whole. Don't be afraid to play with the balance of animal and landscape if you feel it adds to the story, mood or atmosphere of the painting.

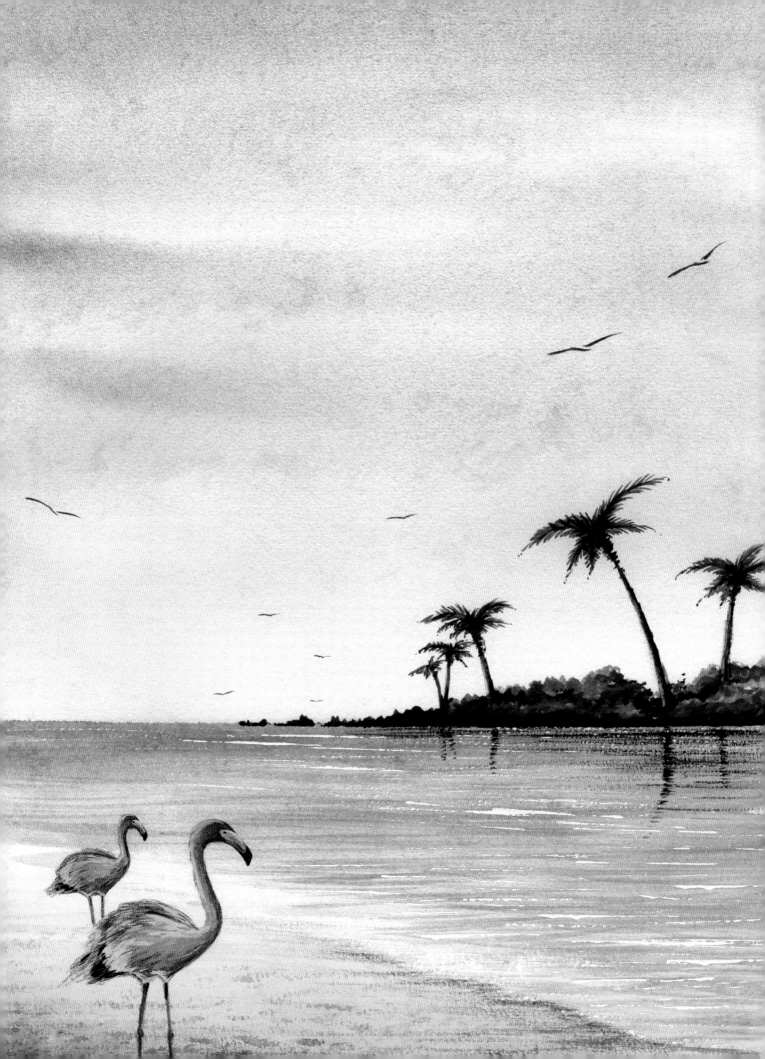

YOU WILL NEED

Paint colours: grey in three shades from 60 per cent French ultramarine, 30 per cent yellow ochre and 10 per cent alizarin crimson – vary the amount of water in each mix

Brushes: sizes 10, 6, 4 and 2 round, 6mm (¼in) flat brush

Other: tracing number 21, small coin, kitchen paper

Cat on the lookout

In this first project with a landscape setting, we'll keep it simple by using a monochrome palette and an animal silhouette. Play close attention to the highlights and shadows here, to ensure you achieve a good range of tones.

1 Wet the whole paper with clean water and a size 10 brush. Sweep in the greys, starting with the lightest grey and working up to the darkest grey, working in diagonal strokes. Don't fill the whole paper – create a vignetted effect and work over the top of the cat and the stone wall. Put in a few flicks of medium grey in the foreground behind the fence to represent misty, out-of-focus grasses.

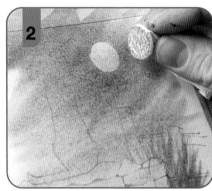

2 Wrap the coin in kitchen paper and stamp out a moon from the damp dark grey (see page 9).

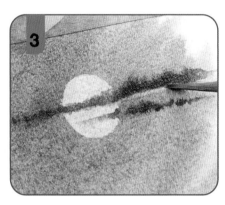

3 With strong grey on a size 6 round brush, twist in a few horizontal clouds over the top of the moon and allow the colour to spread into the background. With a clean, damp brush, soften the ends of the clouds to taper them away. Soften any sharp lines in the clouds and lift out some of the darker colour underneath the clouds with a flattened brush.

4 With the dark grey and size 6 round brush, flick in some tall grasses in the foregound; dot in some fine detail on the grasses with the brush tip, and overlap the misty grasses from step 1. Allow the painting to dry.

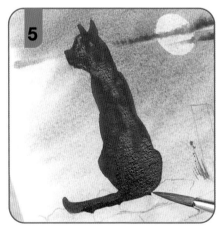

5 Block in the body of the cat in a solid dark shape with the strongest grey. At the base of its body, mould the grey into the shape of the stones at the top of the wall.

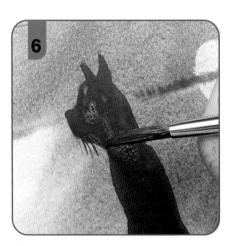

6 Put in the whiskers using a much smaller brush – either a size 2 or 4 round.

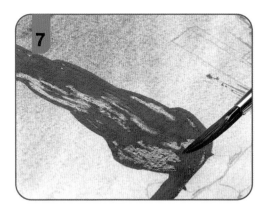

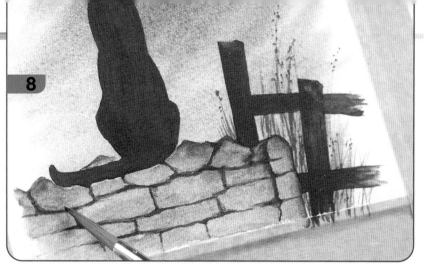

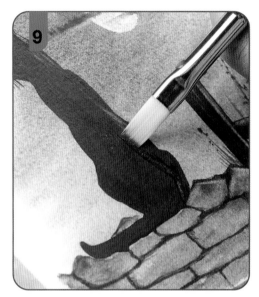

7 Strengthen the grey further. With the size 4 brush, put in a few flicks of strong dark grey to accentuate the contours of the cat's body. Allow to dry.

8 With the size 6 brush and the medium grey mix, paint a line around the edge of the stone wall and then dot some texture all over. Then clean and dampen the brush and use the water to spread the colour into the wall. Avoid darkening the area directly under the cat as its bottom and tail will shape the wall in that area. Again, allow to dry. Use dark grey to block in the fenceposts in a solid colour then wipe away or soften the edges to give them a more rugged appearance. With a darker grey, add shape to the fenceposts then put in dark areas between the stones. These can be softened into the bodies of the stones themselves.

9 Using the flat brush, dampened, lift out highlights on the right-hand side of the cat's body where the moonlight will catch it. You can also lift out highlights on its left-hand side to suggest muscular structure, but keep the focus on the right. Lift out the highlights by blotting the areas with kitchen paper, then add a final highlight to the cat on its tail, to extend it to the centre of the animal's back. Finally, lift out highlights on the fenceposts and add further dark tones next to the highlights to emphasize them further (refer to the finished painting below for details).

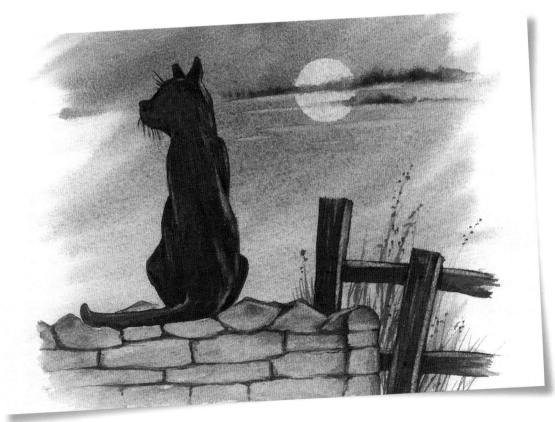

YOU WILL NEED

Paint colours: French ultramarine, aureolin, yellow ochre, alizarin crimson, viridian hue

Brushes: old brush for masking fluid, sizes 10 and 6 round brushes, 6mm (¼in) flat brush

Other: tracing number 22, masking fluid, kitchen paper

Sheep in a field

These three sheep, in varying sizes, give this scene its depth and sense of distance. In order to preserve the white colour of their fluffy coats, use masking fluid to protect the paper.

1 Using the masking fluid and old brush, mask out all three sheep and a few spots of foliage in the bottom left-hand corner. Run a line of masking fluid along the top edge of the hill against the horizon. Allow the masking fluid to dry completely.

2 Wet the sky area with clean water, then use the size 10 round brush to touch in French ultramarine at the top and aureolin at the bottom; use sweeping, diagonal strokes and allow the colours to blend gently.

3 To create a soft treeline, work while the sky is still damp. Use the size 6 round brush and a light green mix (70 per cent aureolin and 30 per cent French ultramarine); twist the brush across the background to create the trees, working tight to the masking fluid line. Rotate the brush as you work, making larger twists towards the right-hand side. Without cleaning the brush, apply a loose line of darker green at the bottom of the trees to create the undergrowth (use a mix of 50 per cent aureolin and 50 per cent French ultramarine).

4 With the same dark green mix, use the tip of the brush to create some larger trees; spot or tap the brush to create individual leaves. Spend time playing with the shapes but try not to be precise with them. Pick up a tiny bit of medium grey (mixed from 60 per cent French ultramarine, 30 per cent yellow ochre and 10 per cent alizarin crimson). Use the same twisting motion at the base of the trees to ground them. This will make the meadow stand forward. The background will be almost dry now. Taking the dark green mix again, paint in the tall fir tree with a straight line first, then with concave lines work upwards using the central line as a line of symmetry. Gradually make the lines shorter as you move upwards. Allow to dry.

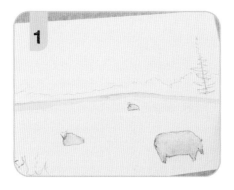

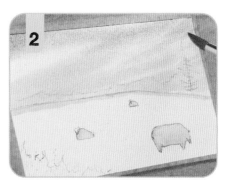

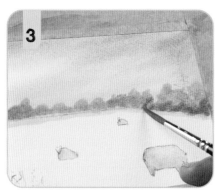

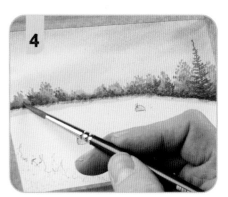

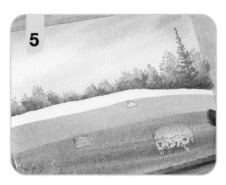

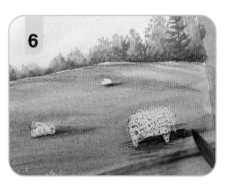

5 Remove the masking fluid from the treeline. Using the size 10 brush and lighter green mix, and starting a little way below the treeline, work across and down the meadow. When you reach the bottom third, change to the darker green and blend it in with the lighter green; run the greens of the field all the way over the top of the masked sheep.

6 Clean the brush, wipe off any excess moisture, then soften the green edge up to the treeline to lighten it; don't leave any white showing. Smooth the area in. Use the darker green to apply tree shadows over the brow of the hill in a downward diagonal direction. Pick up a strong dark grey (use a stronger mix of the grey used in step 4, with a touch of viridian hue). Run in fine shadows from the bases of the sheep; these should match the directions of the shadows from the trees. With a clean, dry brush, encourage the shadows to 'disappear' to the right of the painting.

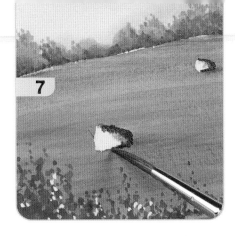

7 Using the size 6 brush and a strong green, add the foreground foliage simply by spotting the colour over the top of the masked-off flowers. Add a lighter green to add life to the tops of the plants; allow the colours to mix on the paper. Repeat in the bottom-right corner and along the base of the painting. Once the paint has dried, rub away the masking fluid. Add some texture to the meadow using the dry-brush technique (see page 13): with the light green, lightly stroke over the meadow for texture – keep splaying the brush hairs as they will come back together. Allow the paint to dry. Remove the masking fluid from the sheep. With the strong grey, add shadows to the right-hand sides of the two distant sheep. With a clean, damp brush, drag the shadow across the fleece of each sheep to soften it. As your brush picks up the grey from the shadowed areas, spot some texture over the white fleeces.

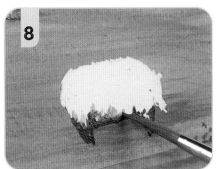

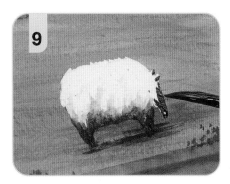

8 With the same grey, darken the legs of the foremost sheep, then work in the underbelly. Soften the shadow upwards in a stippling motion with the brush tip. Keep cleaning your brush so that the grey doesn't spread too far; gently tap the colour in around the white areas. Pull out more shadow along the base of the sheep in a horizontal motion to 'sit' the animal on the grass.

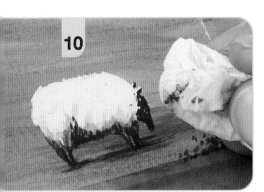

9 Use the dark grey to add heads to the distant sheep – these should be almost triangular in shape. The head of the foremost sheep should be even darker and should look as if it is pointing towards the ground. Add in tiny flicks at the top of the head for ears, then darken the legs so they almost disappear into the grass. With the same grey, touch in some horizontal flicks at the base of the trees on the right-hand side. Add a few spots at the base of the trees to give them depth; also add some fine branches and a few darker spots around the foliage in the foreground.

10 With a clean, damp brush, tap water over the heads of the sheep, then, with kitchen paper, lift off highlights. To finish, do the same to put back a little light on the legs of the foreground sheep to help it stand forward: less is more.

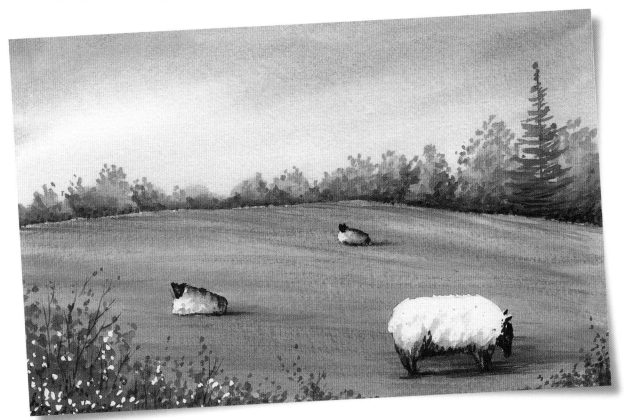

YOU WILL NEED

Paint colours: yellow ochre, French ultramarine, viridian hue, burnt umber, alizarin crimson, rose madder, burnt sienna

Brushes: sizes 10, 6 and 4 round, 6mm (¼in) flat brush

Other: tracing number 23, plastic card, kitchen paper

Flamingos paddling

This colourful scene allows you to practise painting these lovely birds in water – capturing their colourful reflections 'grounds' them in their habitat and brings the painting to life.

1 Wet the entire sheet of paper with the size 10 brush. Lay in yellow ochre over the base of the sky. Clean the brush, then run the French ultramarine from the top down into the yellow, and across the top half of the sea in horizontal strokes. Create a turquoise mix of 70 per cent French ultramarine and 30 per cent viridian hue, then run it in across the lower half of the sea.

2 Use kitchen paper to lift out the turquoise from the bodies of the birds. Make a strong sandy mix from 80 per cent yellow ochre and 20 per cent burnt umber, load some onto the size 6 brush, tap off the excess and, in horizontal lines, paint in the distant beach to help it 'step'. Do the same in the foreground, working from left to right. Clean the brush; on the edges of the foreground beach, extend the sand so it almost disappears into the sea. Add a tiny bit of blue to the sand mix to make it grey, then darken the bottom corner of the beach in flicks from left to right. Darken the sand in the distance along the base of the cliff. Finally, flick the plastic card across the foreground beach to create the illusion of pebbles and shells. Allow to dry.

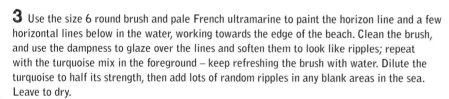

3 Use the size 6 round brush and pale French ultramarine to paint the horizon line and a few horizontal lines below in the water, working towards the edge of the beach. Clean the brush, and use the dampness to glaze over the lines and soften them to look like ripples; repeat with the turquoise mix in the foreground – keep refreshing the brush with water. Dilute the turquoise to half its strength, then add lots of random ripples in any blank areas in the sea. Leave to dry.

4 Use a pale natural grey (a mix of equal parts French ultramarine, yellow ochre and alizarin crimson) to outline the left-hand cliff, about halfway down to the sea. Use water to fade the colour the rest of the way down. Strengthen the mix. When this cliff is almost dry, paint in the second cliff in the same way. Pick up some yellow ochre and put a few drops in to warm the cliffside. Allow to dry. Use a stronger grey for the final cliff, and take it about a third of the way down. Use a pale yellow ochre to fade the grey down towards the beach. While damp, add a touch of burnt umber to the yellow ochre and add a few drops at the base where the cliff meets the beach. Add a few hints of grey following the diagonal contours of the cliffs. Allow to dry.

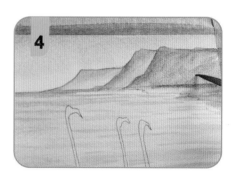

5 Use the same grey to paint in the breaking waves furthest to the left, following the pencil line; S-shapes create the illusion of water. Use water to fade the line over to the right. The 'points' of the 'S's need to be softened to the left. Allow to dry, then run in the second set of ripples in the same way, closer to the shore. With the same grey, put in a few foreground ripples around the birds' feet to lift the foreground and add interest. Put in a few lines over the waves. Use a slightly stronger grey just to add a few spots of detail to the sand.

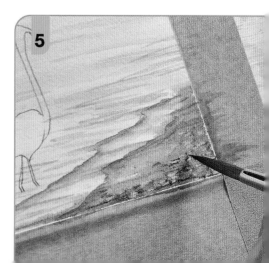

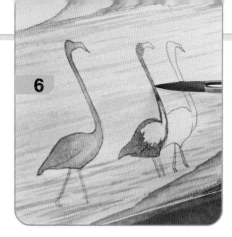

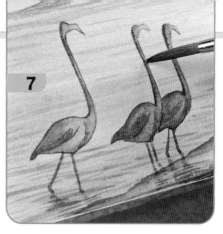

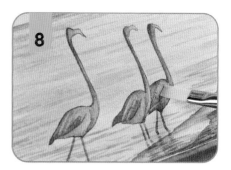

6 Create a pink mix from 90 per cent rose madder and 10 per cent burnt sienna; outline the first bird from its head down to its tail. Apply the paint more fully on the back wing, then use a clean brush to soften the colour over the rest of the body, towards the beak and up the neck. Pick up a little yellow ochre and rose madder and add a flash of colour down the side of the wing. Apply the pink to the underbelly and across the back of the wing. Paint the other two birds in the same way.

7 Use the pink mix to paint in the legs. Add reflections with the pink mix using horizontal brushstrokes in the water underneath each bird. With a darker version of the same mix, darken the bottom edges of the wings on all three birds. Clean your brush, then soften the colour upwards. Use the same colour to add some darker tones to the underbelly; soften up towards the head. As the light is coming from the right, add a darker line to the back of the neck and across the top of the head. Soften the line so it fades into the neck. Allow to dry.

8 Put in a few highlights around the background cliffs with the damp flat brush; scrub the paint away following the shape of the cliffs, then dab with kitchen paper to reveal the light. Add some horizontal highlights in the sea close to the shore. Add in some highlights to the chests of the flamingos, then lighten the edge of the middle flamingo where it touches the right-hand bird. Put in a few diagonal highlights on the wings to give a little interest and shape.

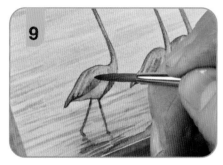

9 Using the size 4 brush, paint in the dark tips of the beaks with a strong grey mix (60 per cent French ultramarine, 30 per cent yellow ochre and 10 per cent alizarin crimson) and add tiny dots for the eyes. Run a thin line down towards the tip of the beak. Add a little grey just to pick out the darker tips at the base of the wings. Add some grey to the top of each leg as it meets the body, slightly working it into the underbelly on the right-hand leg. Clean the brush, then soften the dark areas down. Brush in where the colour overlaps the underbelly. Using the pink mix from step 6, add V-shapes to the backs of the heads and behind the eyes. Work this mix down the neck to soften it. Finish the birds by using a mix of burnt sienna with a tiny bit of rose madder to add a few random flicks of feather detail.

10 With the dark grey mix, put in horizontal shadows underneath the two waves lapping on the shoreline and a few darker spots amongst the pebbles. On the closest cliff, add a few contour lines from the beach upwards to create more shape. With the same grey add a couple of dark flicks under the closest cliff and a few horizontal lines over the beach areas to 'ground' the sea. Apply grey dry-brush marks into the curve of each neck, and where each front leg connects to the body. (Refer to the finished painting, right.)

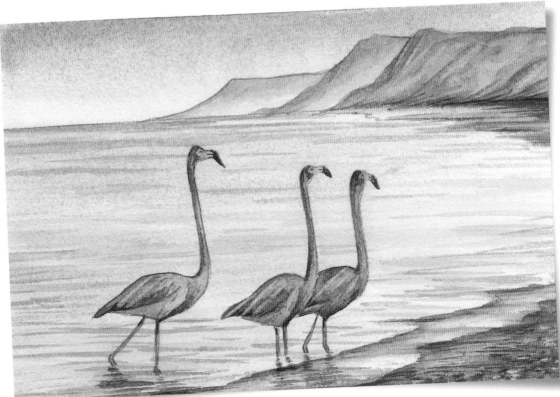

YOU WILL NEED

Paint colours: yellow ochre, aureolin, alizarin crimson, cerulean blue, French ultramarine, opaque white (optional)

Brushes: sizes 10, 6 and 2 round

Other: tracing number 24, kitchen paper

Penguins

Here our three intrepid penguins are in their cold, icy habitat. Use a cerulean blue to suggest this cold environment, and don't be afraid to add darker tones to make the ice and snow recede where it needs to. Because the penguins are quite small here, I haven't used a wax resist (as on pages 46–47) – but feel free to experiment if this is a technique that interests you.

1 Wet the entire paper with the size 10 round brush. Put a tiny bit of yellow ochre across the base of the sky on the left and also across the water – don't be afraid to go over the penguins. Use strong yellow ochre to add a touch of colour to the penguins' necks. With a strong orange mix (60 per cent aureolin and 40 per cent alizarin crimson), add a spot of colour on top of the yellow. With a paler wash of yellow ochre, add a sweep of colour down the top right of each penguin's body. Clean your brush.

2 Apply a medium wash of cerulean blue over the sky, sweeping down from the top until it fades into the yellow. Apply a wash over the foreground, too. Clean your brush, wipe it on kitchen paper, then blend the paint up to the edge of the ice. Put a few horizontal lines of cerulean blue into the water but do not go over the penguins too much.

3 Use a dry brush and a medium grey (equal parts French ultramarine, yellow ochre and alizarin crimson) to add a horizontal shadow from the feet of the penguins, sweeping to the left. Fade the shadows into the landscape after drying the brush with your fingers. Add the same grey where the top of the water meets the ice to create a nice separation. Use a dry brush and sweep horizontally until the paint fades towards the bottom of the water. Any stray colour that has crept over the penguins can be lifted out with kitchen paper. Allow to dry.

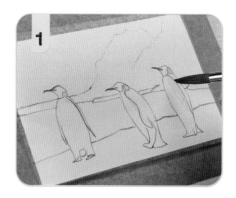

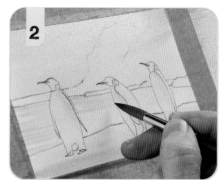

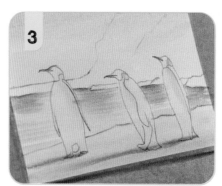

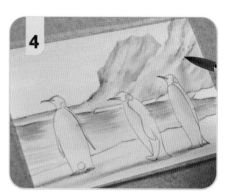

4 Use a medium cerulean blue to paint in the distant mountains on the right-hand side. Work on each individually, using your brushstrokes and bolder and blended marks to make them look craggy; again avoid the penguins. Paint the left-hand ice floe in the same way, then clean the brush on kitchen paper and use water to drag the blue downwards. With the medium grey, add a few extra shadows on the ice floe and then add some line details to the mountainous area, where the ice overlaps the sky; put in a few lines coming down towards the penguins.

5 Using a lighter grey mix, add a few strokes to the bank at the base of the mountains. Scribble and blend some areas together; a few hard lines here will give character so don't feel you have to blend all of them. Add a few areas of lighter grey for character and shadow across the mountains; use a dry brush for part of this. Use a strong cerulean blue wash along the top edge of the foreground area. Clean the brush, then soften the paint down, avoiding the penguins. With the same colour on a dry brush, add a bit of texture to the foreground by dragging the brush over the paper. Pick up the medium grey and add a few broken lines into the foreground and into the bottom right-hand corner. Once these have been added, clean and wipe the brush almost dry, then soften the broken lines slightly. With the size 6 brush and a stronger grey, work on the water's edge where it meets the bank in horizontal lines all the way across, ensuring the water's edge is darker than the snow. Clean to almost dry, then soften the paint down into the picture. Allow to dry.

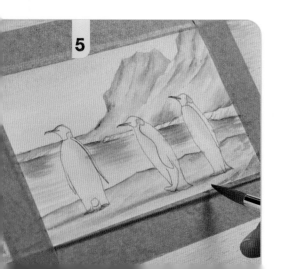

6 Use the size 2 brush and the strong orange mix from step 1 to add the beaks to all three penguins. Add more orange to the base of the necks, then soften with a clean, damp size 6 brush. With the pale grey mix from step 5, paint the left-hand edge of each penguin's body, widening the area at the top. Blend the paint with water until it fades out for a really smooth blend – clean the brush twice if you need to. Use the same grey to add shadow to the legs and base of the stomach, then blend upwards; the central penguin has a V-shaped shadow running in front of its leg, and the penguin on the left has an upside-down L-shape.

7 Mix a strong grey (60 per cent French ultramarine, 30 per cent yellow ochre and 10 per cent alizarin crimson). With the size 6 brush, paint the wings of the left-hand penguin. Paint the head, leaving a thin, light line where the beak meets the body. The eye is very small, but leave a tiny white dot if possible; you can use white paint later to emphasize the eye if need be. For the middle penguin, leave a thin white line to the right of the wing as it meets the dark part of the body. The tail should be painted in the same colour; fade it across with a clean, damp brush until it meets the leg. Repeat for the right-hand penguin, then clean the brush, wipe it almost dry, then use the tip to feather the tops of the wings and the bottom of the neck to 'attach' the head to the body.

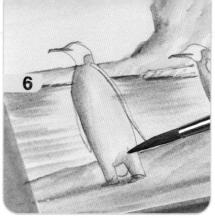
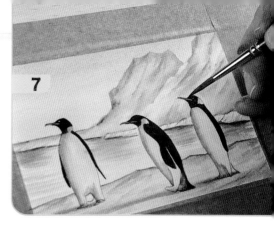
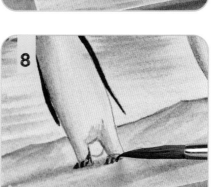
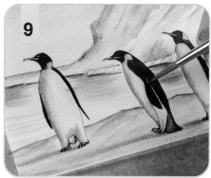

8 Paint in the feet using the dark grey. Use small diagonal touches of paint, then soften the feet into the legs.

9 For the left-hand penguin, use dark grey to paint in the curved line of the tail between the legs, then soften it up. To make the leg of the middle penguin stand forward, paint a dark line up the right-hand side, then soften to the right. On the middle and right-hand penguins, with pale grey, add a thin shadow line running down the left sides of the wings. Wipe the brush almost dry then lift out a few highlights from the dark areas (see page 15). For the middle penguin, add highlights to the wing, back and tail, to suggest the shape of the wing and give character. Add a highlight down the middle of the wing of the right-hand penguin. With a size 2 brush and dark grey, add a thin line above and below the beaks of the penguins; these lines need to be very fine. Finally, put in a few random dots and spots around the feet and tail to ground the penguins.

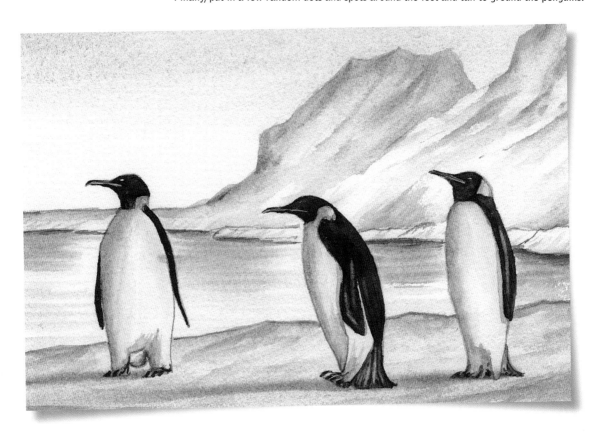

Asian elephant

This project is a great exercise in painting shadows – both across the foreground and on the body of the elephant itself – as it's the shadows that help to give the elephant shape, form and character. Although the shadows on the ground may look very dark when you first paint them in, remember that they are cast by the burning, setting sun, so they need to be bold, long and heavy to be believable.

1 Work wet-into-wet to create the background. Apply yellow ochre on the size 10 round brush. Work from the bottom of the paper up over the grassy ground and up towards the sky. Without cleaning your brush, work in aureolin just above, and over, the yellow ochre. Finally, put in pale burnt sienna from the top of the paper working downwards. Put a few horizontal strokes of burnt sienna into the landscape beneath the elephant's feet.

2 Using a coin wrapped with kitchen paper, stamp out the sun (see page 9), then mix brown from 80 per cent burnt umber and 20 per cent French ultramarine. Run horizontal clouds over the top of the sun. Twist the brush tip slightly to make the clouds look natural. Mix a strong green (70 per cent aureolin and 30 per cent French ultramarine), and lay it in horizontal strokes in the foreground, from the bottom upwards. Fade the colour away towards the feet of the elephant.

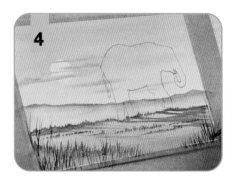

3 Pick up the size 6 round brush. Take up a strong grey (60 per cent French ultramarine, 30 per cent yellow ochre and 10 per cent alizarin crimson) with a fairly dry brush. Keeping in mind the direction of the sun, add some cast shadows using a downward diagonal brushstroke, leading out from the feet of the elephant. Group the shadows more closely together towards the right of the picture to create a low-lying shadow effect. Don't forget to put in a cast shadow for the elephant's tail. Run in some shadows cast by the ridge of foliage on the left of the scene. Allow the shadows to dry. Use the same mix to paint in the top edge of the mountain range, then soften the colour down with a clean, damp brush.

4 Mix a brown for the foliage (80 per cent burnt umber and 20 per cent French ultramarine), and use controlled, flicking movements to paint in the line of mid-ground foliage, the tufts of grass on the mid-ground and the taller grasses in the foreground.

5 Block in the elephant using the size 10 round brush for larger areas: add a touch of yellow ochre to the grey mix (see step 3) for a perfect, warm grey where the elephant's hide catches the sun. Block in the left sides of his legs and the top of his back with the lighter grey; run it down the tail and on the underside of the curled trunk.

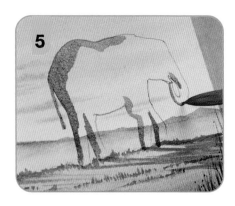

6 Change to a pure grey mix – with less yellow ochre – for the darker parts of the elephant. Put the colour in quite patchily, then blend the greys with a clean, damp brush using a gentle scrubbing motion. Allow to dry.

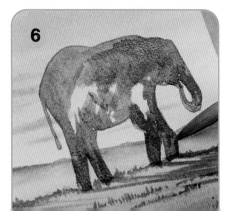

7 With a darker mix of the pure grey on a size 6 brush, add shadows to separate the legs, and to define the upward curl of the trunk and the front edge of the face; blend the shadow into the trunk to shape it.

8 Put in a couple of shadows across the top of the back. Add another shadow on the underneath of the belly in the form of an L-shape. Clean and wipe the brush then fade these shadows into the body – this helps the shadows give shape and form to the elephant. The left foreleg needs a dark shadow in the area where it is not meeting the leg behind. This shadow runs up underneath the elephant's mouth, almost like an arrowhead. Clean the brush, wipe it on kitchen paper and swiftly work the grey into the shape of the animal. A tiny shadow can be added around the mouth area, worked into another arrowhead shape. Soften to give the mouth shape and form. You wouldn't see the detail of the eyes, so we are not going to paint them in.

9 Put in a shadow at the top of the right hind leg on either side to give it more form. Finally, run in a couple of contours into the head from the top, almost in a curve and up into the same curve from the bottom of the mouth. Clean the brush, wipe it, then soften these in. Add a few stringy lengths of hair at the end of the tail.

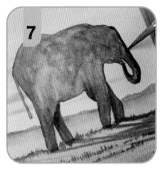
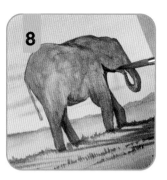
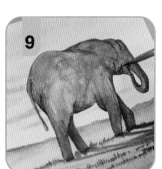
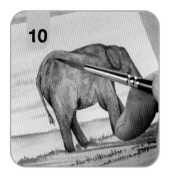

10 Define the ear with shadow: work at the back of the ear, then soften the shadow away to the left. This will create the impression of the ear. Finish with strong grey to give extra weight to the shadows: use little dry-brush flicks to give extra character and shape, following the curve of the backside and around the belly to give shadow and contour lines. To balance out the strong shadows used on the elephant, add more dark areas into the landscape. Darker grasses in the foreground will create the illusion of depth.

11 With a damp size 4 round brush, lift out highlights to the left-hand side of the ear, in an L-shape. Dab the excess paint off with kitchen paper. Also lift out highlights on the curve of the trunk; highlights support the shadows by increasing the contrast. The legs can be further separated by adding lightness to the left sides of the near legs. Finally, lift out a very subtle highlight roughly where the eye would be: remember here that less is more.

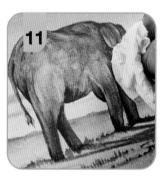

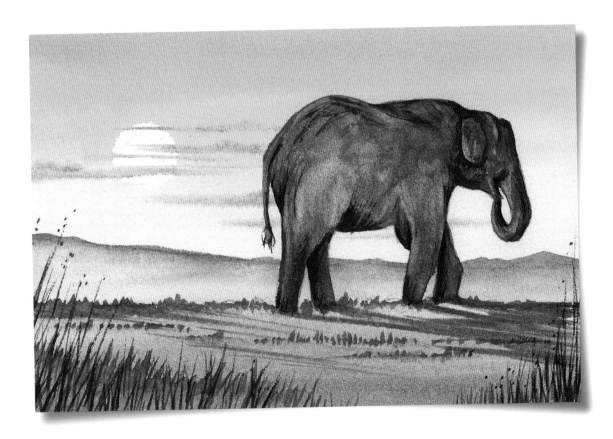

YOU WILL NEED

Paint colours: French ultramarine, aureolin, burnt sienna, burnt umber, yellow ochre, alizarin crimson

Brushes: sizes 10 and 6 round, 12mm (½in) and 6mm (¼in) flat

Other: tracing number 26, plastic card, kitchen paper

Stag in woodland

This majestic stag, surrounded by beautiful autumnal woodland, will give you the opportunity to practise your lifting out (see page 15). The stylized stag is almost silhouette-like, but the use of highlights gives him a solid sense of shape and form.

1 Wet the background. Lay the size 10 brush flat and twist in French ultramarine for the sky, at the centre top of the painting. Clean and wipe off the excess, then pick up aureolin and work it down both sides of the painting and across the top of the stag; it will mix with the blue to create a green tinge in places.

2 Immediately pick up some burnt sienna and twist this in over the top of the aureolin – this is a great way to allow colours to mix together for variations in tone. Don't be afraid to paint over the stag. Work down towards the bottom.

3 Go straight in with some burnt umber – use horizontal brushstrokes to fill in the foreground area. With a strong grey mix (60 per cent French ultramarine, 30 per cent yellow ochre and 10 per cent alizarin crimson), add some dark tones in the foreground. Add shadows from the bottom of the hooves with diagonal flicks towards the bottom right. Use the same grey to create a few soft branches, working up from the dark area towards the sky. Make use of the tip of the brush. If you find you're not getting a fine line, thicken the colour or use a smaller brush for these branches. The drier the paint, the less spread is created.

4 Create an orange mix (60 per cent aureolin and 40 per cent burnt sienna). Clean the size 10 brush, wipe it almost dry, then stipple the brush in the palette first to splay the bristles. Hold the brush at a right angle to the paper and tap in the suggestion of a few autumn leaves with the tip of the splayed brush. Work on both sides of the picture and across the top; practise on scrap paper first, if you need to.

5 Go straight in with a green mix (60 per cent aureolin and 40 per cent French ultramarine) to add in a few green leaves as well. These are better towards the edges of the scene and will work nicely in contrast to the orange leaves. Put in a few of these at the bases of the trees for the underbrush. Clean the brush well, wipe almost dry and stipple the damp brush over the tops of the leaves to soften and blend them together. This encourages the orange and green to mix on the paper and beds in the leaves. Use the corner of a plastic card to scrape away a few finer branches over the tops of the painted areas for a twig effect (refer to the finished painting). Allow to dry.

6 To add a bit of stony texture to the foreground, use the strong grey, and a size 10 brush. Paint from the lower left-hand side down in a diagonal direction towards the bottom-right corner. Clean the brush, wipe it almost dry, then use the damp brush to fade the grey towards the background. With the corner of a plastic card, scrape off the dark paint to create the lighter stones. Allow to dry.

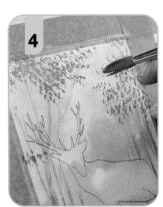
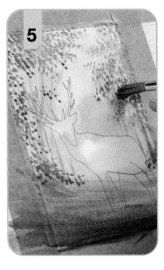

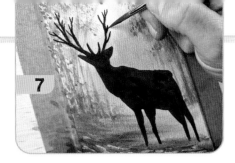

7 Using your strong grey mix with a tiny bit of burnt sienna added to make a brown, fill in the stag; use a size 10 brush for the large areas and a size 6 round brush for finer details. Painting a stag's antlers is a very similar process to painting in tree branches.

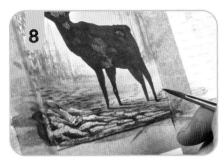

8 In the same colour and still using the size 6 round brush, add some darker areas in between some of the foreground stones. Work above and below the highlighted areas. A quick flick of shadow from the base of each hoof will help ground the stag, while a few horizontal flicks with the tip of the brush will give a little more detail to the ground. Reduce the size and number of these as you work upwards towards the background. Allow to dry.

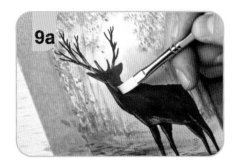

9 Use both large and small flat brushes to lift out highlights on the stag's body. Clean the brushes, squeeze out excess water, scrub away the paint and then lift out with kitchen paper. Use the larger flat brush to lift out highlights on the underbelly, working up and around, before easing the highlight in, then lighten the left side of each leg. Use a 6mm (¼in) flat brush for finer highlights. Add these up the left-hand side of the stag's chest and neck. Try to blend the highlights in by lightly stroking your brush to the side of the area and allow it to dry naturally. This will make the highlights look more natural and not like a hard line. If you do get a hard line, lightly pull in the surrounding colour. Allow to dry naturally. Once the glaze has gone from the water you will be able to see the highlights properly. Put in highlights on the left-hand sides of both antlers to separate them. Add a little highlight to the left side of the stag's head (9a). This is almost an L-shape. Put in a few highlights coming down from the top of the stag's back, as if the sun is catching those areas (9b), but remember that less is more with this particular painting.

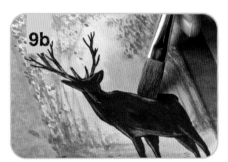

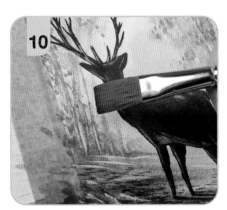

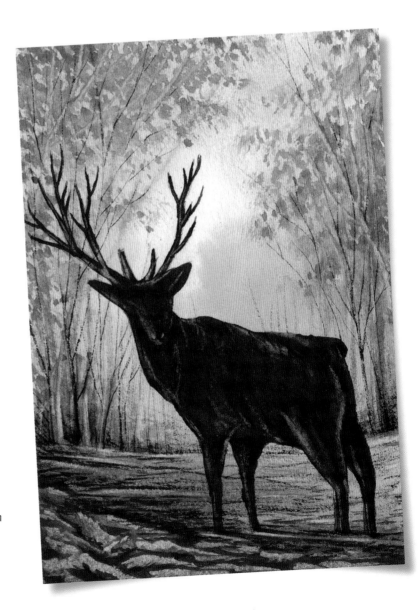

10 Finally, lift out some highlights around the landscape using the large flat brush: add a few horizontal highlights on the forest floor to create the effect of dappled light. Also lift out some highlights from the forest floor up into the trees, using kitchen paper to lift off the colour. This will bring the trees forward.

YOU WILL NEED

Paint colours: alizarin crimson, Prussian blue, French ultramarine, yellow ochre, burnt umber, cadmium red, burnt sienna, opaque white

Brushes: sizes 10, 6, 4 and 2 round, 6mm (¼in) flat, old brush for masking fluid

Other: tracing number 27, masking fluid, kitchen paper

Robin on a branch

The Prussian blue used here gives a lovely, gentle 'evening' feel to the scene. Paint the background as I have (refer to the box below, which will take longer than 30 minutes) or simply focus on the robin and its branch and wash in a simple background to help the bird really stand out.

THE BACKGROUND

1 Use masking fluid to add snow to the branch; work across the top then add some finer branches to the tip.

2 Wet the paper with the size 10 brush once the masking fluid is dry. Start with pale alizarin crimson across the base of the sky, then add a little across the field too; don't be afraid to go over the bird.

3 Clean the brush, wipe almost dry then wash in some medium strength Prussian blue at the top using diagonal strokes, mixing the blue with the red.

4 Apply the same blue in the foreground; paint over the branches but this time be careful not to go over the bird too much. Take some medium grey (equal parts French ultramarine, yellow ochre, alizarin crimson) and apply to the foreground in the same way; allow it to fade up towards the pink. Use kitchen paper to lift out any colour on the bird then allow to dry.

5 Use a pale grey mix for the profile of the background hills. Apply a 1cm (½in) wide line over the tops, then sweep the paint down. Encourage the colour to wash out and disappear to nothing further down. Allow to dry.

6 Add a touch of Prussian blue to your grey mix. Rotate the board if need be and put in a line of colour across the back of the nearest hedgerow. Blend the colour up so it disappears into the distance.

7 With the same mix, paint in the track, working around the bird; get wider as you get lower down to suggest proximity. Wipe the brush on the kitchen paper, then use it to drag little flicks of colour to the left and right of the track to break up the edges. Allow to dry.

8 With the size 6 brush and a pale version of the mix just used, add some horizontal shadows coming across the field from the left; use the shadows to shape and contour the land. Use an almost-dry clean brush to lightly glaze over the top of the lines and bed them in. Repeat on the right-hand side of the track.

9 Add a few lines onto the background hills just above the field, following the pencil lines and the contours of the hill. Glaze over the top to bed in the lines, then allow to dry.

10 Using the size 6 or 4 round brush, use a grey and burnt umber mix (dark) to paint in the middleground hedgerows almost by stippling; vary the heights of the marks, to give the impression of trees and bushes. Leave a gap for the gateway at the end of the track.

11 Use a dry brush and put in tiny horizontal flicks along the edges of the track to create the effect of dirt visible through the snow. Add a few random dry brushmarks here and there in the foreground to add detail and to bring the foreground forward.

12 Dilute the colour and use a fine brush to put in some distant hedgerows towards the top of the hills; varied dots and spots give the impression of trees. Follow the contours of the hills and, as you work up to the highest peak, use a drier brush to give the impression of distance.

13 Create a medium–strong mix of grey and burnt umber (with more burnt umber than in step 10). With the tip of the size 4 brush, paint in the branches in the direction of growth. Use the size 2 brush to add even finer branches right on the ends, tapering them away. Use strong grey on its own to add a few darker areas into the branches for clarity and contrast; the darker they are, the more they will stand forward. With the same colour, add a few flying birds in the distant sky.

14 Use a 6mm (¼in) flat brush to remove some highlights on the far hills, more so on the left, to add shape. Remove the masking fluid, then add a couple of tiny highlights with the opaque white paint and a size 2 brush to the edges of the tree branches to soften them into the previously masked-off areas.

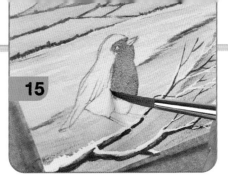
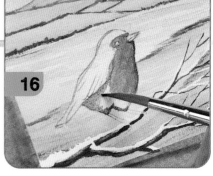

15 With the size 6 brush, paint in the red breast of the robin with a mix of 90 per cent cadmium red and 10 per cent yellow ochre; start around the eye, move to above the beak then down the right-hand side. Once you reach the bottom of the breast, clean the brush, wipe almost dry, then gently feather the left-hand and bottom edges where the paint will meet the wing and underfeathers.

16 Add a touch more cadmium red to the mix, but wipe much of the colour off your brush before putting in the red again at the bottom of the beak and top of the breast; ease the colour back towards the left. Take a tiny bit of strong grey on your brush (70 per cent French ultramarine, 20 per cent yellow ochre and 10 per cent alizarin crimson) and apply it below the beak and as a thin line down the edge of the breast. Clean and wipe the brush, then feather the grey back into the red to create a soft shadow. Mix a tan colour (50 per cent burnt sienna, 40 per cent yellow ochre and 10 per cent French ultramarine) and apply this under the wings and under the belly towards the legs and tail. Clean and wipe the brush, then soften the tan back towards the red – make sure not to lose all the white.

17 Use the strong grey and a size 2 brush to paint in the beak: apply lines across the top and bottom, softened towards the centre, then paint a thin line through the centre and feather down. Surround the eye with a thin grey line. Clean the brush, wipe it almost dry, then gently feather the grey away from the eye into the body. To complete the eye, use the dark grey to form a backwards C-shape in the centre, then finish with an opaque white dot. With the same grey, but a very dry size 4 brush, add some textured feathers next to the red and below the wing; splay the bristles as you do so. Continue in the same way to add some texture to the feathers between the bird's legs, over the top of the tan colour. Bear in mind that a few hints of the feathering over the red are good – but shouldn't be overdone.

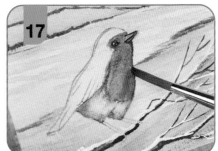
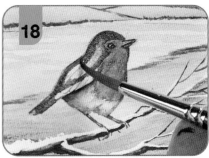

18 To help the wing stand forward, add a very dark grey shadow underneath it, and taper it up towards the eye. Clean and wipe the brush, then soften the shadow down. Use the same dark brown used for the branches to paint in the feet; leave a few light dots, as a bird's feet are scaly. Using a medium to pale brown burnt umber and French ultramarine mix and the size 6 brush, paint all the way down the bird's back and across the top of the head towards the beak. Paint in the head and down along the edge of the wing, leaving a white edge next to the dark shadow. Clean and wipe the brush, then soften the brown into the rest of the bird, keeping it nice and light where it meets the grey underwing shadow. Allow to dry.

19 Refer to the finished painting for details. Using the size 4 brush and the feet colour, tap off the excess, then add lines to represent tail feathers. Clean and wipe the brush almost dry, then brush down over the tail feathers and over the top and back of the head. Add a thin line from the top of the tail feathers around the top of the wing, then clean the brush and soften it down. With strong grey, add a few fine lines to the brown wings to give shape and form. Add dark lines to the tail feathers too, and use quick flicks of the brush (which should be quite dry) to add some feather texture around the lower breast and below the wing. Use a damp number 6 round brush to lift out highlights at the bottom of the neck, to give shape to the throat, and on the feathers. Finally, use a very pale dilute Prussian blue to add a few spots to the bottom of the settled snow on the branches.

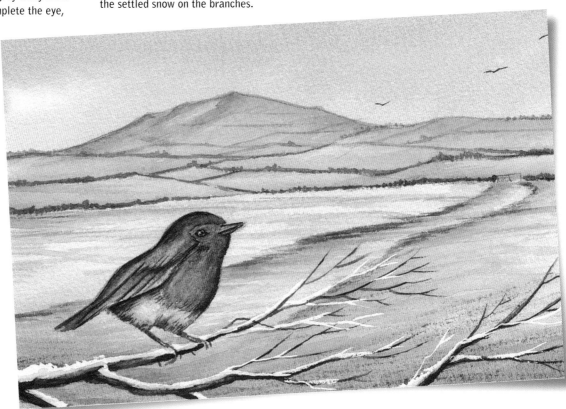

YOU WILL NEED

Paint colours: yellow ochre, dioxazine violet, French ultramarine, alizarin crimson, cadmium red, burnt sienna

Brushes: sizes 10, 6, 4 and 2 round, 6mm (¼in) flat

Other: tracing number 28, kitchen paper, masking tape

Stag in winter

You'll need to use a combination of shadows and lifting out to hint at the muscular structure of this mighty stag. Paint the background as I have (refer to the box below, which will take longer than 30 minutes) or simply focus on the stag and wash in a simple background around him to help him really stand forward.

THE BACKGROUND

1 Use masking tape to mask off the hills, taking care to remove some stickiness first (see step 1 on page 32) – the top edge of the tape will be the top edge of the hills. Use your fingernails to shape and give more character to the top edge of the tape.

2 Using the size 10 brush, wet the sky area, being careful not to put too much water around the tape to avoid moisture seeping under it. Wipe the excess water off your brush. Starting with pale yellow ochre, twist and roll the brush across the bottom half of the sky, right down to the tape, in an irregular way. Clean and wipe off the brush then twist in dioxazine violet at the top – fill in the top section of the sky, working down towards the trees and the masking tape, adding plenty of colour at the top of the tape itself. Without cleaning the brush, pick up some dilute dark grey (60 per cent French ultramarine, 30 per cent yellow ochre and 10 per cent alizarin crimson). Tap off the excess before twisting in some darker clouds behind the tree and across the top of the hills – this contrast will help the snow stand out. Leave to dry then remove the tape.

3 Using a lighter violet (90 per cent dioxazine violet with 10 per cent French ultramarine), build up the shadows in the winter landscape, starting off with the back of the foreground area by the stag. Apply a good line of violet, about 1.5cm (⅝in) wide – using it to negatively paint in the foreground snowdrift – then scrub the paint upwards to create the effect of distance, working quickly as the violet will stain the paper. Add the same colour into both foreground corners, then fade the colour towards the stag. Don't use too much violet here, as some areas should remain white. Allow to dry.

4 Mix a pale grey (70 per cent French ultramarine, 10 per cent cadmium red and 20 per cent yellow ochre), then add a touch to the violet to darken it. Paint the right-hand side of the overlap between the two hills, then soften the paint to the left with a clean, damp brush. Use this same colour to add darker tone to the right side of the larger hill – leave a thin white line before it meets the sky and paint around, not over the stag. Soften the colour down and away to the left. Use an almost dry brush to feather away the thin white line at the top. Continue with the same colour to add contour lines following the direction of the larger hill, working down to the left. Feather away any hard lines. Allow to dry.

5 Dilute some pure dioxazine violet, and add shadows between the two areas of raised snow at the base of the trees to create separation between them. Clean and wipe the brush, then soften it up and away. Drag a few lines away for contours. Add a shadow to the base of the stag, from the feet and running off the bottom right of the picture. Allow to dry. Once dry, if any stronger shadows are needed to create more depth, put them in now using the violet, then blend them away and allow to dry.

6 Mix a dark brown (60 per cent burnt sienna and 40 per cent French ultramarine), and using the size 10 brush block in the two main tree trunks. Switch to a size 6 for the finer branches; work in the direction of growth, taking the lines from thick to thin, making use of the brush tip. Using a finer brush (size 2 or 4 round), paint in the really fine branches. Try to flick or taper these away, almost lifting the brush off the paper to create the stippled branch effect. Rotate your board if you need to; the more fine branches you add, the more life the tree will have. Dilute the brown, wipe off the excess, then add a few lighter branches to give the impression of distance.

7 Using the undiluted dark grey mix from step 2, add a shadow line to the right-hand edges of the trunks and larger branches. Using a clean, damp brush, ease the grey shadows to the left to shape the trunks and branches. Allow to dry. Use the 6mm (¼in) flat brush to lift out highlights along the left sides of the trunks. Where a branch forks off, lighten the branch but bring the highlights into the centre of the tree to make it look three-dimensional.

8 Create a fairly strong mix of the grey with some burnt sienna added. Using a size 6 round brush, tap off the excess on kitchen paper, then add some dry-brush marks at the base of the tree to suggest earth poking through the snow. Add a few little taps above this to suggest winter foliage. Use the same dry brush over the tips of the branches to indicate wispy twigs that are too fine to paint in individually.

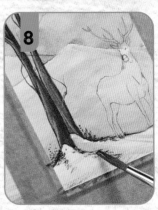

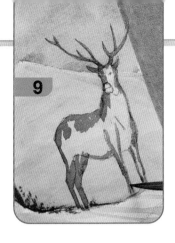
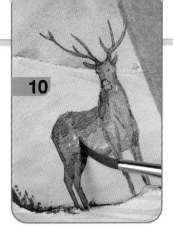
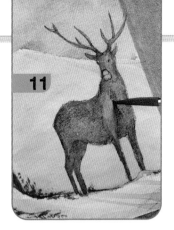
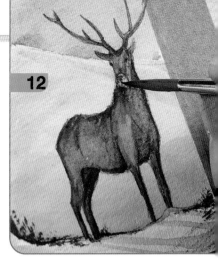
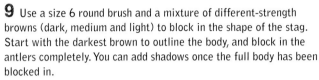
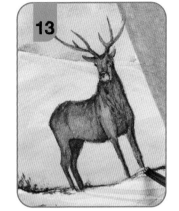
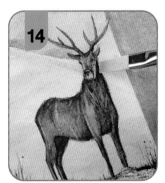

9 Use a size 6 round brush and a mixture of different-strength browns (dark, medium and light) to block in the shape of the stag. Start with the darkest brown to outline the body, and block in the antlers completely. You can add shadows once the full body has been blocked in.

10 Use the medium brown to fill in most of the body, working towards the centre, and blend the browns as you go. Put in the lightest of the browns right in the centre. Spend time scrubbing the colour into the paper, and retracing your steps to reactivate the darker colours and soften the blended areas. Leave some areas lighter than others.

11 While the body is still damp, take the first, darkest brown, and put in a few contour lines to suggest the muscles.

12 Use the strong grey to add darkness to the right-hand side of the stag, starting from the base of the head. If the background colour is still damp, this will help the paint to spread. With a damp, clean brush, blend the grey into the frame of the stag's body. Use the grey on the stag's underbelly and on the rear legs to separate them from the forelegs. Put in a dark shadow under the base of the mouth in an L-shape, and run this down onto its neck. Put in dark spots for the eyes and nose; then with a smaller brush (a size 2 or 4 round), darken the mouth and muzzle.

13 With a dry brush, use strong grey to put in a furry collar and the stag's breast in the form of lots of little downward flicks. Add in a thin, dark line on the right sides of the antlers and the ears. Mix grey and brown. Using a fairly dry size 6 round brush with its bristles pinched, put in a little earth and texture around the hooves of the stag to ground it in the scene. With a fine brush, add a few tall grasses as well.

14 With the flat brush, lift out a few highlights. Focus these towards the left to show the multitude of tones on the animal. Add highlights on the left side of the legs to give them shape and to suggest the light catching them. Add curved highlights from the top of the animal's back down to the left, and from the base of the belly upwards. Lift out a few diagonal highlights on the collar and chest to exaggerate the fur. Run a highlight along the left-hand side of the head to bring his face forward, and on the right-hand side of his jaw to 'lift' his face from the paper.

15 Paint any final strong grey shadows on the stag, ensuring the shadow between the back legs is very dark. A few darker contour strokes can be painted around the collar – use the size 6 round brush. Finally, using a slightly dry size 2 round brush, flick in a few fine branches on the far side of the tree that almost disappear into the tops of the trees. These set the scene and balance the painting. (Refer to the finished painting.)

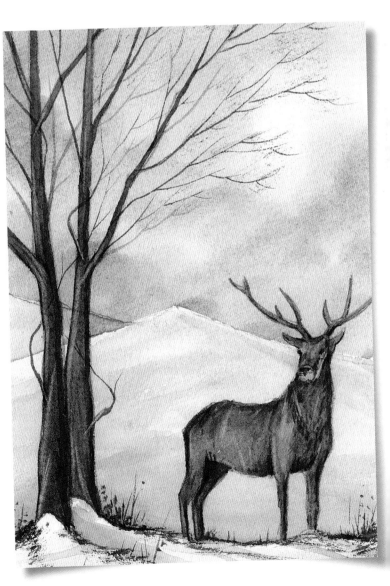

YOU WILL NEED

Paint colours: yellow ochre, burnt umber, French ultramarine, alizarin crimson, aureolin

Brushes: sizes 10, 6, 4, and 2 round, old brush for masking fluid

Other: tracing number 29, masking fluid

Giraffe

This graceful giraffe is captured here mid-stride – perhaps on her way to nibble some leaves. Don't be overly precious about painting her spots – they should be irregular, and will look odd if they all look too similar in shape; try to allow the form of the giraffe to dicate their shape and colour. Paint the background as I have (refer to the box below, which will take longer than 30 minutes) or simply focus on the giraffe and wash in a simple background to help her really stand out.

THE BACKGROUND

1 Use masking fluid to mask off the legs and tail. Leave to dry, then wet the entire paper using the size 10 brush.

2 Go in with pale yellow ochre over the base of the sky to about halfway up it. Using a stronger yellow (80 per cent yellow ochre and 20 per cent burnt umber), go in over the bottom, working up into the background hills until it fades in. Add in a touch more burnt umber and make it darker at the base over the legs. Add a touch of dark grey (60 per cent French ultramarine, 30 per cent yellow ochre and 10 per cent alizarin crimson) in the foreground, then ease it into the background. Add some horizontal shadows running across the meadow (70 per cent French ultramarine, 10 per cent alizarin crimson and 20 per cent yellow ochre).

3 Clean the brush, wipe it almost dry, then paint in French ultramarine for the sky: work to about halfway down, then soften the blue down to the bottom of the sky. Use kitchen paper to wipe off any blue from the giraffe.

4 With a dark green mix (50 per cent French ultramarine and 50 per cent aureolin), put in a few horizontal bands across the foreground grassland area.

5 Using a pale grey with a touch of yellow ochre, work across the distant hill tops, leaving space for the giraffe's neck. Bring this down about 1cm (½in), then soften down. Allow it to fade into the foreground.

6 Use the size 6 brush and the strong yellow ochre and burnt umber mix. Splay the bristles and make some quick upward strokes to represent the grasses in the foreground. Work a few rows, adding more grasses, working towards the background. Make the grasses shorter as they become more distant. As you head towards the background, the grasses become dots and dashes, with a few horizontal sweeps for extra texture. Put in a few individual tall grasses, especially along the foreground.

7 Use the dark green mix (from step 4) to add further grasses along the foreground, and spots and dots for extra clarity in the corners.

8 Using a light green mix (70 per cent aureolin and 30 per cent French ultramarine), add in the distant tree line. Make horizontal and then twisting strokes to create texture. Then add in the dark green along the bottom of the tree line, twisting in some of the darkness to give depth to the undergrowth, giving the impression of shadows. Go straight in with the dark grey to add just a little more darkness to the base of the trees – but not too much.

9 With the darker green, add a tiny bit of dry brush horizontally across below the edge of the tree line. Add a few horizontal strokes of this around the grassy areas, too.

10 Where the hills divide, paint in a pale grey shadow on the right-hand hill to separate them, then fade the colour across with a clean, damp brush. With a size 2 or 4 brush, use the dark grey with a touch of burnt umber to paint in some of the overhanging branches in the top corner of the picture in the direction of growth; rotate the board if you need to. Use the size 6 brush and the lighter green to spot in a few individual leaves of the overhanging tree. Put in a few darker green leaves over the top.

11 Dilute the lighter green and, with the size 4 brush, add a few pale lines of distant trees over the far hills and along the brow of the hill – use twisting brushstrokes and add as much or as little as you need. Leave to dry. Once dry, go over this area again in the same way to give a little more tone to the trees. Dilute the dark green and work in a similar way as before to add a little more undergrowth shadow. Once dry, dilute the light green to 80 per cent water and add some directional brushstrokes on a diagonal from the base of the trees to give character and shade to the background.

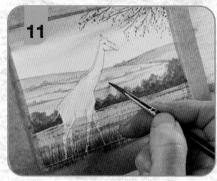

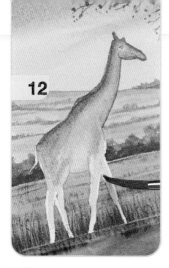 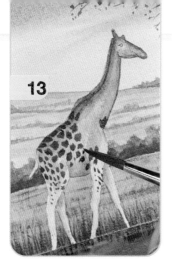 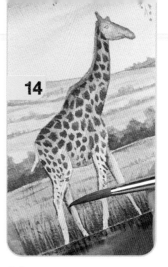 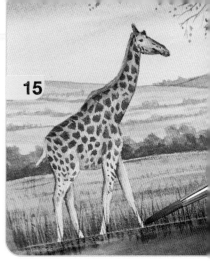

12 Once the background is fully dry, remove the masking fluid. With the size 6 brush, take up the medium-strength yellow ochre and burnt umber mix from step 2. Outline the giraffe, starting from her backside and working up to the top of her head, around her head and down her long neck. When you approach where the masking fluid was, leave a slight gap. Use pale yellow ochre with just a touch of burnt umber to blend the colour in towards the centre; scrub the outline inwards to soften it. Blend down into the legs. Clean the brush, then soften the colour down so no traces of pure white remain on the legs. Blend into the tail, then allow to dry.

13 Add a couple of shadows using the medium-strength mix from step 12: paint a line up the back of the giraffe, leaving a thin line for the mane. Also add this colour underneath the chin and down the neck. Add a couple of lines under the belly, but not over the legs. Soften the lines towards the centre of the giraffe. The front leg is furthest away so needs a shadow painted in the same colour. The furthest hind leg is the same. Soften down the shadow colour then leave to dry. Using the size 6 brush and a very thick mix of dark grey with a touch of burnt umber, start to build up the irregularly shaped spots – as many as you feel are needed; use smaller spots towards the back legs and dots on the legs.

14 Continue to add spots, keeping the spaces between the spots smaller than the spots themselves: add larger spots at the back of the neck. Dilute the colour and make some lighter spots underneath the belly. Add some lighter dots, that almost fade away, at the bottom of the belly and down the two nearest legs. Soften the edges of some of the larger spots. Use the same colour to add in some contrast lines with the size 4 brush: work down the backs of the legs – on the two nearest legs this will run as an outline down the back; on the two far legs you can take this line up along the overlap between each pair. Clean the brush, then soften the line, working into the legs to give shadow and contrast.

15 With the same colour and brush, add more detail to the head. Touch in the ossicones (small horns), and the shadow under the mouth. Soften these details into the head. Add a dark line across the top of the head, and add darker spots for the nostrils. The eye is just a dark spot at this distance. There are a few small spots around the back of the head and around the jaw area. Add a few final tall, dark grasses to balance out the scene; take some of the tall grasses up over the legs so that the giraffe appears to be walking among the grasses.

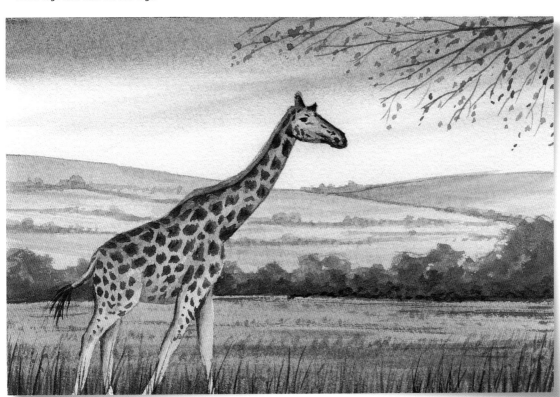

16 With the same colour, add some long dark hairs to the tip of the tail for swatting away the flies. A dark line under the tail will help it stand forward. Soften and round the tail with a damp brush. Feel free to add darker dry-brush strokes over some of the spots to add more contrast. Run a thin line down the back of the neck, below the mane, to help the head and neck stand forward with the same dry brush. (Refer to the finished painting.)

'MAX', CAVALIER KING CHARLES SPANIEL

See tracing number 30

Creating a portrait is a great way to remember a much-loved pet who is no longer with us. Some of the first professional work I did was domestic pet portraits and they are still popular subjects to this day – they often feature this vignetted, or faded-edge background. Every breed of dog will require slightly different painting techniques to account for their physical differences, however there are often similarities in their noses, eyes and mouths; referring back to the Jack Russell portrait (see pages 36–39) will help you here. With Max, I especially enjoyed painting the transitions, capturing both the short facial hair and the long, shaggy hair of the ears.

Getting a likeness to a known pet, or indeed any animal, can be difficult, so remember that there is no harm in tracing your own photographs, especially if the drawing stage adds fear for you.

Use a good strong pencil when drawing the animal so that you can still see the lines even after laying down layers of paint – it is so easy to paint over and hide them. I recommend a 2B or 4B pencil. Leave the pencil lines in place after the painting is complete – there is no need to remove them. It's part of watercolour, whether animal paintings or landscapes, and adds a sharpness.

The background

Fading away the background and the neck gives a wonderful vignetted effect. I do this with all the animal portraits I paint as I feel it really suits the scene. It is achieved by working wet-in-wet (see page 12) and using a large brush. Use pale colours for the background and slightly stronger colours over the animal. When dry, use smaller brushes and build up wet-on-dry layers of paint.

Eyes, nose and mouth

These are the three areas of the painting that it is crucial to get right: not only will they identify the animal as the pet you know and love, but they will also be the areas that any viewer will be drawn to look at. Take your time on these areas, because adding extra details here – the contrast, texture, highlights and shadows – will help make the painting look three-dimensional.

Highlights

One of the last jobs is to add highlights, and on a long-haired animal, a flat or square brush works well for lifting out (I use a 6mm/¼in or 12mm/½in size). Simply dampen and, using the tip, scrub two or three times over the area to be lightened. Then firmly dab away with kitchen paper (see also page 15). This is a great technique and an essential part of my painting. You can also use an opaque white for fine, light areas like the whiskers (see page 15).

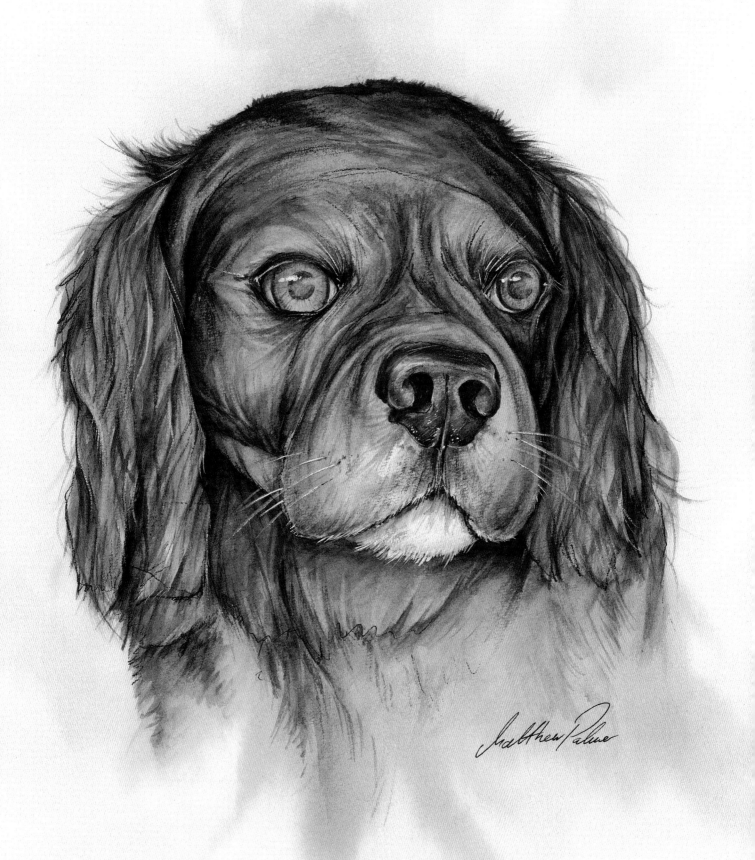

SNOW LEOPARD

See tracing number 31

Big cats and wild animals are probably my favourite subjects in the animal kingdom. The challenge of each animal is wonderful – each requires its own set of techniques. The best part for me is the face of the animal, and working on its details makes the rest of the painting pop. A phrase I use all the time in my teaching is: 'you must finish the painting, because the magic happens at the end'. And there is no better example of this than this snow leopard. I taught a similar portrait to this to a large group, and it wasn't until we added the spots and stripes of the big cat, right near the end, that the painting worked. This is true of all paintings, whether they feature a landscape or an animal. It's those last brushstrokes that make the painting. No matter how much you feel the painting isn't working, you must finish it off. I call this 'the painting depression wall'. All paintings have it, but trust me, if you see past this stage and complete the painting it'll work out great.

 The background

This wonderful background technique using plastic wrap (see page 59) really works well in this scene; it adds great atmosphere and an almost icy, marbled effect. This effect works in so many paintings and gives an excellent, random texture. The secret is to apply the plastic wrap while the paint is still wet or damp, and simply scrunch it up, before leaving the paint to dry.

The fur

To capture the spiky fur, simply pick up the colour on a small brush, such as a size 6. Dab off the excess paint from the brush onto kitchen paper. Then, using your fingers, splay the hairs to make a fan shape; 'wiggle' your fingers between the bristles to create a nice small, spiky, fan-shaped brush (see page 13). Use the tip of the hairs to gently stroke in the fur. This works on all portraits; the combination of the dry brush and spiky hairs work great.

The darkness and depth

The strong darkness on the nose, eyes and mouth is so important to get right. For example, you need to see the shadows in the nose to help it recede. Avoid using any paint with black pigment, like Payne's gray. This shouts out and doesn't cause depth; instead it has the opposite effect. A better option is to mix this dark from primary colours (see page 11). And remember, the darker or stronger you make this, the more depth and recession you get.

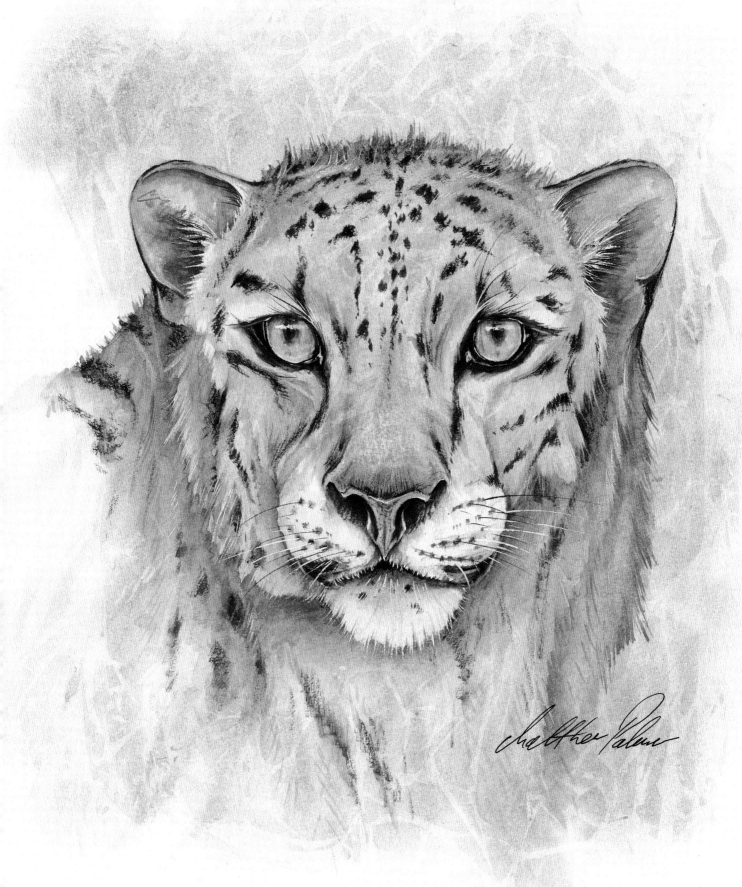

HUMMINGBIRD

See tracing number 32

All kinds of animals make fantastic subjects, including those you might not see in your own house or garden. So why not apply the techniques from this book and have a go at painting this hummingbird in flight? These are such beautiful birds, and capturing their fast wing movements is great fun. The secret is to paint the background and the wings while the paper is wet, as this allows the paint to bleed. The preparatory work with your colour mixing is important when working wet-in-wet, as it saves time and prevents the water drying. It's important to get the strength of colour right too, as stronger colours won't bleed as much as more dilute colours. Here, the background colours are simply a pale yellow-green and a pale brown, and I used a fairly large brush. For the wings I used a smaller brush and stronger colour – this gave me greater control over the paint, but still allowed the paint to slightly spread at the edges, to help capture the movement.

Hummingbirds are tiny, so I have worked small flowers in this scene to emphasize their diminutive size. I could have left out the flowers, but for me they just make the painting, and I love the rose madder and the distant, pale, almost out-of-focus flowers. The flowers 'disappear' into the wet-in-wet background because the depth of field is very short.

Strong dark details bring bird paintings to life. Mix your dark colours from your primaries, rather than buying a pre-mixed paint (see page 11). This dark is used throughout in the claws, all the shadows, the markings, the eye, and even the darkness under the flowers. The stronger the better. The eye is simply painted just by leaving a thin white line around the edge and the white highlight, top centre.

◀ *White paint*

Notice how I've just used very fine touches of paint to create a few light areas and fine highlights on the claws. This is the final job and, for me, it always brings an animal to life. Use an opaque white or even gouache (see page 15). Also try dragging it across the surface of the paper to add texture to the wings.

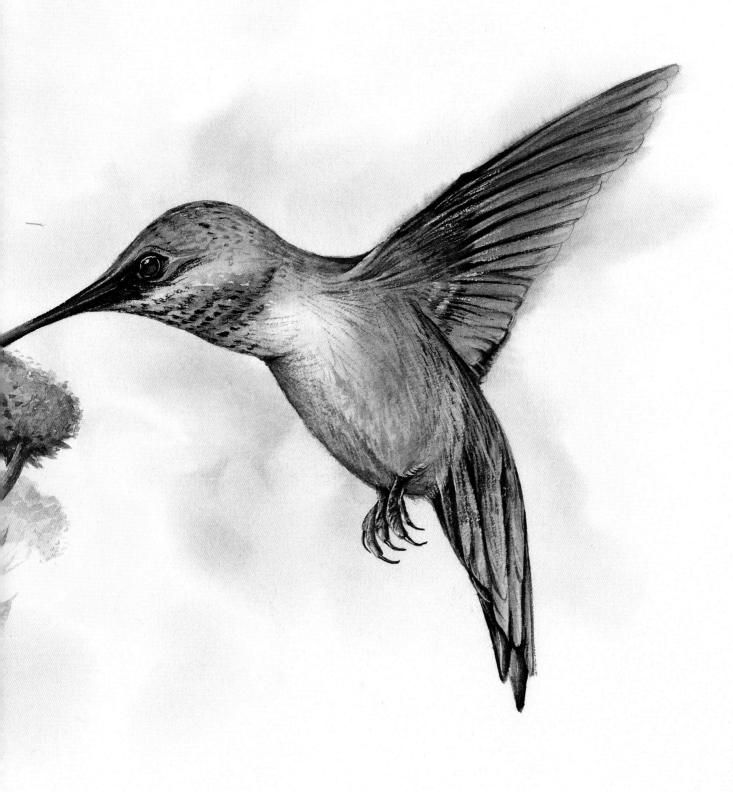

INDEX

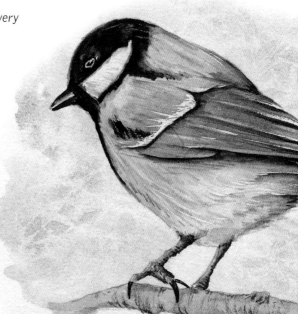